co...... Expressionism
numerous exhibition catalogues. H
History at Goldsmiths' College, Lond
his PhD on Primitivism at the University of Essex and is currently
Reader in Art History and Theory at Loughborough University.

World of Art

This famous series provides the widest available range of
illustrated books on art in all its aspects. If you would like
to receive a complete list of titles in print please write to:

THAMES & HUDSON
181A High Holborn
London WC1V 7QX

In the United States please write to:

THAMES & HUDSON INC.
500 Fifth Avenue
New York, New York 10110

Printed in Singapore

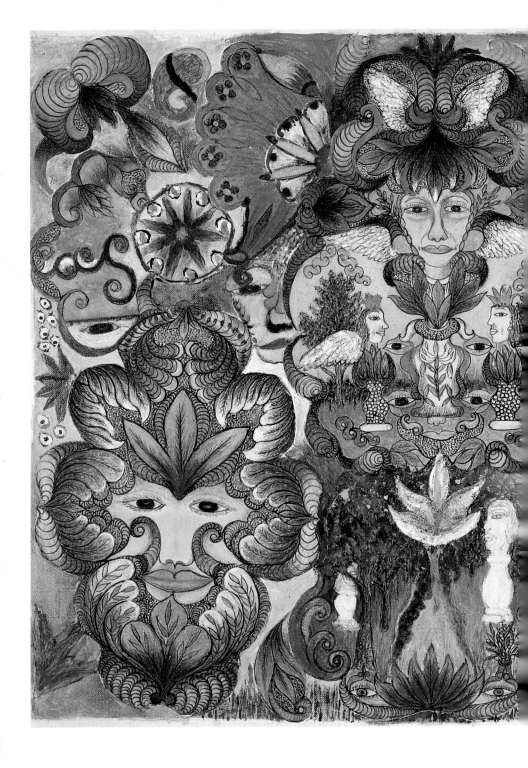

Colin Rhodes

Outsider Art : Spontaneous Alternatives

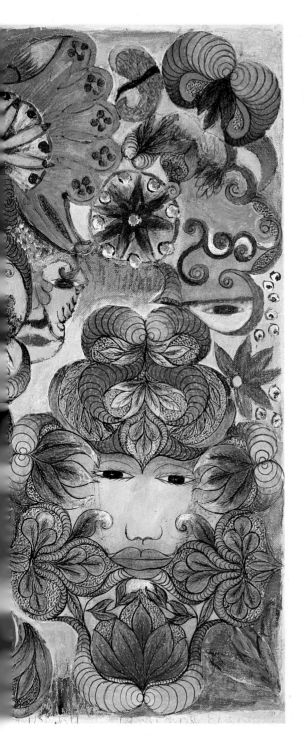

188 illustrations, 75 in colour

THAMES & HUDSON

Acknowledgments

For my mother, Beryl Rhodes

*Many people deserve thanks for their help and support throughout
this project. First, and most importantly, I owe a profound debt of
gratitude to my family for their forbearance and continued love
and support throughout the project, and most especially to Nicky,
Tom, Anna, Tess and Lila. I have been fortunate in being able
to share my interests with others whose enthusiasm for Outsider
Art knows no bounds. In this I am particularly grateful to Roger
Cardinal and Ans van Berkum. Also, to Peter Vergo, Henry Boxer,
John Maizels, Mieke Rijnders, Neil Cox and others too numerous
to mention here by name. The arguments presented here are,
nevertheless, my own. Finally, I want to thank Nikos Stangos
for his continued gentle encouragement and Raymond Morris
for opening my eyes.*

First published in the United Kingdom in 2000 by
Thames & Hudson Ltd, 181A High Holborn, London WC1V 7QX

© 2000 Thames & Hudson Ltd, London

British Library Cataloguing-in-Publication Data
A catalogue record for this book is available from the British Library

ISBN 0-500-20334-2

Designed by John Morgan
Typeset by Omnific

Printed and bound in Singapore

1. **Minnie Evans**, *Untitled
(Landscape – Many Faces)*,
1959–61

Contents

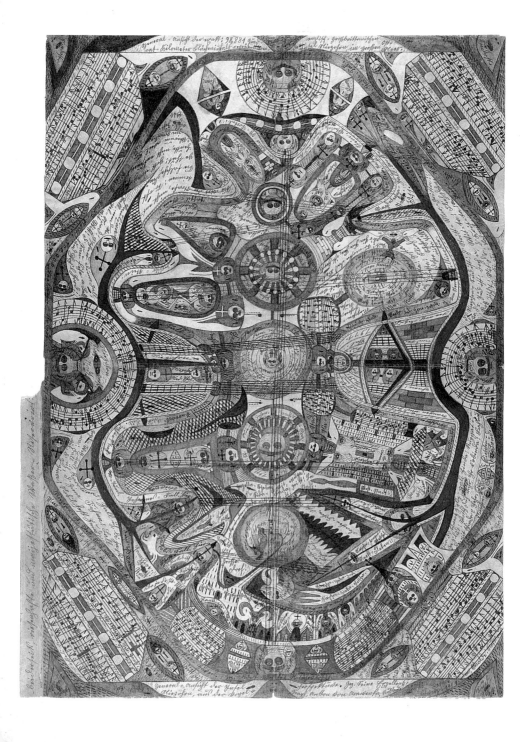

Introduction

The desire to make images and to communicate something of the otherwise unsayable is innate in all of us. There can be few people who did not make drawings as children, whether using materials provided by earnestly indulgent adults or scratching marks into dried earth with a stick. Early in our lives we make patterns and representations with anything that comes to hand, unconsciously exploring the bounds of space with the objects we arrange and depict. In this way we begin to learn about a relationship with the world which goes beyond practicality. For most, creative activity of this kind declines and ceases by the time adulthood is reached, though creativity and considered looking are often channelled imperceptibly into other areas of our lives, our work or leisure activities. A few people become professional makers of images or spectacle, that is artists in the modern western sense. But there is also a rich and varied group of creators who do not fit into the official category of the professional artist, however it is defined. At their best, they are the creative patternmakers par excellence, often producing interesting and powerful bodies of work that find their way, through various means, into public view. Here their artistic production takes on a life that distances it – often emphatically separating it – from its producer. This is the domain of Outsider Art.

The specific term Outsider Art was first coined in 1972 by the British writer Roger Cardinal, in his eponymous book, as an English-language equivalent for the French term 'Art Brut', originally formulated by the painter Jean Dubuffet (1901–85) in the mid-1940s. The artist outsiders are, by definition, fundamentally different to their audience, often thought of as being dysfunctional in respect of the parameters for normality set by the dominant culture. What this means specifically is, of course, subject to changes dictated by history and geographical location. Thus, the emergence of a heterogeneous group has been made possible which includes those *labelled* as dysfunctional through pathology

2. (opposite) **Adolf Wölfli**, *General View of the Island Neveranger*, 1911

(usually, though not always, in terms of psychological illness), or criminality (often in tandem with the first), or because of their gender or sexuality, or because they appear to be in some way anachronistic, or are seen as un(der)developed, or often simply because of a cultural identity and religious belief that is perceived as significantly different.

Psychiatric patients, self-taught visionaries and mediums are the groups at the heart of early definitions of Outsider Art. Connections between art and madness had been explored by the Romantics in Europe in the nineteenth century, but it was only shortly before the First World War that artists belonging to a new generation, whose interests leaned towards formal distortion and Expressionism, began to develop an interest in the artistic production of psychiatric patients. This 'discovery' was part of an extensive search by modernist painters such as Pablo Picasso (1881–1973) and Paul Klee (1879–1940) for new forms of art that offered an alternative to what they perceived as the dried-up academicism of the western tradition. As in the case of the parallel 'discoveries' of tribal art, folk art, prehistoric art and children's drawings, these powerful works seemed to be spontaneous expressive outpourings from the well-springs of creativity, unmuddied by artistic training or received knowledge.

The first psychiatrists who regarded patients' work in aesthetic terms were themselves influenced by Expressionist theories that valued spontaneity and immediacy, above all, as the proper means to artistic communication and this is reflected in their patterns of collecting. The vast collection amassed in Heidelberg, Germany, by Hans Prinzhorn (1886–1933), an Austrian art historian turned psychiatrist, and others at this time is a case in point, with the work of such artists as Hyacinth, Freiherr von Wieser (Heinrich Welz) (1883–?) and Franz Karl Bühler (Pohl) (1864–1940) being foregrounded. Similarly, the Swiss psychiatrist Walter Morgenthaler's (1882–1965) discovery and championing of the Swiss peasant Adolf Wölfli (1864–1930), probably the greatest and certainly the most famous 'Outsider artist', is inconceivable without the critical visual framework laid down by modern western art. In their turn, Prinzhorn and Morgenthaler were influential in shaping the Surrealists' reception of the art of psychiatric patients and in leading Dubuffet to his conception of Art Brut.

At the end of the Second World War Dubuffet emerged as one of the most important apologists for art produced outside the mainstream. After amassing a collection of children's drawings in

2

around 1940, he turned his attention to the work of psychiatric patients and other self-taught artists. A trip to several Swiss asylums in 1945 resulted in the acquisition of work by Wölfli and other patients such as Heinrich Anton Müller (1865–1930) and Aloïse Corbaz (1886–1964) who have become classic examples of Outsider artists. At the same time Dubuffet collected the art of mediums, such as Madge Gill (1882–1961), Augustin Lesage (1876–1954) and Laure Pigeon (1882–1965), and sought out other non-psychotic artists working outside the structures of the art market – for example, Gaston Chaissac (1910–64) and Scottie Wilson (1888–1972). Despite often significant stylistic differences in their work, the group was united by Dubuffet's belief in the raw, unpremeditated nature of their art arising as an imperative out of their 'inner selves'.

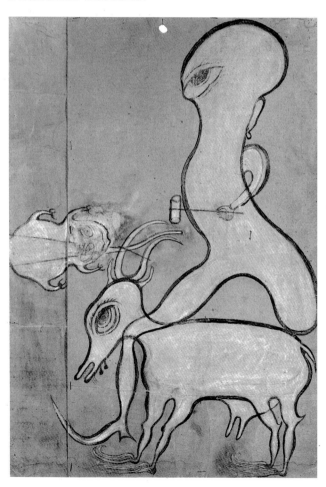

3. **Heinrich Anton Müller,**
Personnage avec chèvre,
1917/22

4. (opposite) **Aloïse Corbaz**,
Dans le Manteau de Luther, c. 1950

5. (above) **Madge Gill**,
Composition, 1951

6. (above) **Gaston Chaissac**,
Untitled, c. 1957–59

7. (right) **Gaston Chaissac**,
Totem, n.d.

8. (opposite) **Jean Dubuffet**,
The Reveller, 1964

By way of his continued collecting activity and a sustained polemic in favour of art created outside the mainstream, Dubuffet assumed the position of arbiter of the scope of Art Brut and the relative quality of its inclusions. In this way a position that had originally been born of a desire to escape the straightjacket of the art market now threatened, ironically, to develop into an 'alternative' orthodoxy. This was made more real when Dubuffet permanently established the Collection de l'Art Brut in Lausanne, Switzerland, in 1975 and took steps to 'protect' the work from the kinds of misapprehension that might distort its value and significance, including a stipulation that objects from the collection proper should not be allowed to travel, thereby removing any risk of a work of Art Brut being seen beside mainstream art, or entering 'the cultural circus of art promotion'.

Dubuffet's search for an art that lay entirely outside cultural concerns was doomed to failure from the start, for no one can create from a position oblivious to the world around. However, he established the idea of this 'non-cultural' production not as something that he believed existed, but as an ideal aspiration. As the French writer Michel Thévoz says, 'the polar concepts of Art Brut and Cultural Art constitute guidelines rather than watertight categories. One has to bear in mind that a given work is *more or less* indebted to culture. A work can be classified as belonging to Cultural Art or Art Brut depending on whether it veers toward one or other of the two poles.' As if to emphasize the point, Dubuffet invented a new category, *Neuve Invention* (Fresh Invention), in which 'borderline' cases of works that seemed to straddle the boundary between Art Brut and mainstream art might be placed.

Where Art Brut has in large measure maintained its original boundaries (developments in France have tended to be accompanied by the invention of new terms, such as Art-hors-les-normes, Les Singuliers de l'art, Art en marge), in recent years the term Outsider Art has begun to be used extensively to describe a bewildering range of artistic activity situated outside, or in opposition to, mainstream concerns. While it is surely desirable to maintain flexibility, there is a danger of the term becoming all-inclusive and therefore meaningless. Thus, while some other groups of self-taught, obsessive and visionary creators are included here, such as so-called 'folk' or 'grassroots' artists from the Southern United States – for instance, Mose Tolliver (b. 1919), Leroy Person (1907–85) and Howard Finster (b. 1916) – and certain semi-professional non-western artists operating in post-colonial contexts – for instance, popular urban painters from Central and

9

West Africa – other categories are absent. Most obviously, perhaps, there is no place here for the struggling would-be professional artist attempting to find his or her way into the mainstream, but currently languishing outside the system. Similarly, the amateur artist whose practice is primarily recreational is not included. Also absent are the rural artists from Europe and elsewhere whose production, while naïve in style and culturally outside dominant structures, is both central to the 'folkish' culture to which they belong and is the product of a recognizable tradition.

It is most important when addressing Outsider Art to remember that neither it nor its possible sub-categories refer to a stylistic tendency or historical movement. Rarely are the designations embraced by the artists who are inscribed in them. Compared with 'insider' movements in western art such as Impressionism or Cubism, which functioned in socially sophisticated ways, individual outsider creators seldom even know of each other, let alone form a cohesive group. In other words, Outsider Art does not follow the usual art-historical patterns. Instead, its descriptors tend to be based more on sociological and psychological factors that are held together principally by commonly made claims by Outsider Art's apologists about the artists' fundamental difference to or antagonism towards a supposedly dominant cultural norm. This difference is not merely marked by exclusion from the mainstream of the professional (western) art world, but also by exclusion from, or marginalization in relation to, the very culture that supports the market for mainstream art.

The fairly recent acceptance of the specific term Outsider Art in the United States coincides both with a marked increase in public interest in work produced outside the mainstream of contemporary art practice and with the appearance of postmodernist ideas in popular culture and the mass media. Ironically, the cultural relativism and obsessive self-referentiality of the American and European artistic 'mainstream' has isolated it from a mass public that has nonetheless accepted cultural fragmentation as a fact and often looks for art in alternative, though relatively *anonymous*, forms. Anonymity in this sense does not refer so much to mass-produced products, or simply not knowing the names of individual producers (as with the works of European Gothic masters or tribal African carvers from the nineteenth century whose identities are long since forgotten), but to the requirement that the producers should reside outside, or on the margins of, canonical structures of reputation and fame; a position that is, in itself, fraught with problems once a work becomes visible to an 'insider' public.

Difference, in itself, does not make for the conferment of outsider status; being made invisible by the structures of culture, or placed beyond the pale does. In orthodox notions of Outsider Art the status of the artist as cultural outsider is a vouchsafe for the 'purity' of the art, because the detachment of the creator proves the absence of deviousness or cynical manipulation of fashionable taste in the work on his or her part. It is inconceivable, the argument goes, that an artist working outside a dominant culture, whether separated internally by incarceration or rejection, or externally through cultural difference and physical distance, will be tainted by its mores. The answer to the question as to whether one has to be a social outsider to be an outsider artist seems to be in the affirmative, but the definition of this is relative. In other words, you may be *part* of a culturally marginalized group and function perfectly well in that context, but marginal all the same in relation to the culture of art consumption. This is a politically suspect line of thought, because the assimilation of marginal art implies election to the institutions of dominant culture without social emancipation for the maker.

Direct engagement with the art-going public and, worse, the art market has always proved a dangerous activity for individuals named as outsiders. Dubuffet himself excommunicated the provincial French self-taught artist Gaston Chaissac, one of his

9. **Howard Finster,**
What is the Soul of Man, 1976

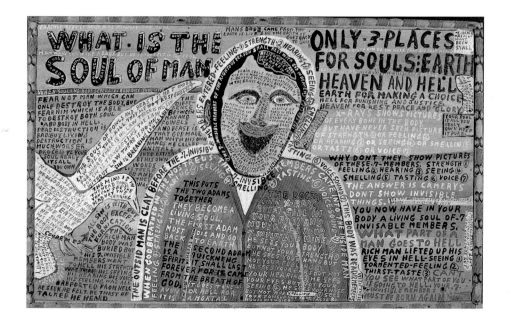

earliest Art Brut 'discoveries', allegedly because of his contact with 'cultivated circles'. Professional ambition is regarded as anathema to the 'authentic' artist outsider, yet in countless cases self-taught artists working outside folk and naïve art traditions conceive of an audience for their work. Though this projected audience might be global, as in the case of 'preacher' artists such as Finster or Leroy Almon, Sr. (b. 1938), in practice it is always localized. Protected by their parochial context, ironically, the positions of these creators are inevitably undermined by exposure to national and international markets. Finster's engagement of family members to help him create pieces more quickly, for example, while justifiable in terms of his artisan's perception of production, is anathema to collectors in search of the 'authentic' hand of the artist.

The English self-taught artist Albert Louden (b. 1943) is a more recent casualty of rejection by the Outsider Art orthodoxy because of artistic ambition. Coming from a blue-collar background, Louden worked for many years as a van driver, making pictures in his spare time. He first realized that an audience might exist for his work after visiting an exhibition in London in 1979 entitled *Outsiders* and approached one of the show's curators, the art dealer and collector Victor Musgrave, who was immediately enthusiastic. Louden's reputation grew on the basis of his bold figure compositions – his lyrical, semi-abstract landscapes are still

10. (below left) **Albert Louden**, *Family*, c. 1980

11. (below right) **Albert Louden**, *Landscape*, c. 1980

10

11

12. **Eugene von Bruenchenhein**, *Untitled*, *c*. 1945. This is one of the thousands of photographs Von Bruenchenhein took of his wife, Marie, in the decade after their marriage, in 1943, in a compulsive collaboration which saw her transformed into queen, goddess, film star, or gentle erotic icon. Despite using limited means, such as dime-store jewelry and props, including a large tiara fashioned from Christmas-tree ornaments, there is nothing ridiculous about these images. Rather, they have a poignancy that speaks of a rich, though essentially private, shared fantasy world. Like many artist outsiders Von Bruenchenhein decorated his house and yard with other creations, ranging from cement reliefs and painted ceramics to tiny furniture and towers made from chicken and turkey bones. The other major part of his *oeuvre*, which came to light only after his death, is a huge body of apocalyptic paintings, originally inspired by reports of hydrogen-bomb testing in the early 1950s.

virtually unknown – and he was given a one-person show at London's mainstream Serpentine Gallery in 1985. At this point Louden found himself subject to the fate of many marginal artists; as he seemingly 'came in' from the outside, his old support dwindled, while mainstream acceptance failed to materialize. As with Chaissac, his critics argued conveniently that his interest in his own success was deemed to have adversely affected the quality of his production. Similarly, works produced by the southern American self-taught artist Mary T. Smith (1904–95), after the piecemeal sale of the original painted environment she had created in isolation from the art world, are generally regarded as being of inferior quality.

Paradoxically, for living artists, problems relating to the quality of Outsider Art arise only when the work becomes visible to national and international audiences. In other words, the status of works only becomes problematical at the point at which they begin to move 'inside'. Contemporary discoveries such as the Americans Henry J. Darger (1892–1973), Achilles Rizzoli (1896–1981) and Eugene von Bruenchenhein, whose monumental *oeuvres* came to light only after their death, or Malcolm McKesson (1909–99), who emerged from self-imposed seclusion only as he approached his eightieth year and with three-decades' worth of accumulated work, are infinitely easier to deal with by the market than the work of younger, living self-taught artists. 12

Except in cases of extreme indifference to their surroundings, the new status afforded to work produced in different circumstances will almost inevitably alter the aspirations of the maker (without necessarily altering the *look* of the work). This does not necessarily manifest itself in a desire for wealth and possessions, or other trappings of fame, but it must include a developed sense of being appreciated and of an extended audience for the work, as well as the loss of anonymity (unless the makers are purposefully denied access to their reputation by their 'champions', as has happened on occasion in the past). All of this (including material gain) can occur without the individuals themselves moving 'inside', as in the case of Louden, while at the same time they might come to recognize the desires of their 'insider' audience. In this way another paradox can arise, namely that by engaging with the desires of a culturally sophisticated audience 'outsiders' assume the appearance of 'ordinary' social function and are thereby cast – along with their *new* works – not into the outside proper, but into the realm of 'ordinary' anonymity (they become 'like everyone else'). The elision of creator and work implied here suggests the

13. (opposite) **Martin Ramírez**, *Untitled*, 1954

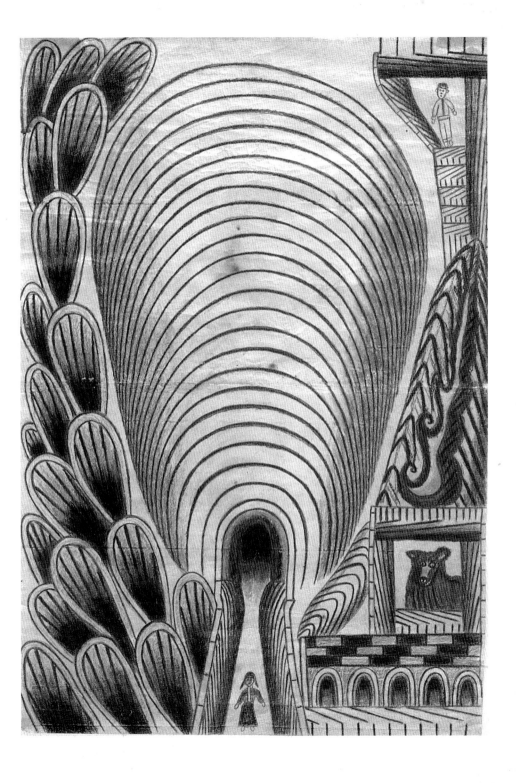

existence of a paradox of the inevitable diminution of quality of the work with the cultural 'rehabilitation' of its creator. It also raises questions about the quality of the production of outsiders as set against that of both contemporary and historical art in the mainstream.

The discovery of Outsider Art relies on the chance encounter. It becomes art only in the act of naming, though this in no way alters its intrinsic qualities. It is seductive whether visible to a wide audience, or hidden from view entirely, and in this sense possesses a tantalizing and fragile presence exemplified by the 'discovery' of Martin Ramírez (1895–1963) after years of wanton destruction of his work in a hospital that had an institutional disinterest in image-making by patients. Dubuffet's conception of Art Brut grew out of Surrealism's interest in phenomena that lie outside individual prejudice and expectations and in the commonplace of experience that is too often overlooked. The rare works described here arose in unpretentious circumstances, although they are never subsumed by banality or mundane things. The external viewer cannot hope to exercise the same control over these singular realities as did their creators, but when approached in a spirit of openness the works reveal something of the meaning of their enigmatic life. The abiding power of Outsider Art lies precisely in its elusiveness; a characteristic dear to Surrealism. We cannot hope to contain it, but should approach it in the spirit described by André Breton, writing in another context, in his lyrical essay *L'Amour fou* (*Mad Love*) (1937): 'A pox on all captivity, even should it be in the interest of the universal good, even in Montezuma's gardens of precious stones! Still today I am only counting on what comes of my own openness, my eagerness to wander *in search* of everything, which, I am confident, keeps me in mysterious communication with other open beings, as if we were suddenly called to assemble. I would like my life to leave after it no other murmur than that of a watchman's song, of a song to while away the waiting. Independent of what happens and what does not happen, the wait itself is magnificent.'

Chapter 1: Art Brut

The term Art Brut, which Dubuffet coined in the mid-1940s, has come to signify the orthodoxy of the Outsider Art field, though as Cardinal points out, his idea evolved in the course of his career: 'at first a hazy intuition, it solidified into a rigorous set of criteria before finally becoming a more flexible and congenial yardstick'. Dubuffet's writings – which are nevertheless remarkably consistent over four decades – are characteristically anti-bourgeois in tone and abound with calls for audiences to turn away from the accepted (and acceptable) products of culture, which he saw as being rendered lifeless by virtue of their very acceptability. 'Art, by its very essence, is of the new,' he wrote in 1963, 'we expect art to uproot us, to unhinge doors.' As far as Dubuffet was concerned this could not occur in the context of what he referred to as the dull, 'hollow works' produced by and for mainstream taste: 'When the pompous platforms of Culture are erected, and awards and laurels come raining down, then flee as fast as you can, there'll be little hope for art. If art did once exist here, it's already gone by now, it hurried off for a change of air. It's allergic to the air of collective approval.'

Here, as elsewhere, Dubuffet invites us to look for 'true art' in unexpected places. His own search took him to the archives of psychiatric hospitals and to the work of people living either on the margins of society, or distanced from 'high culture' by class and lack of education. From these outsiders a collection of work emerged that produced the spectrum of recognizably Art Brut types. The French term 'brut' is not easily translated into a single English word, but it carries with it connotations both of simplicity and naturalness as well as ill-breeding and clownishness. However, this range of possibilities – its resistance to precise definition – is probably one of the reasons that Dubuffet was

drawn to the word in the first place. The notion of being in the 'natural' or 'raw' state lies at the heart of the word and in this sense it is set in opposition to 'culture'. However, Dubuffet's early career – not as an artist, but working in the family wine business – provides the clue to the most celebratory and poetical meaning of Art Brut, namely that, like the best champagnes, brut here signifies the unadulterated, purest state of things. This is implied in the classic early definition in Dubuffet's 'Art Brut in Preference to the Cultural Arts' (1949):

We understand by this term works produced by persons unscathed by artistic culture, where mimicry plays little or no part. ... These artists derive everything – subjects, choice of materials, means of transposition, rhythms, styles of writing, etc. – from their own depths, and not from the conventions of classical or fashionable art. We are witness here to the completely pure artistic operation, raw, brute, and entirely reinvented in all of its phases solely by means of the artists' own impulses. It is thus an art that manifests an unparalleled inventiveness.

Western Primitivism

Dubuffet's formulation of Art Brut must be seen in the context of a specific tendency in western modernist art to look for inspiration outside the accepted canon of art-historical precedents. He was aware of the important role played in the development of early twentieth-century art by the appropriation of traditional tribal objects from Africa, Oceania and North America, as well as European folk art and children's drawings. The three groups referred to here – tribal peoples, rural populations and children – were commonly regarded as sharing a number of 'primitive' traits which placed them metaphorically at the well-springs of culture and therefore more directly in contact with the forces of creation. Artists such as Picasso, Wassily Kandinsky (1866–1944) and Klee used such primitivizing notions to hold up a mirror of lost inno- cence and authenticity to a civilization that they regarded as over complex and riven by falseness. Klee's *Ventriloquist* (1923), for example, reclaims a 'magical' purpose for western art through its sophisticated utilization of a range of sources, from Australian bark paintings and African masks to children's drawings. Characteristically, the content of this work concerns the process of becoming and the enunciation of the world, attained through the central 'dummy' figure that is the vessel of its message.

47

Primitivism is central to the character of much of the visual art produced in Europe in the first half of the twentieth century.

Tribal artefacts – often regarded as the paradigmatic 'primitive' object in histories of primitivism – had been on display in western ethnographic museums since at least the eighteenth century as scientific curiosities, but modern artists in France and Germany were among the first to regard them as art objects, through the lens of an emerging 'expressionist' aesthetic. The appropriation of 'savage' sculpture by the avant-garde was part of a characteristic policy of artistic innovation and cultural opposition and its early re-definition should be viewed in these terms. However, interest in the 'primitive' indicates a further questioning of the validity of assumptions about the superiority of western viewpoints by valuing precisely those people previously held up by the West as culturally, technologically and sometimes even mentally inferior. In this way the 'primitive' could assume many forms, of which an interest in tribal art was but one.

Interest in the 'primitive' was a function of the artists' discontent with aspects of their own culture. Primitivism invariably encompasses some form of the myth of the artist outsider operating at the periphery of society as observer and judge and it was often employed as a tool to attempt to fashion a renewal in art and, in some cases, a utopian renewal in society. At the base of this was a vague, but pervasive, belief that civilization was over complicated, and that sophistication masked truths that were still to be found if access could be gained to essentials, or to earlier, simpler states of being. In this, artists turned on its head Darwinian evolutionary theory which postulated that development always occurred from the relatively simple to the relatively complex. Such reductionism was equated with 'nature' and the 'natural' and, characteristically, it was in more natural beings – identified variously, and often with little qualitative distinction, as Medieval Europeans, peoples of the Orient, peasants, tribal peoples and children – and particularly in the decorative production of these groups that western artists sought alternatives with which to create an expressive vehicle that spoke directly to the viewer. In this way a number of apparent dichotomies were constructed in the primitivizing world-view: primitive against civilized; nature against culture; intuition against reason, and so on.

Dubuffet encapsulates this type of Primitivism in his 'Anticultural Positions' (1951) in which, having acknowledged advances in western knowledge about 'so-called primitive civilisations and their specific ways of thinking', he says, 'We are beginning to ask ourselves whether our Occident doesn't have something to learn from those savages. It could very well be that

in various domains, their solutions and approaches, which have struck us as simplistic, are ultimately wiser than ours. ... I, personally, have a very high regard for the values of primitive peoples: instinct, passion, caprice, violence, madness.' Like the Surrealists, Dubuffet worked from the assumption that there exists a 'primitive' mentality that is innately different from the 'civilized' one and that its operations are essentially mythic in character. Taking their lead from the writings of Sigmund Freud and anthropologists such as Lucien Lévy-Bruhl and Marcel Mauss, they commonly regarded 'primitive' thought as analogous with the operations of the unconscious. In this way, parallels could be drawn between the seemingly irrational rituals that are central to tribal cultures, children's play and the insane. It is precisely because this kind of thought takes place at a more primitive level, they would argue, that these groups share a more clearsighted and profound vision of reality.

By the mid-1940s, when Dubuffet was attempting to reinvent himself as an artist at the cutting edge of his discipline, interest in tribal forms had become something of a modernist cliché. In addition, a new anthropology was emerging that had begun to bring into question ideas about the primitive state of tribal culture, while the adventures in psychology begun by the Surrealists in the 1920s in response to their reading of Freud had revealed the possibility of finding groups possessing different mental states to conventional norms within western society. It is perhaps not surprising, therefore, that in his search for an alternative art that lay outside dominant culture psychologically, but whose practitioners were geographically situated within it, Dubuffet turned first to art made by children and subsequently to that produced by psychiatric patients.

Child Art

Modern artists' interest in the 'primitive' was an aspect of a common search for directness of expression and a desire to experiment unhindered by high-art precedents. Nowhere was this directness more evidently perceived than in the art of children, stemming from a belief, originating with the eighteenth-century philosopher Jean Jacques Rousseau, that children are not so much imperfect versions of adults requiring 'correction', but 'natural' beings with an enormous potential for development. The child is the primitive par excellence in all evolutionist models of cultural development; the younger the child, the further he or she lies outside the complex social structures that govern the lives of most

adults. Or, as Klee famously put it in 1912, 'Children also have artistic ability, and there is wisdom in their having it! The more helpless they are, the more instructive are the examples they furnish us; and they must be preserved free from corruption from an early age.'

Artistic interest in children's pictures began at the end of the nineteenth century and its stylistic influence was first felt in the work of the Fauves in France and the Expressionists in Germany in the first decade of the twentieth century. In his evaluation of the creativity of children in the *Blue Rider Almanac* (1912) Kandinsky placed particular emphasis on the importance of their position outside culture in language similar to that used by Dubuffet in relation to Art Brut thirty-five years later. In his view, 'the child is indifferent to practical meaning since he looks at everything with fresh eyes, and he still has the natural ability to absorb the thing as such', whereas the academically trained artist 'produces a "correct" drawing that is dead'. Though the works illustrated in the *Almanac* are clearly by older children providing clear visual parallels with the folk art also included, the drawings that Kandinsky and his partner the German painter Gabriele Münter (1877–1962) collected from around 1908 are almost without exception by young children. The art historian Jonathan Fineberg has shown that in the period from 1909 to 1914 both artists appropriated forms extensively from this collection (which has only recently come to light) in an effort to look back 'to a point in the evolution of visual language that he thought might precede the influences of culture and individual personality'.

Kandinsky and Münter were based in Munich during this period and their interest should be seen against the fact that the city was already well established as an important centre for the study of the nature and development of child art, largely owing to the work of the city's superintendent of public instruction, Georg Kerschensteiner, whose book *Die Entwicklung der Zeichnerischen Begabung* (*The Development of the Gift of Drawing*) was published in 1905. Another artist associated with the Blue Rider was Klee whose interest in child art dates from as early as 1902 and he almost certainly knew Kerschensteiner's book. Fruitful comparisons can be made between drawings reproduced there and works by Klee, such as the conceptual and formal similarity of the web of lines and dots that chart the path of the snowballs in the child's *Snowball Fight* and the connecting cosmic threads in Klee's *Human* 14, 15 *Helplessness* (1913).

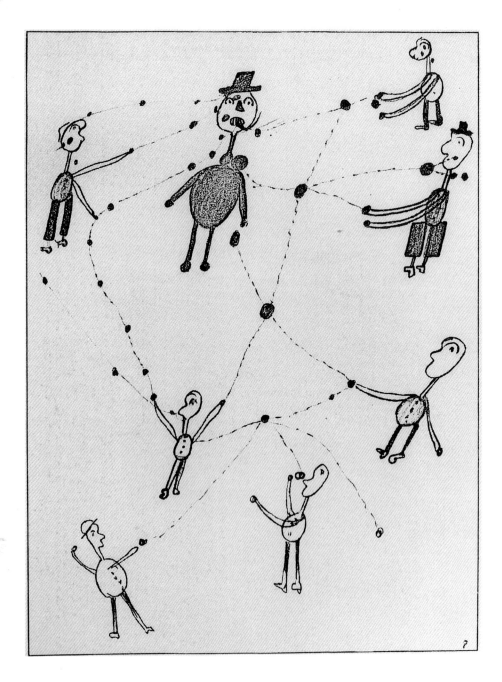

14. **Georg Kerschensteiner**, Child's Drawing,
Snowball Fight, plate from *Die Entwicklung der
Zeichnerischen Begabung* (*The Development of
the Gift of Drawing*), 1905

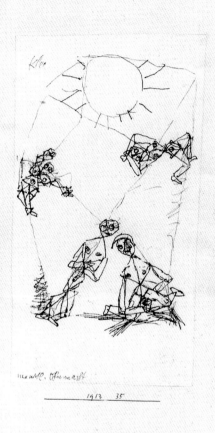

15. **Paul Klee**, *Human Helplessness*, 1913

16. **Jean Dubuffet**,
White Mirobolus, 1945

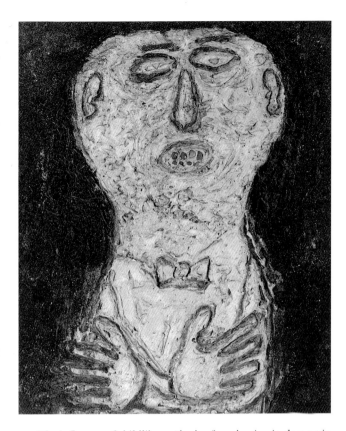

The influence of childlike methods of production is clearest in the brutalist work of a number of European artists from the immediate postwar period, for instance, Dubuffet, Enrico Baj (b. 1924) and the Cobra group, which included the likes of the Dutch painters Karel Appel (b. 1921) and Constant (b. 1920), and the Danish artist and theorist Asger Jorn (1914–73). Dubuffet's collection of 'non-cultural' art actually began with children's drawings and its lessons are manifest both in the forms of his works such as *Coquette* (1945) and *White Mirobolus* (1945) and in his disregard for the 'proper' use of his materials that went far beyond what in retrospect seems like the rather tasteful utilization of non-painterly elements by Picasso and Braque in their Cubist works from around 1912 or even the Surrealist sand paintings of André Masson and Max Ernst's (1891–1976) *frottages*. Like a child, Dubuffet characteristically digs furrows into the thick wet paste of *White Mirobolus* in an effort to delineate form, resulting in a sort of negative relief. He presses fibres into the dark background around the head to stand for hair, two pieces of plaited rope become eyebrows, and

23

16

30

eight brown pebbles are punched into the oval mouth area as teeth. The resulting image is intensely physical and uncompromising.

Cobra, too, discovered the purest evidence of the 'primitive' in childhood. Constant argued typically that, 'The child knows of no law other than its spontaneous sensation of life and feels no need to express anything else.' Child art provides one of the group's most direct formal precedents. It lies behind the free experimentation underpinning paintings such as Appel's *Hip, Hip, Hoorah!* (1949) and Constant's *The Little Ladder* (1949), whose playful, exuberant qualities set them apart from the postwar existentialist gloom more common to European art at this time. Comparisons can also be made, for example, between drawings by children reproduced in the fourth issue of the journal *Cobra* and Constant's *Two Animals* (1946), particularly in the expressive distortion of forms and the use of scribble. Constant also reveals the interiors of his animals, in a kind of X-ray image which is a feature of the art of some young children, as well Aboriginal painting from northern Australia and some Precolombian and prehistoric art.

In Jorn's work specific references to the styles of child art mix with prehistoric nordic sources and are usually subsumed in the general, all-over Expressionist feel, with figures occasionally emerging, such as the small girl at lower centre in *Letter to my Son* (1956–57). Stylistic influence is most direct, however, in the work of Appel and Constant. The left-hand animal in Constant's *Festival*

17. **Karel Appel,**
Hip, Hip, Hoorah!, 1949

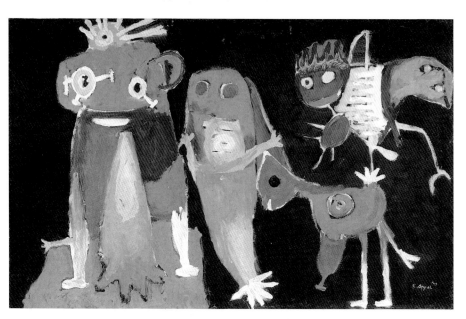

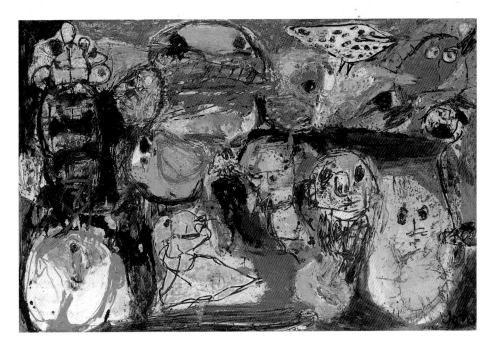

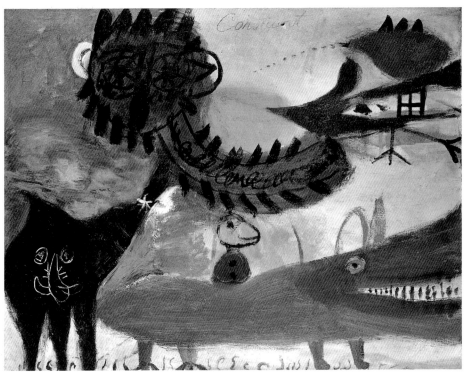

of Sadness (1949) can be compared with a drawing of a dog by a six-year-old produced much later. They share a mixture of boldly developed general form and minute attention to what are perceived to be the most important details, such as eyes, muzzle and nostrils. Yet, a recognizably adult wit operates in Constant's picture which is alien to the work of children, not least in the animal's prominent genitals, which can also be read as a comic face.

Unenlightened criticism of modern western art often focuses on perceived similarities with children's drawings. Yet, the economy of means and apparent spontaneity achieved in the work of trained professionals does not signal a continuation of childhood, but a 'recovery' at a highly sophisticated level of certain childlike features. Klee, one of the artists most often equated with a childlike style, explained it in the following way: 'If my works sometimes produce a primitive impression, this "primitiveness" is explained by my discipline, which consists of reducing everything to a few steps. It is no more than economy; that is the ultimate professional awareness, which is to say the opposite of real primitiveness.' Also implicit in this is a rejection of the charge that

18. (opposite above) **Asger Jorn**,
Letter to my Son, 1956–57

19. (opposite below) **Constant**,
Festival of Sadness, 1949

20. (below) **Tom R**,
drawing of a dog, 1996

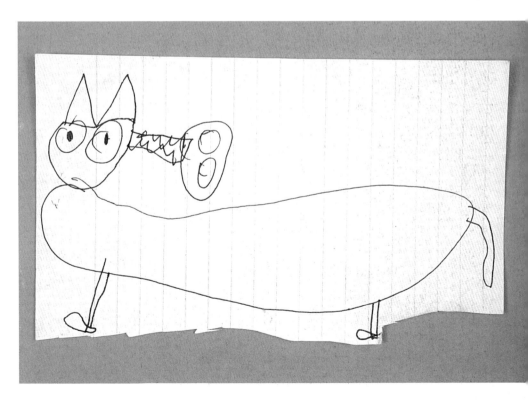

children and modern artists have in common a lack of technical facility. Once again, the difference lies in its incomplete development in the child and its measured rejection in the adult. As the Cobra artist Pierre Alechinsky (b. 1927) said, 'It takes years to find the childlike inside oneself. At the outset, one is an old man. Cobra is a form of art which heads towards childhood, tries to recover folk art and child art for itself. With the means available to adults, non-naïve means. It is not naïvety which is required.'

Interesting questions are raised in the cases of collaborations between children and professional artists, such as Alechinsky, Keith Haring (1958–90) and Jean-Michel Basquiat (1960–88). A number of children made drawings for Basquiat in the early 1980s, including an eight-year-old boy, Jasper Lack, who was hired specifically for that purpose. In *Untitled (Pakiderm)* (1984), 21 a joint work with Cora Bischofberger, the five-year-old daughter of his Swiss dealer, the viewer is alerted not only to the very literal act of appropriation that has taken place here (the picture's currency in the art market still relies on it being a Basquiat), but also to the extreme measure that Basquiat has taken in order to circumvent adult facility.

Because we can recognize more or less clear stages of development in picture-making in children as they grow older there is a tendency to group their images as types, rather than as the production of sentient individuals, and irrespective of perceived differences in the quality of production. As a result, although we often know the names of child artists, because of the ways in which their work was originally collected, we rarely know much more. Effective anonymity remains the standard. In the case of Kerschensteiner's 'specimens', for example, or the collections of such artists as Kandinsky and Münter, and Dubuffet, the child producers remain ciphers, cut adrift from cultural and historical referents. This only heightens the sense of children functioning as outsiders; disenfranchised and subject, outside the parameters of their imaginative world, to the controlling will of others. However, for the majority of children this is not a lasting condition. Unlike most adult outsiders, childhood carries within it the promise of cultural 'redemption'. Nevertheless, the transitory nature of childhood does not deny the possibility of the production of a body of work that articulates a complex and self-contained world system. Though replete with meaning, its hermetic quality is emphasized by the fact that the key to this world picture is lost even to its creator as he or she matures.

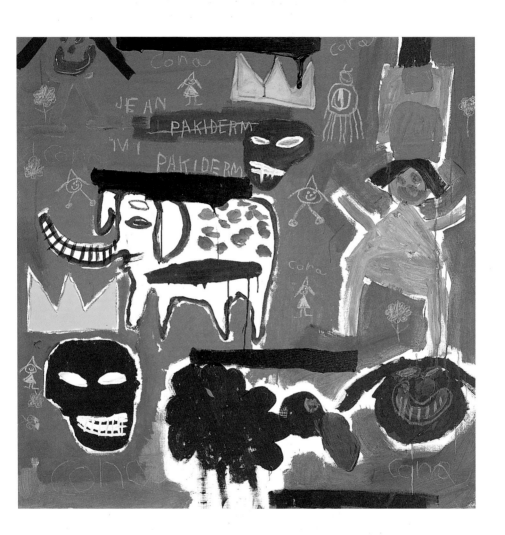

21. Jean-Michel Basquiat and Cora Bischofberger, *Untitled (Pakiderm)*, 1984

22. **Annemarie Münter**, *Untitled (House)*, 29 August 1913

Child Art and Outsider Art

The same comparisons between child art and modern western art have also been applied to the production of Outsider Art by adults. For example, the pieces by Basquiat and Bischofberger, and Otto Paskegg appear to share a family resemblance with works by a number of institutionalized artists, such as Philipp Schöpke (1921– 98), Evert Panis (b. 1940) or Herbert Liesenberg (b. 1930). The 95, 96 connection between a child's drawing from Dubuffet's collection 23 and August Natterer's (1868–1933) *Witch's Head (Transparency)* 24 (pre-1919) seems even more compelling. Natterer's piece displays greater technical facility in its execution, but the landscapes in both images are drawn as aerial views, with vertical elements, such as trees, buildings and people tipped back onto the picture plane. In this way, spatial relationships are subordinated in both cases to the artists' desire to present a detailed account of a particular place. However, the paranoiac content of Natterer's work, in which a quiet rural landscape is revealed as containing evil in the shape of a witch's head, is absent from the child's schematic inventory.

Unlike the case of art-world figures such as Klee and Basquiat, there is no question of these outsiders knowingly appropriating childlike means. Rather, they share those same qualities of sponta- neity and freshness – or rawness, in Dubuffet's parlance – in their approach that twentieth-century artists had valued in child art. Outsider artists are almost always self-taught; their creativity usually manifesting itself late in life or after some kind of trauma. Given the absence of formal training, it is not surprising that much Outsider Art displays an idiosyncratic technical achievement, though this is not to be confused with ineptitude. The paintings of Finster and Tolliver, for example, are remarkably 9, 142 consistent in quality, reflecting the importance of arriving at a satisfactory statement within the purview of their highly individ- ual projects. But in both cases any concern with the reproduction of a mundane appearance is greatly subordinate to the creative process and expressive content of the work. In Tolliver's work a limited number of themes – the family, 'moose woman', etc. – are constantly revisited in endless minor variations, while Finster's phenomenal output is governed by his stock of biblical references.

Though rare, there are cases in which outsider artists have sought and achieved technical mastery. For example, over a period of three decades the American self-taught obsessive Morton Bartlett (1909–92) produced a group of fifteen anatomically accurate, half life-size sculptures of children, complete with inter- changeable wardrobes, which peopled the perfect private world

of his imagination. They appear in more than a hundred photographs which the shy and enigmatic artist used to conjure up the family he never had. The visionary work of Vonn Ströpp (b. 1962), another obsessive artist, displays an attention to detail and sureness of hand that is worthy of Renaissance masters such as Albrecht Dürer. Yet, we are faced here with an artist from humble and troubled origins who is entirely self-taught.

23. Child's drawing from Jean Dubuffet's collection, May 1939

24. **August Natterer**, *Witch's Head (Transparency)*, pre-1919

Where similarities do exist between the forms of children's drawings and Outsider Art, the two are nevertheless separated by elements of their content. Even in the most psychologically damaged individuals there is evidence of the accumulated experience of living a life that only comes with maturity. Similarly, the physical and emotional changes resulting from the onset of puberty separate adults emphatically from children. Sexuality plays a prominent role in many outsider works, sometimes in a notably raw state, as in the case of drawings by Johann Hauser (1926–96) and Schöpke and the striking ceramic sculptures of Downs Syndrome artist Wim van de Sluis (b. 1944). Sexual content is conveyed in more sophisticated ways by artists such as Corbaz whose bright, decorative style collides with the very physical urges that dominated the relationships in her fantasy existence. Similarly, although the agitated calligraphic line in technically sophisticated drawings by Malcolm McKesson lends his subjects an air of silent mystery, the conditions of their creation render them profoundly sexual – in this case they are sublimations of the artist's heightened state of sexual excitement when engaged in the act of drawing.

76, 77

The Art Brut Society

Dubuffet's increasing interest in art by adult outsiders stemmed from their ability to go further than the child in expressing the base facts of existence. 'Children's works are very rudimentary', he said, 'because children are very unskilful, and because their little minds are very restricted. While I, restricted as I may feel … can still run faster on my longer legs and thus further! Much further!' A high proportion of his own work is emphatically sexual in content, although most often his imagery is energized neither through the depiction of sexual acts nor voyeuristic intent. In such paintings as *Archetypes* (1945), *Volonté de puissance* (1946), or *La Belle aux seins lourds* (1950) men and women are revealed as nothing more or less than the primordial matter to which everything belongs, rendered profoundly physical by the sheer brutality of Dubuffet's technique. According to him, 'A painter's basic action is to besmear, not to spread tinted liquids with a tiny

26

25. (opposite) **Vonn Ströpp**,
Untitled, c. 1984

26. (right) **Jean Dubuffet**,
La Belle aux seins lourds, 1950

pen or a lock of hair, but to plunge his hands into brimming buckets or basins and then rub his palms and his fingers across the wall offered to him. … He has to employ his naked fists or else, if they happen to be available, improvised instruments (a chance blade or small stick or stone chip) as good conductors that neither cut off nor weaken the currents of waves.' In Dubuffet's view of the world aesthetics are equated with a kind of blindness to reality. He regarded both his paintings and the promotion of Art Brut as a corrective to this through making people see the sublime in 'things they consider ugly': 'A painter must be honest! No veils! No ruses! Everything has to be naked; presented at its worst.'

In common with the Surrealists, Dubuffet believed that the conscious mind mediated our perception, erecting a repressive barrier between reality and our experience. The unconscious provided the key, accessible only through states that simulated or resembled madness; a space in which analysis is replaced by

27. Jean Dubuffet,
Man with a Rose, 1949

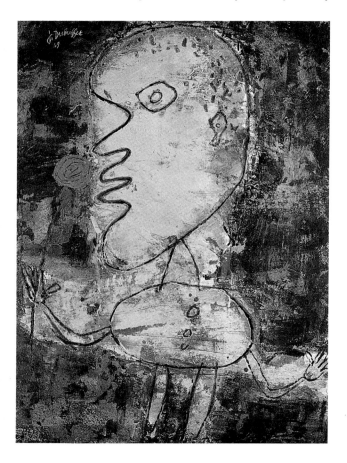

synthesis. He believed that all art worthy of the name 'has a great deal to do with delirium'. Dubuffet began collecting art by asylum inmates in 1945 when he made a three-week trip to Switzerland to visit psychiatric hospitals. His original intention had been only to collect information and photographs for a projected series of publications on the art of the insane to be published in France by Gallimard, but his experiences convinced him to begin acquiring original works. Swiss hospitals were particularly rich sources of psychiatric art, including the work of two paradigmatic outsider artists, Wölfli and Müller, which the French painter encountered on this trip. Indeed, the influence of the latter, especially, is clear in subsequent work by Dubuffet such as *Man with a Rose* (1949), which bears clear similarities to Müller's *Two Faces* (*c.* 1917–22) and *A Ma femme* (*c.* 1914). The possibility of such an homage arises not so much from a stylistic interest as in the recognition that Müller had attained the 'anti-cultural' state that Dubuffet sought in his art.

27

28

28. **Heinrich Anton Müller,**
Two Faces, c. 1917–22

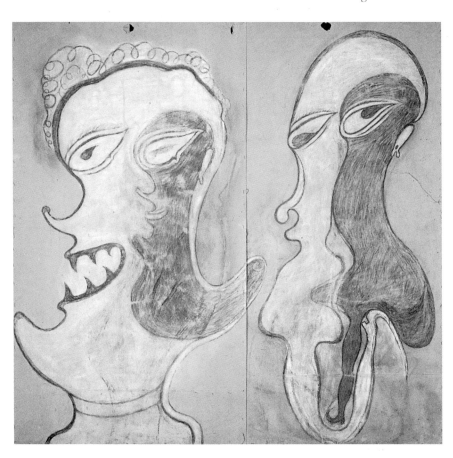

Dubuffet's interest in art by the insane had first been stimulated in 1923 when he encountered Hans Prinzhorn's pioneering book, *Bildnerei der Geisteskranken* (*Artistry of the Mentally Ill*) (see Chapter two), published a year earlier. Though Dubuffet could not read the German text, Prinzhorn's book was richly illustrated and it was from a purely visual response that his interest had originally sprung. The 1945 trip took him to several of the same hospitals that Prinzhorn had acquired work from and in Bern, Switzerland, he met and became friendly with the author of the first full-length monograph on an outsider artist, Walter Morgenthaler, whose study of Wölfli – *Ein Geisteskranker als Künstler* (*A Mentally Ill Person as Artist*) – had been published in 1921. Despite Prinzhorn's collecting activity before the war, Dubuffet was still able to acquire work of very high quality. According to him, 'The Swiss psychiatrists were little interested in this art, and not looking after the work. But they were friendly and helpful. They gave me things. In those days people had no sense of the value of these things.' In this way he was able to amass an unrivalled collection of Outsider Art quickly and, by the middle of 1948, he had formed the Art Brut Society (Compagnie de l'Art Brut), consisting of a group of like-minded people whose purpose was to help administer the project. Besides Dubuffet, its founders included André Breton, the poet and leader of the Surrealist movement, and major publishing and art-world figures such as Charles Ratton, Jean Paulhan and Michel Tapié. That Art Brut was initially equivalent to art by the insane is confirmed by Breton's text written at that time:

I am not afraid to put forward the idea – paradoxical only at first sight – that the art of those who are nowadays classified as the mentally ill constitutes a reservoir of moral health. Indeed, it eludes all that tends to falsify its message and which is of the order of external influences, calculations, success or disappointment in the social sphere, etc.
Here the mechanisms of artistic creation are freed of all impediment.
By way of an overwhelming dialectical reaction, the fact of internment and the renunciation of all profits as of all vanities, despite the individual suffering these may entail, emerge here as guarantees of that total authenticity which is lacking in all other quarters and for which we thirst more and more each day.

In true primitivist fashion, 'authenticity' is here equated with a renunciation – in this case of the social values associated with the production and reception of art. The high price of the 'purity' gained through absolute mental liberation – though in Breton's eyes one worth paying – is the removal of one's physical freedom.

However, Dubuffet quickly broadened his concept of Art Brut to embrace a much wider range of artists whom he perceived to be operating outside dominant artistic culture, though not necessarily vilified by society. In 1951 he disbanded the Art Brut Society (it would re-form in 1962 after the collection returned from the United States, where it had been in the care of the artist Alfonso Ossorio), partly because of disagreement with Breton, whom he accused of attempting to coopt Art Brut into the 'huge cultural machine' of Surrealism, as well as increasing problems with its administration. Dubuffet later said: 'I never liked Surrealism, though I was very interested in Breton. I loved to talk with him.'

In 1949 the first exhibition of Art Brut was held in Paris at the Galerie René Drouin. It included over two hundred works and was accompanied by a catalogue containing Dubuffet's now-famous text, 'Art Brut in Preference to the Cultural Arts'. At the heart of his argument lies the claim that creative thinking – what he refers to here as 'clairvoyance' – is different in kind, and superior, to the analytical mode: 'Knowledge and intelligence are puny flippers alongside clairvoyance. Ideas are a dull gas, a rarefied gas. Only when clairvoyance is extinguished do ideas and the blind fish of their waters – the intellectuals – appear. The reason art exists is because its mode of operation does not take the road of ideas.' Against the 'intellectual', picking over the bones of a cadaver, he offers instead the live, intuitive intelligence of the 'imbecile' – the person cast outside norms set by dominant culture. Madness, Dubuffet claims, is merely a mechanism for revealing true creativity, a sign of 'liberation' from the stultifying effects of social convention: 'Madness lightens the man, gives him wings, and promotes clairvoyance – or so it seems.' But he refuses to accept the special nature of the art of the insane in relation to illness, arguing that, 'we see no reason to establish a special department for them, as some have done. All of the numerous relations we have had with our comrades more or less decked out in little bells have convinced us that the mechanisms of creativity are exactly the same in their hands as they are for all reputedly normal people. ... From our point of view, the artistic function is identical in all cases, and there is no more an art of the insane than there is an art of dyspeptics or those with knee problems.'

Like the nineteenth-century German philosopher Friedrich Nietzsche, Dubuffet believed that artists are by definition asocial creatures whose innovatory powers spring from dissatisfaction with the status quo. Creativity, he claimed, is born of no-saying, 'refusing and disputing culture, rather than that of merely being

uncultured. … The important thing is to be *against*.' In 'Make Way for Incivism' (1967), written for a large Paris exhibition of the collection, Dubuffet went much further than his earlier polemic in claiming the profound relativism of judgments of insanity: 'From the very outset, the very question of madness must be rethought since, all things considered, it has hardly any criteria other than the social.' Thus, he says, it is hardly surprising that his search for 'productions which escape the norms', that emanate from 'individuals who are extremely recalcitrant toward social conventions' should have taken him to psychiatric hospitals, because 'asocial persons are to be found in greater numbers there'. For him, madness lies at the extreme of individualism and its creative outpourings are particularly focused. In asylums, he said, 'we found in certain cases (quite rare, it is true) extraordinarily inventive works, works which are, it must be stressed, the most lucidly deliberated, the most methodically undertaken and constructed of any we know.' Claims for the pathological nature of this work are, he says, designed only to restrict the means of addressing it to medical discourse: 'The notion of psychotic art is absolutely false! Psychiatrists emphasise it because they wish to believe they are in a position to differentiate, to tell who is sane and who isn't.'

In 'Make Way for Incivism' Dubuffet described the Collection de l'Art Brut as, 'comprised of works created by persons foreign to the cultural milieu and protected from its influences. The authors of these works have for the most part a rudimentary education, while in some other cases – for example through loss of memory or because of a strongly discordant mental disposition – they have succeeded in freeing themselves from cultural magnetisation and in rediscovering a fecund ingenuousness.' The imperatives invoked here help explain the deliberately private way in which Dubuffet built his collection. As Cardinal has pointed out, 'to allow it to become public property would be tantamount to offering the cultural system the chance to reassert its ascendancy by classifying, evaluating and in due course marketing the works of Art Brut. Apart from some modest early exhibitions in the late forties and a single large-scale show in 1967, Dubuffet's collection remained effectively closed to the public gaze until, following its transfer to Lausanne, it opened its doors as a public museum in 1976.'

From Dubuffet's tireless research and collecting activity over four decades a classic set of Art Brut producers has emerged, which includes psychiatric patients such as Guillaume Pujolle (1893–1971), Gaston Duf (b. 1920) and Carlo Zinelli (1916–74),

mediumistic artists such as Madge Gill and Raphaël Lonné (1910–89), and self-taught obsessives such as Scottie Wilson and Francis Palanc. All of those mentioned here are represented in the Collection de l'Art Brut in Lausanne, Switzerland. However, the possibility of dogmatic acceptance of a narrowly defined Art Brut canon based on Dubuffet's polemic is undermined by a chain of exclusions and readmittances of works from his own collection according to the discovery of their supposed indebtedness to 'culture'. Notable artists who had a troubled relationship with the collection 'proper' were Gaston Chaissac, an outsider who came 'inside', and Louis Soutter (1871–1942), a professional artist whose work was nevertheless transformed entirely with the onset of mental illness. Dubuffet even went so far as to create a new category for those artists whom he saw as occupying the creative hinterland between professional art and Art Brut. This new category came to be known as *Neuve Invention* (Fresh Invention) and was described by Michel Thévoz as, 'designating those works which, though not characterised by the same radical distancing of mind as Art Brut, are nevertheless sufficiently independent of the fine-art system to constitute a challenge to the cultural institutions.' In this way, an uncomfortable paradox has arisen, namely that in seeking to preserve the 'integrity' of his collection Dubuffet was moved to devise a rigid set of generic outsider properties which, with the aim of foreclosing on the art world, not only excluded a large number of creators he admired, but also suggested the emergence of a new orthodoxy from something that had been introduced initially in a spirit of art-political agitation, calculated to subvert received knowledge, rather than construct a new dogmatic imperative. Nevertheless, apologists for individual outsiders have traditionally attempted to pay homage to Dubuffet's shifting category in their lobbying for position. But undue respect for the boundaries of Art Brut actually undermines its subversive power and returns it to the mausoleum of past art that Dubuffet sought to escape. When viewed in this way some of the paradoxes and dilemmas of Outsider Art, though mainly unresolvable, begin at least to come more sharply into focus.

Chapter 2: Art by the Insane

Artistic interest in the creative work of psychiatric patients is essentially a twentieth-century phenomenon, although image-making by asylum inmates is as old as the founding of mental institutions. Because the works were deemed to have no value nothing has survived of these early manifestations, but we know of their existence from the accounts given by a small number of doctors and from depictions of patients by professional artists, beginning around the middle of the eighteenth century, where individuals are characteristically shown drawing directly onto asylum walls. The patients' subject matter tends to fall into the categories of 'grotesques' or diagrammatic representations of impossible theories; both of which are commonly found in work from early psychiatric collections, as in, for instance, the figures and animals of Müller, the notebooks, calendars and charts by Josef Heinrich 29
Grebing (1879–1940), which amount to a highly sophisticated cosmology, and the illustrated 'proofs' of Jacob Mohr (1884–?). 30

29. (opposite) **Josef Heinrich Grebing**, *Calendar of my 20th Century – Chronology for Catholic Youths and Maidens (Hundred-year Calendar)*, n.d. Before the onset of his illness Grebing was a businessman in Magdeburg, Germany. Well educated and knowledgeable, his work, consisting of illustrated notebooks, charts, calendars, certificates and bonds, represented a sophisticated, but ultimately futile, attempt to remake and give sense to a world shattered and rendered malignant by his breakdown. His lists and calculations utilize methodologies from his previous incarnation, but the 'proofs' and suppositions that they contain can only be tested within the hermetically sealed vessel of Grebing's own universe. Like many German patients in long-term psychiatric care he was murdered by the Nazis in 1940.

The earliest extant examples of patients' drawings date from the early nineteenth century in the United States and Britain, but it was not until towards the end of the century that a small, but significant, number of doctors began to collect such works for diagnostic purposes and for scientific study. In these cases there is little evidence of any aesthetic interest in the work which, in any case, was still likely to be discarded or destroyed after its psychiatric usefulness had passed. The work of Andrew Kennedy (1825–99), a patient at the Glasgow and Crichton Royal Asylums, Scotland, provides a good example. A joiner by trade, Kennedy suffered from religious and sexual delusions, and began to draw in around 1882, five years after becoming a patient. From surviving case notes it is clear that he produced an enormous body of work, including 'three or four volumes of natural philosophy' described by staff as 'rambling nonsense, illustrated by designs of his own'. However, only thirty-four pictures still survive, and they were not 31
among the papers of his own doctors, but another psychiatrist, Dr Thomas Clouston, who acquired them as part of the visual material he used in his lectures to 'illustrate' different forms of insanity and not because of any perceived artistic merit.

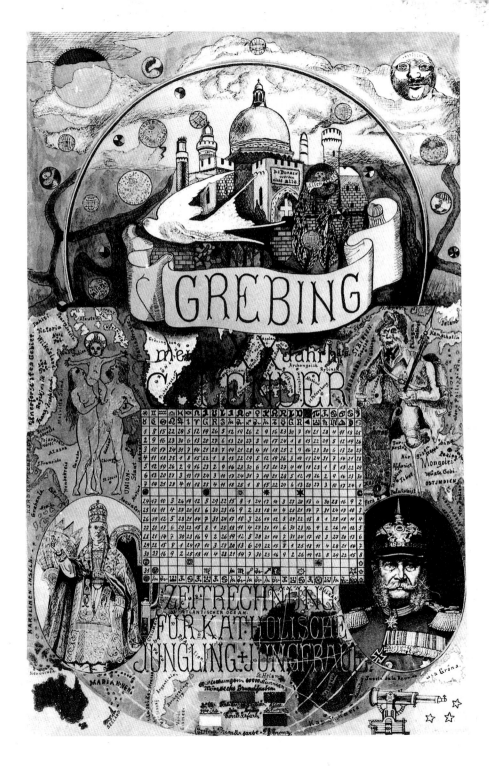

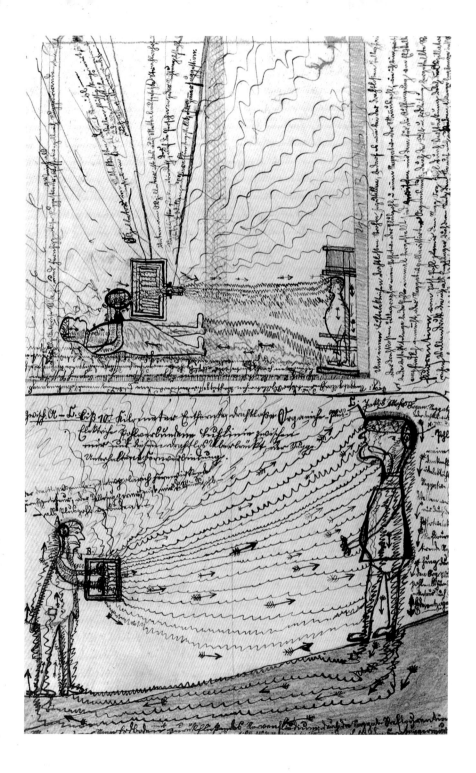

In the nineteenth century the only examples of patient art made visible belonged to individuals who had been professional artists or writers before becoming insane. The two most celebrated early examples are the British painters Jonathan Martin (1782–1838) and Richard Dadd (1817–86), both of whom were incarcerated in the ward for the criminally insane at the Royal Bethlem Hospital, Beckenham, Kent. The content of such images as Martin's *London's Overthrow* (1830) or Dadd's *The Fairy Feller's Master-Stroke* (1855–64) is informed by the artists' psychological condition, though it can hardly be said to constitute the cultural liberation to which Dubuffet referred, and these works are related stylistically to their previous training – as in the later case of the British illustrator Louis Wain, who produced a series of intriguing arabesque variations on cats' faces after becoming schizophrenic. More interesting is, for instance, Louis Soutter whose vision and 32, 33 style was entirely transformed by mental illness. There are other cases in which professionals in another creative field, such as the writers Gérard de Nerval (1808–55) and Antonin Artaud (1896–1948), began to draw with the onset of psychosis. Their work is interesting in this context because, although clearly highly cultured, they were entirely self-taught in the visual arts.

30. (opposite) **Jacob Mohr**, *Proofs*, c. 1910

31. (above) **Andrew Kennedy**, *Factory Maid*, c. 1890s

32. (above) **Louis Soutter**, *Seuls*, n.d.

33. (right) **Louis Soutter**, *Ascension*, 1937–42

Given the connections made between the 'primitive', children and the insane in the second half of the nineteenth century, it should come as no surprise that the artistic reevaluation of creative work by mental patients occurred at around the same time that modern artists in Europe were 'discovering' tribal art. Such interest coincided with the emergence of art by mental patients into a wider sphere of visibility, initially as a result of a number of public exhibitions at the beginning of the twentieth century. For example, landmark exhibitions of 'Psychotic Art' were organized by the Royal Bethlem Hospital in Beckenham in 1900 and 1913, similar exhibitions were held subsequently in Berlin in 1913 and Moscow in 1914, and the first 'mad museum' was opened in France at the hospital at Villejuif by Dr Auguste Marie in 1905 (the remains of Marie's collection were donated to Dubuffet's Collection de l'Art Brut in 1966 by his widow). The latter event was widely reported in the popular press in France and Britain, including *The Sketch*, which reproduced many images from Marie's collection. Most of the works illustrated have a measured, folk-like or whimsical quality and one must assume that the engravings by a professional illustrator depicting bizarre, hybrid creatures that fill the margins of the sheet were inserted to suggest a stereotypical view of 'raving madness' that is in fact absent in the patients' work.

The first book to address the art of mental patients from an aesthetic rather than a clinical point of view, *L'Art chez les fous* (*Art by the Mad*), was published in France in 1907 and includes illustrations of many works from Marie's collection. Its author, Dr Paul Meunier (1873–1957), was a physician and psychiatrist who wrote art criticism under the pseudonym Marcel Réja. In common with prevailing medico-scientific views, he saw the art of the insane as relatively primitive in character, but unusually he regarded such production not as pathological in itself, but as an elementary form through which one might approach an understanding of artistic creativity in general: 'The insane are unique in that, possessed with a contemporary and adult mentality, and driven by emotional necessity and the activity of an intellect conforming with their pathological state, they write and draw most of the time, without any technical training. In form, therefore, their productions are relatively simple. ... The systematic study of the work of the insane touches on an essential point: they illuminate with unique clarity the conditions governing the genesis of artistic activity.' There are important connections here with the ideas of such modern painters as Matisse, Picasso and Kandinsky who saw

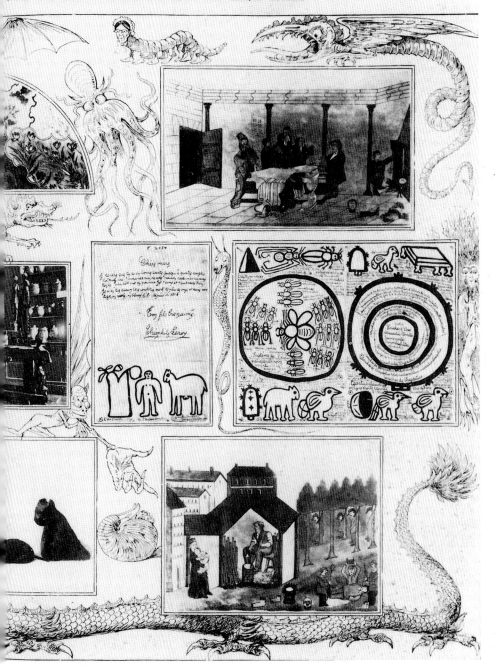

themselves as primitives of a new art and there are clear indications that both Réja and elements of the Parisian cultural avant-garde were in contact with each other, primarily through Picasso's close friend, the poet and essayist Guillaume Apollinaire (1880–1918), who was aware of current psychiatric theory and certainly knew Réja's book.

Though Réja was careful to maintain a distance between the art of the insane and that of professional artists, by the time of the Beckenham exhibition of psychotic art in 1913 at the Royal Bethlem Hospital comparisons between the two had become commonplace, especially among conservative critics who used these supposed similarities to attack the avant-garde. Coming as it did in the wake of the British critic Roger Fry's *Post-Impressionists* exhibition, which had scandalized the London art world a year earlier by showing for the first time the work of European modernists such as Cézanne, Van Gogh, Matisse, Picasso and others, the 1913 exhibition caught the imagination of the British press. One popular newspaper devoted its front page to the exhibition, illustrating six works from the Royal Bethlem Hospital collection under the headline, 'Strange pictures drawn by inmates of an asylum for the insane: are they more artistic than cubists' work?' The anonymous reviewer in *The Times* was more sympathetic. Echoing Réja's position, he argued that, 'There were some pictures in the exhibition which seemed to us to be good because of the madness of those who painted them. ... This, however, does not prove that all good artists are more or less mad. It seems to prove, rather, that many sane people have powers which they cannot exercise because of certain inhibitions imposed on them by their sanity.' Then, in a passage that prefigured Dubuffet's claims concerning the absolute sense of cultural freedom at the heart of Art Brut, he applauded the lack of inhibitions in the psychotic artist: 'It is no doubt a symptom of disease in him that he is not affected by public opinion; but where public opinion is wrong his very disease may give him a freedom that in itself is not irrational. Now, in matters of art public opinion is quite often wrong. ... Among the sane it is only the great artist who frees himself thus in art from the inhibitions proper to conduct. His art, therefore, has more resemblance to the free art of lunatics than to the fettered art of sane men.' Nevertheless, he was careful to draw a distinction between the intellectual processes of the sane and insane creator. The 'freedom' attained by the 'great artist', he says, 'is the result not of insanity, but of a higher order of sanity and of powers so great that they will not endure to be fettered.'

34. (preceding pages) A Mad Museum: the insane as artists, from *The Sketch*, 22 November 1905. These pages show 'natural history' drawings by Théophile Leroy, which were later included by Marcel Réja, in *L'Art chez les fous* (*Art by the Mad*), 1907, a painting by 'Le Voyager français', and a photograph of Dr Auguste Marie with objects from Cesare Lombroso's collection of art by mental patients in Turin, Italy.

Expressionism

The exploration of connections between art and insanity by modern artists began in earnest among the Symbolist generation, but arguably first made a profound direct impact on the work of certain Expressionist painters and sculptors in central and northern Europe shortly before the start of the First World War. Klee had celebrated the art of the insane in 1912 and two years later the poet and publisher Wieland Herzefelde, writing in the Expressionist journal *Die Aktion*, made an implicit plea for an understanding of the formal distortions that were central to modern visual art and poetry by addressing the singularity of vision of insane artists: 'The mentally ill are artistically gifted.

35. **George Grosz**, *Street Scene with Draftsman*, c. 1917

Their works show a more or less unexplained, but honest sense for the beautiful and the appropriate. But since their sensibility differs from ours, the forms, colours and relationships of their works appear to us as strange, bizarre, and grotesque: crazy.'

The Expressionists used the idea of insanity as a provocation; as a sign of their status as harbingers of the New Age. What appeared now as madness, they argued of their art, would later be seen to be its opposite. Thus, when George Grosz (1893–1959) appropriated the forms of lavatorial graffiti and the visual chaos of a mind in turmoil in images such as *Street Scene with Draftsman* (*c.* 1917) it was with the intention of revealing shocking existential truths unseen by the mass of people. For similar reasons he dedicated an important early painting to Oskar Panizza, a German doctor, psychiatrist and satirist much beloved of the Expressionists, whose work was declared blasphemous and who was committed to a mental asylum in 1904. Another intriguing case surrounds the life-size doll depicted by Oskar Kokoschka (1886–1980) in *Self-Portrait with Doll* (1920–21). It was made to the artist's specifications in the image of Alma Mahler with whom he had had a tempestuous relationship before the First World War. The reason, according to him, was that after his first-hand

36. **Oskar Kokoschka,**
Self-Portrait with Doll, 1920–21

37. Photograph of Katharina Detzel with a male stuffed dummy of her own making, *c*. 1918

experience of the brutality of war, he could no longer tolerate humanity. It has been suggested, though, that the doll was part of the artist's attempt to live up to the image of 'crazy Kokoschka' conferred on him in 1918. A poignant comparison exists in a photograph from around the same date of an asylum inmate Katharina Detzel, a widow and former seamstress, which shows her with one of the life-size male dolls that she made in the hospital.

37

The appropriation of the idea of insane art by Expressionism and Dada in Zurich, Switzerland, helped to bring about a reevaluation by doctors of the visual output of mental patients in the German-speaking world. Most notable among these were Hans Prinzhorn and Walter Morgenthaler whose respective books, *Bildnerei der Geisteskranken (Artistry of the Mentally Ill)* (1922) and *Ein Geisteskranker als Künstler (A Mentally Ill Person as Artist)* (1921) are the most significant early texts on Outsider Art.

Artistry of the Mentally Ill

Artistry of the Mentally Ill was written in Heidelberg, the German city that was soon to become the centre for the study of the products of schizophrenics as a means of understanding psychiatric illness. Taking his clinical cue from the work of the psychiatrist and philosopher Karl Jaspers (1883–1969) and the philosopher Ludwig Klages (1872–1956), Prinzhorn set out to analyse the intrinsically 'artistic' production of insane people for diagnostic purposes and as a means of understanding the relationship between this and the work of 'sane' artists. To help him achieve his goals, Prinzhorn amassed, with the aid of the director of the Heidelberg clinic, Karl Wilmanns who originally instigated the collecting process, a vast collection comprising, by the middle of 1920, some 4,500 pieces by around 350 individuals. Prinzhorn's intentions become clear in a letter, signed by Wilmanns, that was circulated to other hospitals in 1919 asking for 'productions of pictorial art by mental patients, which are not simply copies of existing images or memories of their days of health, but intended as expressions of their personal experience.' Specifically, they required '(1) outstanding individual achievements; (2) images clearly influenced by mental disturbance, so-called "catatonic drawings"; (3) any kind of scrawl, even of the most primitive quality.' Thus, from the outset, the focus of Prinzhorn's interest was on extraordinary material that both reaffirmed contemporary notions of madness and bore witness to a belief in the universalizing tendencies of art that Prinzhorn shared with the Expressionists.

Prinzhorn chose the archaic term *Bildnerei* (picture-making) for the title of his book to distance its subject from professional fine-art production, but not because he saw the art of the insane as 'unartistic', but because he wished to separate his analysis of image-making from aesthetic judgments. This is reconfirmed by his use throughout of the word *Gestaltung* (configuration) rather than 'art'. That there is much work of high quality in the collection is without doubt, but Prinzhorn's project led him to claim that the images in the book 'are not measured according to their merits but instead are viewed psychologically'. Similarly, from the point of view of scientific method, he insisted on the importance of using 'spontaneously created pictures by untrained mental patients' (although it has since become clear that the collection includes works by professional and self-taught artists of all social classes) and cautioned against the general diagnostic use of visual art by mental patients on the grounds that 'the percentage of patients who draw is very small'.

In common with much Expressionist art theory (which in turn had important roots in nineteenth-century Romanticism), Prinzhorn believed in the existence of a basic urge to picture-making in each individual that is usually more or less suppressed in most adults. Taking his lead from art historians such as Alois Riegl and Wilhelm Worringer he argued that because this 'will to form' is instinctual it is compromised by reason and causality. In other words, it is concerned with expression and creativity as opposed to the practical considerations of survival and socialization. Like many modern artists, he saw the 'imitation of nature' and 'illusionism' in art as evidence of this compromise and as a result he tended to ignore such work, preferring that in which these primitive urges seemed to be more purely manifest. In this way he provided theoretical confirmation for one of the abiding central tenets of Outsider Art, namely that its forms should be direct, raw and non-illusionistic; a belief that perhaps unfairly raises questions about the status of self-taught obsessive artists who work spontaneously, but whose production is technically accomplished, as in the cases of Morton Bartlett (sculpture and photography), Vonn Ströpp (painting) and Achilles Rizzoli (architectural drawing).

Prinzhorn identified six interrelated 'impulses' to configuration, namely the expressive, decorative, playful, and imitative 'urges', the need to impose pictorial order, and the need to imbue the artefact with symbolic content. Because he regarded these as fundamentals of all artistic production, he was able to address the art of mental patients outside psychiatric categorization. For Prinzhorn, the crucial stage at which individual psychology affects picture-making lies in the ways experience is processed and translated in the imagination. Prinzhorn recognized that schizophrenics form the group most likely to make images spontaneously and devoted his discussion to their work. Central to this is the common tendency for the 'autistic, self-important schizophrenic' to create 'an entirely different, richer world out of the sense data of his environment'. The schizophrenic experiences the world, he argued, not from a practical purposive point of view, but as 'raw material for his inspirations, his arbitrariness, and his needs'. Such art is used as means of reasserting order on a chaotically changed world, while the 'real world as such is devalued and does not compel any recognition; one can use it or switch it off as one desires'. The Prinzhorn Collection boasts a large number of creators who produced highly individual, alternative world-systems that are often extremely sophisticated, as in the cases of Josef Heinrich

38. Emma Hauck,
Letter to Husband, 1909

Grebing, August Klett (Klotz) (1866–1928), Heinrich Hermann Mebes (1842–?) and Johann Knopf (Knüpfer) (1866–1910).

At their simplest level, Prinzhorn also believed that drawings by those in the 'strongly confused final state' of schizophrenic illness provided rare access into that psyche. Prinzhorn regarded the 'scribbles' of such individuals as Emma Bachmayer (1868–?), Regina Klein and Emma Hauck (1878–1928), for example, as a 'progenital form of drawing', or the 'nearest to the zero point on the scale of composition'. Though not included in his list of 'schizophrenic artists', they provide insight, he argued, into the evolutionary process of picture-making, and he emphasized his point by comparing drawings by mental patients with those of very

39. **J. B. Murry**, *Untitled*, 1980s

young children. However, he notes the 'uncertainty' in the children's line as against the apparent confidence and intentionality of the schizophrenic adult. Three essential 'psychological aspects' of non-objective scribbles are suggested: 'Even the simplest scribble … is, as a manifestation of expressive gestures, the bearer of psychic components, and the whole sphere of psychic life lies as if in perspective behind the most insignificant form element. We can call the impulse for the drawing gesture specifically the expressive need. Beyond that we must speak of an activating impulse which we also consider a basic fact of all life and which we distinguish from the expressive need despite their close relationship. Finally, we become conscious of the tendency to enrich the environment.'

In his discussion of these pieces he reveals another of the most common stylistic features of Outsider Art, namely the tendency for the artist to fill every part of the sheet, often with purely decorative elements as if in an effort to deny empty space: 'whole sheets are filled with scribbles to the very edge as if a *horror vacui* gave the drawer no rest until every empty place was covered'. There is, however, a purpose to much of this 'scribble' that Prinzhorn ignored. He noted that 'many patients who are writing letters do not carry out their intention to give news about themselves to relatives and friends but fill their sheets of paper with seemingly senseless scribbles.' Yet, in many cases the reductionism of the script actually intensifies meaning. Thus, although Hauck's letters have assumed a vivid pictorial quality to a contemporary generation attuned to the work of mainstream artists such as Cy Twombly (b. 1928) and Susan Hiller (b. 1942), which has in turn made the work of outsiders such as J. B. Murry and Joseph König (b. 1930) accessible, their strength lies in the verbal articulation of desire. In these letters to her husband we find obsessive repetitions of a simple imperative – *komm* (come), *Herzensschatzi komm* (sweetheart come), etc.

Prinzhorn's desire to treat the works under consideration as true artistic products led to the decision to treat their makers as individuals and in ten specific case studies, to name them, although he still used pseudonyms. This was a crucial departure from previous practice, in which the creators remained anonymous,

40. **Cy Twombly**, *Untitled*, 1970

or were identified in a few instances by only their initials. Morgenthaler's monograph on Wölfli is the only precedent. It is, perhaps, inevitable that Prinzhorn should have undermined his own claim to aesthetic neutrality by referring specifically to his ten 'especially rewarding cases' as 'schizophrenic artists', thereby confirming from within psychiatry the plausibility of qualitative aesthetic judgments in relation to this kind of work. The recognition of the identity of individual creators is now commonplace and must be seen in the context of the celebration of their achievement. Nevertheless, it is interesting to note that without divulging the fact in his text, Prinzhorn chose pseudonyms for all ten of his schizophrenic masters. The identities of Brendel, Klotz, Moog, Neter, Knüpfer, Viktor Orth, Beil, Heinrich Welz, Sell and Pohl have only relatively recently been widely revealed as Karl Genzel (1871–1925), August Klett, Peter Meyer (1872–1930), August Natterer, Johann Knopf, Clemens von Oertzen (1853–1919), Herman Beehle (1867–?), Hyacinth, Freiherr von Wieser, Joseph Schneller (1878–1943) and Franz Karl Bühler.

John MacGregor, a historian of psychiatric art, has convincingly argued that in his choice of 'masters' Prinzhorn 'deliberately set out to mould artistic and critical opinion', even suppressing elements of some of their work that did not fit his aesthetic criteria, or 'might weaken the [visual] impact of his artists' in what amounted to the first fully illustrated survey of art by mental patients. This is clear in the case of Natterer whose schematic, hallucinatory drawings are well known. However, there exists another parallel body of work by Natterer, omitted from the book by Prinzhorn, consisting of unimpressive 'realistic' paintings which look as though they were produced by a different hand. Natterer was one of the patients with whom Prinzhorn was personally acquainted. The youngest of nine children, Natterer was successful in business and could boast a stable domestic life, though there seem to have been certain sexual problems. He was hospitalized after a failed suicide attempt in 1907, having become depressed and experienced detailed visual hallucinations. When he became ill he constructed a marvellously detailed delusional system where he was to complete the task of redemption that Christ had left undone from his position in a global hierarchy in which he was the highest authority. As in so many other cases, Natterer's transformation was marked by a profoundly affective epiphany; a primary hallucination consisting of a celestial stage or screen on which ten thousand 'pictures followed one another like lightning', including a vision of God, 'the witch who created the

world'. Natterer's explanations of his works provide fascinating insights into his mythic universe by revealing his otherwise hermetic symbolism. At times he claimed that he saw his *Miraculous Shepherd* in a tree trunk with a head, describing it as 'a cobra in the air, iridescent green and blue', with two feet, 'made from a turnip'. Prinzhorn reported that, 'The toes on this foot are musical notes, but Neter [Natterer] does not know why. "Then came a Jew, a shepherd who had a sheepskin wrapped around him. There was wool on him, there were lots of W's, i.e. much woe will come.

These W's were changed into wolves, these wolves were danger-ous wolves. And these wolves were changed into sheep: they were the sheep in wolves' clothing. And the sheep then ran round the shepherd. I am the shepherd – the Good Shepherd – God!" He says all this very ceremoniously. "The wolves are the Germans, my enemies".' The Surrealists, in particular, were drawn to Natterer's work because it embodied in a spontaneous way that metamorphosis of objects and concepts that is central to their exploration of the extreme subjectivism of the unconscious summed up in Lautreamont's famous phrase, 'as beautiful as the chance encounter on a dissecting table of a sewing-machine and an umbrella'.

Johann Knopf's early years, like those of Natterer, were stable. His illness seems to have emerged after the death of his mother, with whom he had lived until then, and a subsequent unhappy marriage. He was admitted to a psychiatric hospital after a suicide attempt. From his youth he suffered from religious delusions,

though he only communicated these after he was hospitalized. Knopf believed himself to be a Christian martyr, seeing suffering as an inevitable corollary of his divine calling. Much of his work contains characteristic figures representing Christ/Knopf, executed in a simple geometric style. Bodies are transparent, revealing internal organs and other objects, such as knives and keys, according to the symbolic content of the work. Faces are always inscribed in a circle and often contain numerals as on a clock face and each figure is usually bisected by a line that terminates in the forehead as a 'third eye'. Knopf also believed that he could understand the language of birds, which take their place in his mythology as tragic creatures. Aside from a number of nostalgic country scenes, in most pictures Knopf filled the space around his drawn forms entirely with 'explanatory' writing. Because these drawings developed spontaneously the text is dictated as much by the shape of the space to be filled as by verbal intent, as is clear in *Big Bumperton on the Sabbath* in which the clear presentation of language is subordinated to the pursuit of decorative order.

42

43

The only sculptor in Prinzhorn's book was Karl Genzel. This is, perhaps, unsurprising given that sculpture would have been a more unlikely medium within asylums and also less straightforward as something to send to Prinzhorn by mail. A bricklayer by trade, throughout his twenties Genzel was involved in petty crime. A serious industrial injury to his leg in 1900 and subsequent operations eventually led to its amputation. Genzel launched a vigorous campaign for compensation which may have contributed to the onset of the visual and auditory hallucinations that resulted in his hospitalization in 1907. He began to make sculpture in 1912, initially from chewed bread – a classic sculptural material in prison and hospital art where more

44. **Karl Genzel**, *Three Head-Footer Figures*, from Hans Prinzhorn, *Bildnerei der Geisteskranken* (*Artistry of the Mentally Ill*), 1922

traditional materials were unavailable – which were, Prinzhorn reported, 'distinguished mostly by obscenity'. He was soon given wood to work with by one of his doctors and began to carve shallow reliefs and three-dimensional figures that show considerable confidence with his material. His sculptural forms developed without pre-planning or an exterior model and he claimed that he was guided quite literally by the material itself: 'When I have a piece of wood in front of me, a hypnosis is in it – if I follow it something comes of it, otherwise there is going to be a fight.' Genzel's sexual obsession often manifested itself in a dual sexuality in his sculpture, either in terms of hermaphroditism or the incorporation of male and female figures in a single piece. He also produced a number of so-called 'head-footers', consisting of figures lacking bodies and, usually, arms. Though at first sight reminiscent of drawings by very young children, Genzel explained the forms of these curious pieces in reference to their identity as representations of Christ: 'One sees only the head because the body has been nailed to the cross'. The larger double figure represents the male Jesus and female 'Jesin', while Genzel referred to the other two figures as female, despite their penis-like appendages. The feminization of Christ reflects his fear of subjugation by strong women. Characteristically, he said of these figures, 'The Jesin wants to have the upper hand; she has religion on her brain. She believes but she does not believe.'

Hyacinth, Freiherr von Wieser is unusual among Prinzhorn's 'schizophrenic artists' insofar as he came from an upper-class background and had practised as a lawyer before the onset of hallucinations led to his hospitalization in 1912. Von Wieser was obsessed with the mechanisms of the process of thought which he explained through his own pseudo-scientific system. Because of his megalomania he devised ways akin to sympathetic magic to influence others, such as keeping his eyes closed for a day in order to prevent him robbing his siblings of their strength. Among his drawings are a number in which he attempted to represent his visions, including the often rather literal presentation of image fragments such as radio transmitters as in *Circle of Ideas of a Man Projected onto the Outer World*, or 'force lines' of thought. More interesting, perhaps, especially in the context of work by Klee and the Surrealists, is *Lively Contemplation of Rev. W. Obermaier* in which a portrait representation is constructed entirely from associative detail, creating a dialogue between notions of landscape and a head. Von Wieser took the logic of his belief in the awesome power of his own thought to its extreme and eventually ceased communicating verbally and

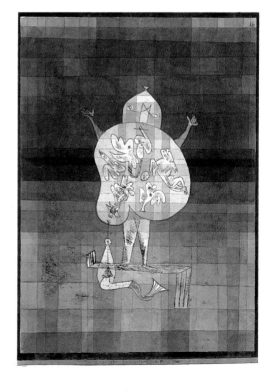

45. (above left) **Hyacinth, Freiherr von Wieser,** *Circle of Ideas of a Man Projected onto the Outer World*, n.d.

46. (above right) **Hyacinth, Freiherr von Wieser,** *Lively Contemplation of Rev. W. Obermaier*, n.d.

47. (right) **Paul Klee,** *Ventriloquist*, 1923

visually altogether, preferring telepathic means. In a rare emergence from this state he told Prinzhorn that in future he would 'simply strew graphite over his drawing paper and would force the particles into lines and forms by staring at them'.

One of the figures not included in Prinzhorn's list of 'schizophrenic artists', but who has come to occupy a central place in the canon of Outsider Art is Müller, an inmate of the Münsingen asylum near Bern, Switzerland. Prinzhorn's interest in 'M.' was restricted to the tendency to 'free, grotesque play' in his drawings. The drawings, especially, have influenced the work of such artists as Dubuffet and Arnulf Rainer, though, as is so often the case, Müller's activities were not confined to picture-making, but included writing and the construction of machines concerned with perpetual motion, or reducing gear ratios, or creating energy for no apparent purpose. The machines – now lost, though some can be seen in contemporaneous photographs – are testament to Müller's grand, but autistic, schemes that he pursued singlemindedly and through which he constantly re-enacted one of his major fixations. Müller claimed to have invented a revolutionary vine-pruning machine, while working as a labourer in the viticulture trade at the turn of the century, which was subsequently stolen, allowing others to profit from it. His misfortune, it is said, brought on the psychiatric condition that led to his confinement. At the hospital Müller spent much of his time standing in a deep hole and in later years he spent hours staring through a large telescope-like object of his own construction at a small object he had made.

48

48. (right) Heinrich Anton Müller, with machines he invented, in the courtyard of the Münsingen asylum, near Bern, Switzerland, c. 1914–25

Adolf Wölfli

One year before Prinzhorn's book appeared, Morgenthaler had published *A Mentally Ill Person as Artist*, his groundbreaking study of Wölfli, an artist-patient who has come to be regarded as the quintessential outsider artist. Yet, the bulk of his work is now contained not in a specialist collection of Outsider Art, but in the mainstream Fine Art Museum in Bern (though only a tiny fraction is on display). In an *oeuvre* spanning three decades Wölfli produced thousands of drawings and musical compositions. Most of them form part of a forty-five volume autobiographical project which begins with an imagined world expedition, during which time his transformation into St Adolf takes place, and culminates in a saga celebrating the new creation of the world of St Adolf II and the events of his fantastic life story.

Wölfli was committed to the Waldau Psychiatric Clinic in Bern in 1895 after he allegedly sexually assaulted a three-year-old

49. **Adolf Wölfli**, *Chocolat Suchard*, 1918, from *Book with Songs and Dances*, Book 15, page 1907

girl – the third such incident. By that time he was already suffering from terrible hallucinations accompanied by bouts of extreme violence which meant that he spent most of his time in solitary confinement. He began to draw spontaneously around 1899 and since this appeared to calm him he was given materials and encouraged by his doctors. Wölfli was born into a poor family, the youngest of seven brothers, two of whom had died in infancy (one was also called Adolf). His alcoholic father deserted them in about 1870 and after the death of his mother a year later, when Wölfli was only nine, he was made a hireling and forced to labour for a succession of foster parents on different farms. His early life was punctuated by a series of ill-fated sexual relationships and alleged molestations which he understood for his part in terms of the most dreadful sin. Yet, this miserable early existence was transformed in his writings and pictures. For example, the presumed occasion of his first sexual transgression when he saw a two-year-old girl

50. **Adolf Wölfli**, *H.M. Queen Hortensia on the Telephone*, 1920

naked in her cradle was transformed into his betrayal of a super-natural personage in his protection, the 'holy Saint-Elisabeth … who will never be my wife here on earth, although I really and truly loved her deeply'.

Significantly, all of Wölfli's visionary adventures around the world in *From the Cradle to the Grave* (1908–12) take place before the death of his mother. He explained to Morgenthaler – who worked at the Waldau Psychiatric Clinic between 1907 and 1919 and knew the artist well – that these were lost 'memories' that had not returned until after he was hospitalized: 'It was after a severe illness contracted when I was eight years old, that is to say, from that moment on, that I directly and radically forgot everything. Yes, even my capital and family relations, etcetera.' According to Morgenthaler, as soon as Wölfli was left to himself or voluntarily detached himself from his surroundings, he turned inwards into his own universe in which he lived entirely and which was 'more authentic for him than the real world'. In this alternative world Wölfli was subjected to an eternal cycle of becoming, death, and rebirth, emerging each time as a more powerful figure: 'just as he cannot die without being revived at once, he cannot conclude anything without immediately beginning again'. Yet, a distinctive ambivalence was also inherent in his cosmology. For example, simultaneously he could be possessed of enormous powers and utterly helpless, or in Morgenthaler's words, 'He may at one time be Adolf Wölfli and Emperor or God; he may be lying in a heavenly bed with a Goddess while his image is in a cradle nearby and he is at the same time in his "cell of sorrows".'

In spite of the often highly complex nature of his drawings, Wölfli worked spontaneously, without advance planning, in a way that is akin to much outsider production. Morgenthaler described how, perhaps surprisingly, 'in most cases, having barely outlined some contours, he begins to draw at some point at the edge of the paper, usually completes the border first, then proceeds by succes-sive layers or sections towards the centre.' Wölfli's drawings have a distinctive iconography in which each component part seems animate. There is a characteristic *horror vacui*, every part of the sheet being filled with representational and decorative elements – including musical notation – and text, often intermingled in a manner similar to Knopf. Some figurative elements assume the function of space fillers, such as the shoe forms and 'little birds' described by Morgenthaler that can be found inside the drawn contours of animals, plants and figures, as well as in the 'empty' spaces of the sheet. Their meaning, as with other symbols in

51

50

51. **Adolf Wölfli**,
The Chimpanzees of the Union of Canada, 1911, *From the Cradle to the Grave*, Book 4, page 143

Wölfli's work, shifts according to circumstance, though given Wölfli's sexual preoccupations and the similarity of the German word *Vogel*, meaning bird, and a slang word for sexual intercourse, coupled with the fact that the 'little birds' also appear sometimes in the genital region of figures, led Morgenthaler to suggest that they were a 'symbol of pansexualism'.

The final movement of Wölfli's immense project was his 'Funeral March', comprising sixteen books, but unfinished at his death in 1930. For much of his life in the clinic he performed his own musical scores on a horn made from rolled-up paper. Wölfli's notation is phonetic, rhyming with the vowels. The scores are structured around the central compositional element of a motif from a magazine photograph collaged into the text, as in the case of 'Pathé-Baby' whose source is an advertisement for a small cine camera. The illustrations for 'Funeral March' consist almost entirely of collaged images reflecting Wölfli's abiding themes of power, beauty, domesticity, wealth and nature. Unlike with Dada and Surrealist collages by the likes of Hannah Höch and Max Ernst, Wölfli did not tamper with his collaged elements, but presented them in a literal way. Their transformation was achieved not so much through ironic juxtaposition as through the function they were made to perform in the artist's other world.

After Prinzhorn
The conditions that allowed Prinzhorn to accumulate such a varied collection of work of very high quality no longer existed by the time Dubuffet (especially as a non-psychiatrist) began his

52. **Gaston Duf**,
Rinauserose Vilritites, c. 1948

collection at the end of the Second World War. Nevertheless, he was able to uncover a number of other artist-patients, such as Gaston Duf, Aloïse Corbaz and Carlo Zinelli, whose expressive strength matched those included in the Prinzhorn Collection.

Gaston Duf was committed to an asylum in Lille, France, in 1940 after a failed suicide attempt. As a child he was brutalized by his alcoholic father and sought protection from his mother. Duf's own descent into alcoholism and a breakdown was fuelled by the marriage of his parents when he was eighteen. He began to draw some time after he entered the asylum, saying that his work was a mythic father figure, Pâpâ Mins'oüzzs (sometimes called Pâpâ Lôé). The central creature in Duf's bestiary is a grotesque rhinoceros. Though the rhinoceros dominates his output, its form constantly changes, as if he were searching for some totemic figure to deliver him from his own state of powerlessness and, having identified it, sought to protect it from appropriation by denying precise definition. Duf stopped drawing abruptly in 1953. When his doctors encouraged him to begin again three years later it became clear that his creatures now threatened his well being, and he retreated into the extreme autistic position where contact is impossible.

Dubuffet argued that the obscurantism of Corbaz's speech and pictures was a device through which she maintained the integrity of her imagined world without taking responsibility for it: 'She was not mad at all, much less in any case than everyone supposed. She made believe. She had been cured for a long time. She cured herself by the process which consists in ceasing to fight against the illness and undertaking on the contrary to cultivate it, to make use of it, to wonder at it, to turn it into an exciting reason for living. ... She had discovered the realm of the incoherent, she had come to realise the profusion of fruits that it can yield.' Corbaz was well educated and had worked as a teacher and governess before her increasing mental disorder led to her being committed to a Swiss psychiatric hospital in 1918. Her symptoms were bound up with her struggles with religion and sexuality, including an unrequited love for the German Emperor Wilhelm II, to whom she wrote passionate love letters. Her imagery is unremittingly sexual in nature. The central figures are always women attended by their male lovers. Invariably these are highly stylized representations; famous lovers from history and opera whom Corbaz reveals in their transcendent forms. They are the creatures of another world created, inhabited and controlled by the artist.

Corbaz's method of representation grew out of, and reinforced her alienation from, the world outside her fantasies. Her figures

52

53. (right) **Aloïse Corbaz**, *Enlève dans le Manteau royal de Sirene*, c. 1940

are iconic and, even though they are usually in close physical 53, 54 contact, remain fundamentally self-contained. The characteristic lack of illusionistic depth in her pictures contributes to their other-worldliness. Michel Thévoz has argued that the flat surface of the paper is, for Corbaz, 'a solace and a refuge' in which a reality with only one viewpoint – the artist's – is admissible: 'if being and seeming are to coincide exactly, they require a flawless surface, with figures and motifs packed so closely that nothing can slip through. She is therefore intent on filling up any gaps which might afford a glimpse beyond or let in a sense of becoming. To paint or draw is, in the first place, tantamount to living in a two-dimensional world.' Once she began a piece Corbaz worked speedily, first drawing the outlines of figures, then putting in the blue ovals that represent eyes, and finally filling the sheet with colour. The eyes never have pupils and their intense blind stare

54. (following pages)
Aloïse Corbaz, *Mickens*, c. 1955

functions as another dissociative device. The artist herself once described the lovers' 'eyes' as glasses: 'They were embarrassed when it came to kissing, so they wear glasses.'

The 'hallucinatory' visual world of Corbaz was not a transcription of her visions, in contrast to individuals like Natterer, Von Wieser, or Duf. Rather, it was in the act of drawing that her vision became manifest. According to Thévoz, 'The subject takes form in the very course of the execution; it is absolutely contemporaneous with it.' He argues further that, 'she resorts to the handful of assorted crayons in readiness as to a cast of the dice, expectantly prepared for any surprise that may turn up. Each colour, by virtue of its intrinsic energy, and even before representing or suggesting something, produces in her an emotional shock as it comes to hand, and this shock is followed at once by a fallout of images.'

56. **Carl Lange**, *On the Holy Miracle in Bread*, c. 1900

Much of the life of the Italian artist Carlo Zinelli was spent in harsh and deprived conditions. Sent away to work as a farm labourer at the age of nine and apprenticed to a butcher at fifteen, he served in the army until he was discharged in 1941 for attacking his captain. He suffered increasingly from terrifying hallucinations and a persecution complex and in 1947 he was committed to the San Giacomo Psychiatric Hospital in Verona, Italy, where he was destined to spend most of the rest of his life. Zinelli's first drawings consisted of graffiti on the hospital walls, but when a studio was established at the hospital in 1957 he began to paint. His works teem with regimented movement and schematic birds and human figures in profile predominate. Zinelli characteristically builds his compositions incrementally, starting with large figures and often, as in the case of *Long-Legged Bird* (1964), gradually filling the whole of the picture space with figures of diminishing size according to the gaps remaining.

55

Art and Madness

Prinzhorn was conscious of the implicit parallels that could be drawn between his evaluation of art by mental patients and Expressionism. He believed that they had in common a 'renunciation of the outside world' and a 'decisive turn inward upon the self'. He was also at pains, though, to describe the fundamental differences between the two, which reside, he argued, in the act of choice. Alienation from the world of appearances is imposed in the case of the schizophrenic, he said, 'as a gruesome, inescapable lot against which he often struggles for some time until he submits and slowly begins to feel at home in his autistic world, which is enriched by his delusions.' In contrast, the 'alienation' of the modern artist 'occurs because of painful self-analysis'. This is the key to the difference, for example, between Klee's work and that of Von Wieser and Carl Lange. Despite certain formal simi- 56, 57 larities, a sophisticated ironic intelligence operates in Klee that can be contrasted with the lived reality of the worlds described by the two mental patients; similarly with Natterer's *Miraculous Shepherd* 58 (pre-1919) and Max Ernst's Surrealist reworking of the image in *Oedipus* (1931). Ernst had been aware of the Prinzhorn Collection 59 from the early 1920s and he was responsible for bringing *Artistry of the Mentally Ill* to the attention of the Surrealist group in Paris. An interest in insanity lay at the heart of Surrealism, though Breton regarded the psychic operations of madness in the same way as other modes – such as the hypnotic trance, dreaming and automatism – which he saw as affording entry into 'primary

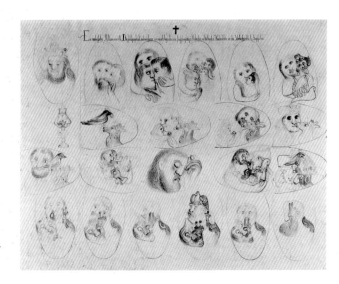

57. **Carl Lange**,
The photographically verifiable, interleaved miraculous images, revealing a fifteen-year-old crime, in the insole of the victim's shoe,
c. 1900

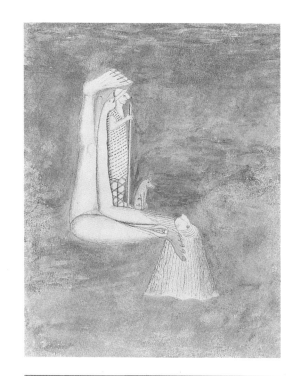

58. (above right) **August Natterer**,
Miraculous Shepherd, pre-1919

59. (right) **Max Ernst**, *Oedipus*,
1931, cover of special issue of
Cahiers d'Art, Paris, 1937

processes' located in the unconscious that are normally inaccessible because of the process of acculturation.

The Surrealists sought to capture in language and image a knowledge gleaned from the psychic depths that they regarded as exemplified by madness without descending definitively into that state. Thus, the techniques of automatic writing and drawing, for which no prior conceptualization is made and in which meaning emerges from the activity itself, are more or less conscious equivalents for the processes of schizophrenic artists. As Breton said, 'let it be clearly understood that we are not talking about a simple regrouping of words or a capricious redistribution of visual images, but of the recreation of a state which can only be fairly compared to that of madness.'

Madness, in Surrealist terms, was a metaphor for absolute freedom. Its name was repeatedly invoked as a provocation for what they regarded as a banal and complacent dominant value system. If madness was rejected absolutely by that culture, the Surrealists espoused complete acceptance of insanity in order not to wipe out the culture to which they felt they belonged, but to subvert and awaken it. This is the spirit in which French writer and collector Paul Eluard's 1924 imperative should be read: 'We who love them understand that the insane refuse to be cured. We know well that it is we who are locked up when the asylum door is shut: the prison is outside the asylum, liberty is to be found inside. … Accept as a postulate the principle of absolute liberty, and recognise with me that the world of the insane cannot be matched in our age.' Breton's interest in madness as a philosophical ideal rather than as a state to be entered irrevocably is perhaps most clearly indicated in his autobiographical memoir *Nadja* (1928). The book is, in part, a study of the psychic deterioration of a young woman with whom the narrator/Breton had become infatuated. Her hallucinatory presence and often impenetrable monologues are central to the production of a newly seen and profoundly uncanny Paris. Towards the end of their relationship Nadja begins to produce drawings that reflect her visions, such as *The Lover's Flower* which contains a variation of one of her self-images as 'a butterfly whose body consisted of a Mazda (Nadja) light bulb toward which rose a charmed snake.' Breton describes Nadja's final hospitalization in terms of the attainment of a state of being that represents, in his own terms, too much of a renunciation, namely to break free from the 'jail of logic' into freedom 'without pragmatic considerations of any sort'. Yet, inherent in Breton's text is a critique of the culture that presumes to exercise its power

over individuals at any level. When he says, 'I do not suppose there can be much difference for Nadja between the inside of a sanatorium and the outside', it is not to reveal Nadja's pathological state. On the contrary, he wants to demonstrate that in either case she is physically subject to the will of the state, and because she has no money, that power is all the more readily wielded: 'Nadja was poor, which in our time is enough to condemn her, once she decided not to behave entirely according to the imbecile code of good sense and good manners.'

The reality of psychosis and the horrific treatment regimes that operated at times, even in the middle of the twentieth century, were brought directly into the Surrealist camp with the mental collapse of the poet and playwright Antonin Artaud in 1937. He spent two years in a state of near total autism during which time he was subjected to electric shock 'treatment' and when friends were finally able to visit him they were unnerved by the experience. While in hospital Artaud continued to write and began, more or less for the first time, to make direct and powerful drawings. But this experience of madness from the inside, so to speak, stripped Surrealist attitudes of their naïve romanticism.

60. *The Lover's Flower*, from André Breton's *Nadja*, Paris, 1928

Degenerate Art

The perceived connection between genius and insanity was given its most complete theoretical treatment by the Italian psychiatrist and criminologist Cesare Lombroso (1835–1909) in his book *Genius and Madness* (1864). Lombroso's main claim was that genius is a form of 'moral insanity', and that artists are innately 'degenerate' types, which he set out to prove by amassing a huge body of comparative evidence. This included a collection of work by psychiatric patients, including drawings, costumes and furniture, some of which can still be seen in the Museum of Criminal Anthropology in Turin, Italy. From this material Lombroso 'identified' a set of thirteen distinctive features of psychotic pictures, arranged around categories relating to 'behaviour', 'form' and 'subjects'. Lombroso saw in these works proof that the actions of the insane – like those of 'savage' peoples – represent atavistic returns to earlier stages of human development. This is why, in his view, both the 'savage' and the mental patient 'exhibit a fixation on the obscene and a stress on the absurd'.

The emergence of an artistic avant-garde in the latter part of the nineteenth century and especially its embrace of 'non-artistic' forms led to the emergence of a reactionary art theory that concentrated its attack on the supposed inherent degeneracy of modern art practice. This received its first extensive coverage in Max Nordau's (1849–1923) influential *Entartung* (*Degeneration*) (1895). A pupil of Lombroso, Nordau set himself the task of revealing scientifically the poisonous social malaise at work in *fin-de-siècle* attitudes. His message was clear from the start: 'Degenerates are not always criminals, prostitutes, anarchists, and pronounced lunatics; they are often authors and artists. … Some among these degenerates in literature, music, and painting have in recent years come into extraordinary prominence, and are revered by numerous admirers as creators of a new art, and heralds of the coming centuries. This phenomenon is not to be disregarded. Books and works of art exercise a powerful suggestion on the masses. It is from these productions that an age derives its ideals of morality and beauty. If they are absurd and anti-social, they exert a disturbing and corrupting influence on the views of a whole generation.'

The specific dangers posed to modern art by the art of mental patients was voiced by a British psychiatrist, T. B. Hyslop, who was until 1910 Physician Superintendent to the Royal Bethlem Hospital, in his article 'Post-Illusionism and the Art of the Insane' (1911). Relying heavily on Nordau's work, Hyslop dismissed the 'non-art' of the mentally ill as merely pathological,

61. (below left) **Cesare Lombroso**, epileptics, from *L'Homme criminel*, Paris, 1887

62. (below right) Germaine Berton and members of the Surrealist group, published in *La Révolution surréaliste*, No. 1, December 1924. The first Surrealist review was modelled on the popular scientific journal, *La Nature*, thereby distancing it from other art and literary magazines and also suggesting the employment of (anti-)scientific methodology. This image of twenty-eight men surrounding a single woman was reproduced in the magazine without comment other than the quotation from Baudelaire which reads, 'Woman is the being who throws the greatest shadow or the greatest light on our dreams'. Her identity as both a woman and the killer of the right-wing editor of *L'Action française* is, however, central to its impact.

but warned against its potentially damaging influence to those inclined towards culturally degenerate attitudes: 'That the works of insane artists may be crude, absurd, or vile matters little so long as they exert no corrupting influence on society, and so long as society fully appreciates their pathological significance. Unfortunately, however, some creations which emanate from degenerates are revered by the borderland critics, blindly admired by the equally borderland public, and their real nature is not adequately dealt with by the correcting influence of the sane.' Nordau's solution was simple and brutal – since the degenerate artist differs only in degree from criminals and the insane, he argued, he should be punished accordingly: 'Ought art to be … the last asylum to which criminals may fly to escape punishment? Are they to be able to satisfy, in the so-called "temple" of art, instincts which the policeman prevents them from appeasing in the street?'

Lombroso's interest in the work of mental patients was related not to any perceived aesthetic value, but to its usefulness as evidence of processes that identified the condition of its makers, in much the same way that he and his followers used comparative photographs of physiognomies to identify criminal types. This

61

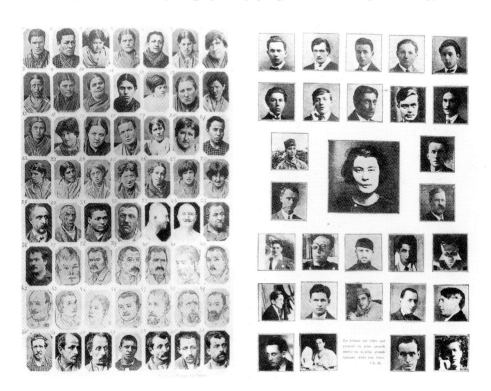

device was adopted in France in the 1920s by the Surrealists in acts of ironic subversion, such as the famous image of members of 62 the group and some of their 'heroes' surrounding the anarchist and murderess Germaine Berton. It was also used more chillingly and to great effect by Nazi propagandists, both as a means of describing a racist taxonomy of human difference in their efforts to portray the 'pure nordic type' to which they aspired and to draw comparisons between what they considered to be degenerate types and the insane – though the ground had been prepared in 1928 by Paul Schultze-Naumburg in his infamous book *Art and Race*. Nazi cultural policy orchestrated by Josef Goebbels not only reproduced the language of Nordau, but attempted to 'correct' the problems he had revealed by a programme designed to eject modern artists and curators with modernist sympathies from their positions within the German art world. This attack reached its apogee with the mammoth *Degenerate Art* exhibition, which opened in Munich in 1937 and travelled to other venues around the country, and a number of publications associated with it, most notably Adolf Dresler's *German Art and Degenerate Art*.

The *Degenerate Art* exhibition included direct comparisons of 63 work by professional artists and examples taken from the Prinzhorn Collection and it is also salutary to remember that the suffering of the avant-garde at the hands of Nazi cultural policy was mirrored by the disappearance (and in all likelihood murder) during that period of many of the artist-patients whose work forms the Prinzhorn Collection. During its war-time occupation France was also subjected to a cultural policy that simultaneously threw together and excluded modern and insane art. The notorious French critic Camille Mauclair included visual juxtapositions of works by modern artists and mental patients in his violently anti-semitic book, *The Crisis in Modern Art* (1944). Ironically, at the end of the war these perceived connections resulted in a renewed interest in art by the insane, marked by the completion in 1945 of a mural designed by a group of Surrealists in the Sainte-Anne psychiatric hospital in Paris, replacing one destroyed by the Nazis and in 1946 by a major exhibition of psychotic art, also at Sainte-Anne Hospital, that was conceived in direct rebuttal of notions of degenerate art.

63. (opposite) Page from the *Degenerate Art Exhibition Guide* (Munich, 1937), comparing works by a mental patient – Karl Genzel's *Head of a Girl* (1912/13), made of chewed bread (above) – and an Expressionist – Eugen Hoffmann's *Girl with Blue Hair*, of plaster (below). The text reads: 'This head of a girl is the work of an incurably insane man in the psychiatric clinic in Heidelberg. That insane non-artists should produce such works is understandable. This abortion was, on the other hand, seriously discussed as a work of art and included in many exhibitions in the past as a masterwork by E. Hoffmann.'

Dieser Mädchenkopf

ist die Arbeit eines unheilbar irrsinnigen Mannes in der psychiatrischen Klinik in Heidelberg. Daß irrsinnige Nichtkünstler solche Bildwerke schaffen, ist verständlich.

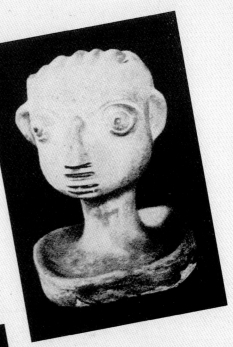

Diese Spottgeburt

aber wurde ehedem ernsthaft als Kunstwerk besprochen und stand als Meisterwerk von E. Hoffmann in vielen Kunstausstellungen der Vergangenheit. Der Titel des Monstrums hieß: „Mädchen mit blauem Haar"; seine Frisur erstrahlt nämlich im reinsten Himmelblau.

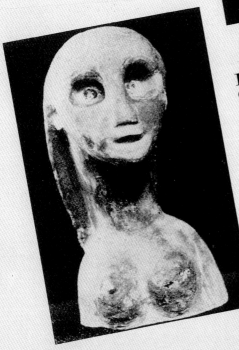

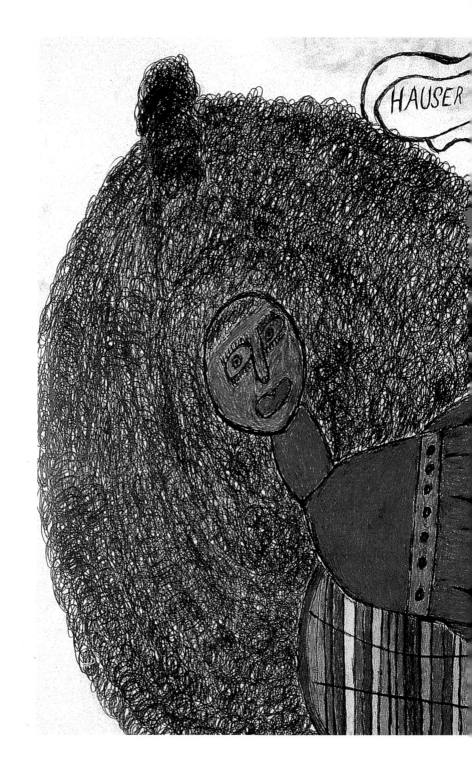

Art as Therapy

The widespread use of therapeutic drugs (at least in the West) in the second half of the twentieth century both reduced the number of long-term hospitalizations and, it was claimed, stifled the desperate creativity previously born of mental illness. Often, patients whose images seem to possess an untamed expressive force when they arise in a period of psychosis produce banal attempts at realism, which are of no interest to art consumers, after their condition has been stabilized by drug therapy. In many cases image-making stops completely. That the 'quietening' of one's condition is not necessarily regarded as desirable by others raises two major issues that run throughout the discourse of Outsider Art: firstly, it highlights the Romantic emphasis placed on expression rather than technique; and secondly, it reveals the continued survival of a related entrenched belief that the most authentic artistic production is somehow linked to suffering. Art wrenched from madness is, in this context, merely the most extreme form of this.

Similarly, the systematic development of art therapy in hospitals and outreach programmes since the 1960s is often cited as an indicator of the demise of Outsider Art. Interference in the creative process by therapists, its critics argue, results inevitably in work of a generally inferior quality. Dubuffet himself was emphatic about what he saw as the 'dangers' posed by modern psychiatric attitudes: 'Physicians in the early part of this century left their patients alone. They didn't try to "cure" them and were simply glad if they kept themselves busy with art. Perhaps they had more sense. Now they want to prevent it, and to kill originality.' Yet, some of the most impressive Outsider Art of the last thirty years has been produced in art-therapy situations. Among a number of well-known units are the Centro Psiquiatrico Pedro II in Rio de Janeiro, Brazil, La Tinaia in Florence, Italy, and the Haus-Kannen in Munster, Germany. Probably the most famous, though, is the so-called Artists' House, which is part of the psychiatric hospital at Gugging, near Vienna, Austria. It was founded in 1981 by the psychiatrist Dr Leo Navratil, after three decades of work with patients at the hospital, precisely to provide a separate space in which his artist-patients might flourish.

Significantly, Navratil was in contact with Dubuffet from 1969 and after 1976 Gugging artists such as Johann Hauser, Philipp Schöpke, August Walla (b. 1936), Johann Fischer (b. 1919), Oswald Tschirtner (b. 1920) and Max (1937–88) were well represented in the Collection de l'Art Brut in Lausanne, Switzerland. Given Dubuffet's insistence on the rawness, or unrefined nature, of true

64. (preceding pages) **Johann Hauser**, *Reclining Woman*, 1994

65. (opposite) **Johann Hauser**, *Slender Woman and Hare*, 1971

92

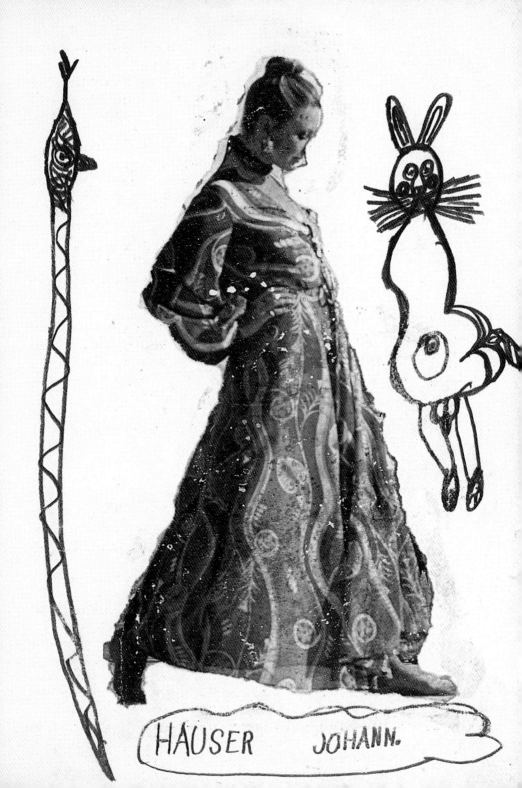

HAUSER JOHANN.

...ntrice Österreich.!! Die Würde der Völker nicht, darf nicht

...ht persönlich, mit den Füßen, nicht treten nicht.

...genen zurückfallen. Mit Geld und Unwahrheiten, nicht

Bedenken, sich unsichtbare Kräfte, sich zu

Dort, wo schon, ein Hin und Her die Kluft

Dimensial, Dimensional, über die Köpfe

...rationen zu Ende sind,

wozu...

Einstweilen

...inden wir
...mit ten in
...nen

Dieser
zoll
durch
heit

Blüt=
wird
Unzu= frieden
im Nachhinein

Und
...e zu
...die
...sie=
...ungen

weil die= se Reg= ier
...ungen sich sel bst
betrogen haben. Und
vor leeren Geldtres= sorn
Ratlos stehen. Anstatt
die echten Friedensgeld=
bank= noten, auf Hoch

...dazu auf Tieren zu drüken sind.
gefordert sind Und die Lebensmittel=
Aufrufen fabriken müs
schon zu ü. Nahrungsmittel sein Die Preise
zu wenig, müssen in Takt nicht, dürfen
sich nicht genrich=
en Völkern sich nicht, ge=
...indet. Das Wasser wückert nicht
...räuch= sich ...ert=

skope und Blech=
Wechselströme und werden nicht. Die Land=
...d im Gefertigten die Kilowatt berechnen. wirtschaften und Gütshöf=
müssen voll aufzeugen können
größten Räuber u. Mörder, dem Tod, nicht zusammen. Wegen dem Blutzoll!

Outsider Art it is perhaps unsurprising that Navratil is at pains in his writings to emphasize that interference with the creative process for therapeutic purposes is minimal. A claim that has not prevented critical dismissals – by the French writer Christian Delacampagne, for example – of Gugging as merely an experiment in art therapy. However, also in line with Dubuffet's beliefs, Navratil has attempted to separate the activity of picture-making from the professional structures of the art world. The Artists' House therefore has no specialist studios or timetables for artistic activity. According to Navratil, 'Drawing and writing take place in an entirely individualistic way in response to personal disposition or external stimulus.' His 'anti-cultural' stance, to borrow Dubuffet's rhetoric, is highlighted by his negative attitude to the 'ordinary departments' of even the same hospital where, in his words, 'the principle of "normalisation" holds sway, associated with notions of healing, resocialisation, and rehabilitation'. In the Artists' House, he claims, 'the creative efforts of the artist-patients thrive precisely because of their deviation from the norm, drawing sustenance from those very psychological conditions which psychiatry ordinarily attempts to eliminate. In the Artists' House the hospital is not preparing patients to re-enter society in the role which once was theirs, but rather offering them a new social identity.'

The Artists' House has produced an astonishing number of important outsider practitioners who have developed international reputations. The most famous is probably Johann Hauser who suffered from manic depression. He attended a school for retarded children and was institutionalized at the age of seventeen. He began drawing in 1959 and developed a characteristic style, employing saturated, bold colour. Much of his work, like that of Philipp Schöpke, is manifestly sexual in content, though at times of depression his imagery became minimal and geometric. Hauser's work frequently consists of images of rockets and heavily armed aircraft, as well as a bestiary of archetypal animals, such as owls, hares, snakes and birds that often accompany his naked female figures. He was also interested in transport and many of his drawings depict aeroplanes and rockets. Hauser was aware that his work was valued in the world outside the hospital and though he often drew unprompted, he worked best when he received praise and was able to show people works in progress (a trait that he shared with Corbaz and many other outsiders).

The schizophrenic artists August Walla and Johann Fischer have, in Navratil's words, 'reproduced themselves, together with

64

65

66

66. (preceding pages)
Johann Fischer,
Unser Trautes Sovarenes, 1990

their delusions, in their work'. They both strive to construct and explain a world, and individual pieces are packed with a mixture of word and image. Walla works with a variety of materials, from paper and canvas to the wall of his hospital room, or some found object. Before he was institutionalized he painted his house with figures, text and symbols – such as hammer and sickle and swastika motifs – and filled his garden with objects created from discarded materials. He has a fascination for language and has amassed a collection of foreign dictionaries. In this way, words from languages he cannot understand find their way into his work, where they function as mythic signposts in his private cosmology. He further controls his universe through documentation of his creative activity in diaries and photographic records of completed works. In contradistinction to Walla's self-motivated desire to create, Oswald Tschirtner never draws unprompted. A student of theology in the 1930s, he was recruited into the German army at the beginning of the Second World War and fought on the Eastern

67. **August Walla**,
Marchen, 1989

68. Oswald Tschirtner, *Many Flying Angels*, 1972

Front. He has been institutionalized since his return to Austria in August 1946. His work, some of which consists of copies of other works of art or of newspaper imagery, is characterized by a singular repetition of simply delineated, elongated figures.

Navratil regards art-making as therapeutic in itself. The sustained creative act is, for him, something that enriches the interior life of that person. Such ideas are connected to Navratil's 'other' relationship with the Viennese artistic and literary avant-garde of the mid-1960s and early 1970s. The influence of such artists as Arnulf Rainer, Georg Eisler and Alfred Hrdlicka, and writers such as Peter Handke was crucial to the development of the Artist's House. Rainer is particularly important as a collector of psychiatric art and a collaborator, at times, with Gugging artists such as Fischer and Hauser where both outsider and art-world professional are given equal prominence.

Rainer began to collect art by mental patients in the 1960s and his drawings from that period were often influenced by its forms. More important to him, though, was the evidence of artistic process that he intuited in the works. He developed methods of overpainting that bring to mind the scribble of severely autistic mental patients such as the Gugging artist Max (as well as the tendency among very young children to direct their primitive mark-making to areas already containing forms), including

69. (below left) **Arnulf Rainer and Johann Hauser**, *Venus unter blauer Tuchtent*, 1994

70. (below right) **Arnulf Rainer**, *Profil im Whiskyrausch*, 1966

a series based on photographs of the late sculpture of Franz Xaver Messerschmidt (1736–84) which consist of strange physiognomic studies produced when Messerschmidt was suffering from a form of paranoid schizophrenia. Rainer's experiments with alcohol and hallucinatory drugs and his series of simulations of the facial distortions of catatonics led him to develop an affinity with the psychotic state that has guided his production since. He says, 'I devote myself to the contemplation of a concise, minimal form of overpainting. But this cannot hold my interest indefinitely: sometimes the swarming of the faces around and within my head is just too insistent. Cause: perhaps a dearth of close personal contacts, perhaps some individual stress? are these the paranoiac's familiar hallucinations of mocking faces, the menacing leers, the piercing unnerving stares, the faces that come too close to one's own?'

72

Rainer was attracted to the art of the insane precisely because he saw in its forms evidence of the same merging together of creativity and lived experience that he sought in his own work. There is here a clear link to early twentieth-century Expressionist theories concerning the possibility of communication of experience through art objects unmediated by symbolism or verbalization by denying distinctions between art and life. It was against the background of this kind of artistic activity that

71. (below left) **Max**, *Untitled*, 1972

72. (below right) **Arnulf Rainer**, *Verziehen*, 1969–70

73. (right) **Ank van Pagée**, *Untitled*, n.d.

74. (below) **Klaus Mücke**, *Yellow Nuns*, n.d.

Navratil 'learned to select what was artistically relevant' in the work produced by those in his care.

What can be seen as the consistently high quality of art coming out of Gugging is partly a function of qualitative selection by informed psychiatrists. This draws attention to a more general fact, namely that the public reception of art produced in the hospital environment is in no small part dictated by filtering mechanisms that determine which objects are to be released. This is as true of Prinzhorn in the 1920s, or the directors of Hospital Audiences, Inc. (HAI), in New York today, or of Navratil himself. The net result is really no different from the more straightforwardly value-laden choices made by Dubuffet and other artist-collectors that effectively defined Outsider Art in the first place. Out of both areas (which are, in any case, interlinked) a canon of Outsider Art has emerged that favours a generally 'modernist' appearance, from 'classic' outsiders such as Wölfli, Karl Genzel and Martin Ramírez to more recent practitioners such as Hauser and Ank van Pagée (1956–95). 73

The central claim that art therapy has reduced the aesthetic quality of hospital production might be used to argue that doctors and critics do not actually exercise a proper selection of work for preservation. However, on the whole, the art-therapy situation does not have as its primary end the creation of art, but images whose function is in some way therapeutic, and it does not expect the producers of these images to be artists in any sense of the word. In this respect it is hardly surprising that *more* bad art survives than hitherto; a fact that only serves to illustrate further that not all outsiders are artists and that, just as in the realms of the mainstream, there is a sliding scale in the quality of individual production. A picture or body of work that is valuable in psychiatric terms is not necessarily interesting as art. Published images by patients from Germany's Haus Kannen in Munster, for example, range from the pedestrian and merely inept to powerful and often moving works by such artists as Klaus Mücke (b. 1943) 41
and Joseph König. Without resorting to the kind of tortured form 74
that is characteristic of earlier outsiders such as Müller, in *Yellow Nuns* Mücke nevertheless poignantly conjures up a vision of his earlier years. In this large, frieze-like collage six discreet elements are repeated in horizontal layers: the nun in her yellow habit, a tin mug, a razor, a sink, a shaving mirror and an umbrella, suggesting the familiar objects of the artist's life and the regimented state of the milieu to which he has had to adapt.

Chapter 3: Alternative Worlds

One of the most striking features of Outsider Art is its general tendency to present the world in transcendent or metaphysical terms. Visual images reveal that which would otherwise remain hidden from view thanks to the special insight of their creators. Almost invariably artists develop a structured cosmology that underpins the 'reality' of their worlds, although the viewer does not always have access to the language of their articulation. Indeed, individuals often deliberately engage in obscurantism or develop complicated iconographies and linguistic systems in order to protect themselves and their ideas from perceived threats, as in the work of Klett, Natterer and Walla, for example. In other cases, such as that of Wölfli, detailed and complete universes are rendered in staggering bodies of image and text produced over many years. John MacGregor goes so far as to claim that, 'a super-abundance of material is essential ... since my definition of out-sider art requires that the artist create a vast, encyclopaedically rich, and detailed alternate world – not as art – but as a place to live in over the course of a lifetime.' In this view he reflects Dubuffet's notion that the outsider artist is an extremist in questions of rep-resentation: 'I believe that the creation of art is intimately linked to the spirit of revolt. Insanity represents a refusal to adopt a view of reality that is imposed by custom. Art consists in constructing or inventing a mirror in which all of the universe is reflected. An artist is a man who creates a parallel universe, who doesn't want an imposed universe inflicted on him. He wants to do it himself. That is a definition of insanity. The insane are people who push creativity further than professional artists, who believe in it totally.'

For most outsiders the transcendent world takes them beyond the reality of harsh living conditions. These might be grinding poverty, incarceration in psychiatric hospitals or prison, or other forms of social marginalization, though it should be remembered that the majority of those who share such conditions survive them without producing art or constructing other worlds. This is not to say that Outsider Art amounts to simple escapism – though the conditions of its production might seem intolerable to other people, the artist reacts not so much to external forces as to an inner imperative; in this context, other worlds are not so much invented

75. (opposite) **Achilles Rizzoli**, *Shirley Jean Bersie Symbolically Sketched/Shirley's Temple*, 1939

as discovered. As Roger Cardinal has said, Outsider Art is 'a startling instance of a circumstantial art which refutes circumstance.'

Besides the paradigmatic example of Wölfli, discussed in the previous chapters, among the most complete renderings of alternative universes that have come to light in recent times have been the projects of three Americans, none of whom were mental patients in adult life, Henry J. Darger, Malcolm McKesson and Achilles Rizzoli. McKesson is best known for the exquisite lyrical pen drawings that Cardinal has described in appropriately poetical terms: 'The viewing eye enters a space of whispers where long forgotten impulses are little by little resurrected. Light, yet not air, trickles into the frame, so that we can peep and yet not touch these tiny tableaux of intimacy, steeped in yearning and as if orphaned from the dimension of time.' McKesson came from a fairly privileged background, but in 1961 he withdrew from the business world and his social life in order to devote himself to his wife, the poet Madelaine Mason, and to art. Though their marriage lasted forty-eight years, it was probably never consummated, but it revealed to McKesson, as he said, 'the strength and wisdom of the female'.

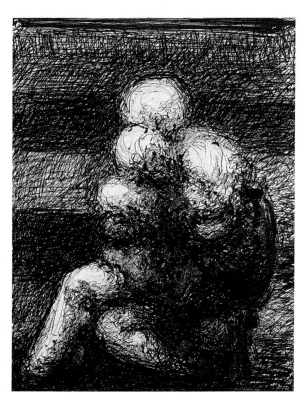

76. **Malcolm McKesson**, *Mistress Reducing Man to Page, c.* 1975

106

Drawings such as *Dancing Page Boy* (*c.* 1970) and *Mistress* 77, 76
Reducing Man to Page (*c.* 1975) invariably possess a general aura of
sanctity and tenderness, yet they are also unremittingly sexual in
nature. He said, 'When I draw, I attempt to see the form of the
undrawn ... I want to rediscover a buried tradition, to rediscover
the female in the man.' McKesson professed to having 'never had
any sexual development ... I didn't have any feelings about
masturbation or about girls ... I feel that I am basically asexual.'
But his drawings were produced in a 'hypnagogic, febrile state of
sexual excitement coupled with anxious torment' and elicit sexual
arousal in the artist like pornographic art. The texts written
on the back of many drawings often provide the only clue to
their sado-masochistic content. McKesson's fantasy world of
servitude at the hands of powerful women is delineated in his
'autobiographical' novel, *Matriarchy: Freedom in Bondage*
(published in 1997). One writer described McKesson's world as
'one of substitutions and transformations. Fantasy can become
autobiography, reality becomes ephemeral and dreamlike, and
intensely perverse reveries become art.'

77. Malcolm McKesson,
Dancing Page Boy, c. 1970

The world of Achilles Rizzoli has been bequeathed in the form of grandiose architectural schemes whose realization lies in a fantastic elsewhere. A trained technical draughtsman, he worked full time for more than three decades for the San Francisco architect Otto Deichmann. Rizzoli's central project was a city that he called Y.T.T.E. (Yield to Total Elation) whose inhabitants included figures associated with his life – his mother, work colleagues and local children – who were themselves immortalized in the large-scale architectural elevations he referred to as 'Symbolizations'. His mother, at the foot of whose bed he slept until her death in 1937, was invariably depicted as a cathedral, drawn on birthday cards that he sent to her at his own address for twenty years after she died. He held his first Achilles Tectonic Exhibit (A.T.E.) in his own sitting-room in 1935, although only some of the neighbourhood children came to see it. Yet, together with his workaday life, these small contacts constituted the full extent of his relationships outside that with his mother. His drawings filled the void left by his inability to engage with people socially and sexually. His yearnings are clear in *Shirley Jean Bersie Symbolically Sketched/Shirley's Temple* (1939) – on the basis of a simple request to see his pictures, his six-year-old neighbour is recognized as 'A goddess in the making' and urged 'to be the First Lady of the Y.T.T.E.' The project for her 'temple' is set to unfold over the course of sixteen years at which time the girl will become goddess and guardian of her own cathedral. Characteristically, Rizzoli is at once 'His High Prince, the Virgin', while simultaneously revealing himself as the jobbing technician through the poor rating for draughtsmanship and rendering he awards himself in the bottom corner of the drawing.

Henry J. Darger worked in America, in Chicago hospitals, for most of his life as a bandage roller and lavatory cleaner. He was

78. **Henry J. Darger,** *Storm Brewing,* 1920–70

79. **Henry J. Darger**,
Untitled, n.d.

a devout Catholic and attended mass daily, but had no family or friends, preferring to keep his own company. Darger had experienced a miserable childhood. His mother died when he was four, shortly after giving birth to his sister, who was subsequently given up for adoption. Abandoned at the age of eight by his father, aged twelve he was committed to the Lincoln Asylum for Feebleminded Children in Lincoln, Illinois – where his diagnosis was 'masturbation' – but escaped five years later. The loss of his sister was a pivotal event in Darger's life, leading not only to a life-long, but unfulfilled, desire to adopt a child, but also to the creation of a vast secret *oeuvre* of writings and drawings discovered only a few months before his death by his landlord, the photographer Nathan Lerner. Besides an eight-volume autobiography that John MacGregor has described as, 'The most extensive body of secret fantasy material ever accumulated by one man', the central work is *The Realms of the Unreal* which consists of more than 15,000 type-script pages in fifteen volumes, accompanied by around three hundred illustrations whose figures are all traced from images in old colouring books, comic strips and magazines. It tells 'The Story of the Vivian Girls in what is known as the Realms of the Unreal, of the Glandeco-Angelinnean War storm, caused by the Child Slave Rebellion', an epic story of the battle between good

and evil in a terrifying world wracked by war and natural disas- 78, 79
ters. In this other universe Darger attained heroic status, usually
as Captain Henry Darger, protector of children, though the real
heroes of the saga are the seven morally perfect Vivian sisters.

Darger's obsession with childhood and what he regarded as
God's injustice in allowing children to suffer was played out in *The
Realms of the Unreal*, often in chilling scenes of physical violence,
slaughter and dismemberment that are described graphically in
words and pictures. Events reported in newspapers are character-
istically incorporated into Darger's fantasy world. The great war
between the child-enslaving people of Glandelinia and the nation
of Abbieannia, for example, is caused by God's failure to send
a newspaper photograph that Darger had lost in 1912 of a little
girl who had been murdered in Chicago. Throughout his life
he collected articles concerning lost children, including stories
of kidnap and murder which he transferred into *The Realms of
the Unreal*. The process was similar in the illustrations which
consist of a mixture of tracings and collaged elements from a
wide variety of sources that combine to produce a surprisingly
uncanny effect. As MacGregor points out, 'Each one of these little
girls had been removed, lifted by Darger, from another setting.
Cut out or traced, she had been forcefully transferred from her
world to his ... by a symbolic process that, for Henry, resembled
adoption.' This act of god-like appropriation is emphasized by
the fact that, when depicted naked, his girls clearly possess male
genital organs. There is evidence that Darger regarded himself as
an artist, though he sought neither an audience other than himself
nor to preserve his work for posterity. The latter occurred only
because of the intervention of others, which raises a question
that is often implicit in the reception of Outsider Art, namely to
what extent we allow ourselves to trespass in lands belonging
to others.

The tragic results of a childhood destroyed are revealed even
more disturbingly in the world created by the Canadian outsider
Roland Claude Wilkie (b. 1939). Suffering from paranoid schizo-
phrenia and, from 1995, a patient at a psychiatric hospital in
Quebec City, Wilkie lost his father at the age of two and his sister
shortly after and was allegedly abused as a child. He developed
violent and paedophilic impulses towards children, particularly
blonde girls, which have been sublimated since his voluntary
admission to the hospital in the obsessive creation of images and
text – he is writing a secret autobiography entitled 'Fearless
Water' – that are unremittingly brutal. Where Darger wrestled

80. **Roland Claude Wilkie**, *My
Sexual Reality (Angela and Ruby)*,
1995

constantly with destructive impulses and the search for deliverance, in Wilkie's universe there is only torture. His drawings of children or of himself, armed and with murderous intent, are all the more disturbing for the awkward child-like style in which they are executed. He refuses drug treatment for his condition that exposes him to the full force of a delusional world in which the impulse to inflict physical and sexual harm is uppermost. There is nothing to be celebrated in these drawings, but they are important uncoverings of a most chilling potentiality of the human psyche.

In modern western thought childhood tends to be conceived as an innocent place in which intrusion by adults is invariably traumatic in some way and its passing is often regarded as a

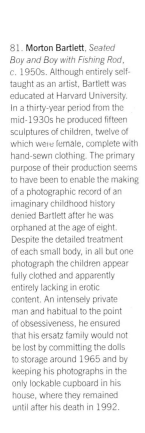

81. **Morton Bartlett**, *Seated Boy and Boy with Fishing Rod*, *c*. 1950s. Although entirely self-taught as an artist, Bartlett was educated at Harvard University. In a thirty-year period from the mid-1930s he produced fifteen sculptures of children, twelve of which were female, complete with hand-sewn clothing. The primary purpose of their production seems to have been to enable the making of a photographic record of an imaginary childhood history denied Bartlett after he was orphaned at the age of eight. Despite the detailed treatment of each small body, in all but one photograph the children appear fully clothed and apparently entirely lacking in erotic content. An intensely private man and habitual to the point of obsessiveness, he ensured that his ersatz family would not be lost by committing the dolls to storage around 1965 and by keeping his photographs in the only lockable cupboard in his house, where they remained until after his death in 1992.

lamentable and irredeemable loss. The crushing effects of this are felt throughout Darger's world-system in which children must ultimately fight for their own salvation. In certain cases artists have also constructed fictive spaces in which ideal childhood is protected. The work of the mainstream British Pre-Raphaelite painter Thomas Cooper Gotch (1854–1931), for example, abounds with obsessively wrought images of childhood transfigured as a Holy state of being. In pictures marked by an almost photographic attention to detail, childhood (specifically that of the female) is rendered simultaneously to be an object of desire and inviolable. This sense of real presence, coupled with a sublimated sensuality, is clearest in the private world created by Morton Bartlett. Orphaned at the age of eight, as an adult he created the family he never had in the form of half life-size 'dolls' 81, 82 of children, ranging in age from infancy to puberty, that are marked by striking fidelity to anatomical accuracy. He made complete wardrobes for these children and produced a collection of innocent family photographs in which they are treated as real presences. All were kept safely locked away so that they could not be lost as his real family had been.

82. **Morton Bartlett**, *Untitled, c.* 1950s

The World in Pictures

In many cases these alternative worlds are not described by artists' texts or commentaries by doctors and are only available to others through visual images and only scant supplementary evidence. Where Wölfli and Darger act as guides, with schizophrenic artists such as Martin Ramírez and Edmund Monsiel (1897–1962), or artists with other special mental states, such as Herbert Liesenberg, Klaus Mücke and Jimmy Roy Wenzel (b. 1959), viewers must make their own imaginative leap. The case of the Mexican artist Martin Ramírez not only exemplifies how far removed from the reality of daily existence the imagined world can be, but also how deeply withdrawn the artist can become. By the time he was hospitalized in 1930, Ramírez was virtually mute and diagnosed as paranoid schizophrenic. He seems to have begun to draw spontaneously and in secret in around 1948, although it is impossible to be precise because the De Witt State Mental Hospital in Auburn followed an all too common policy of tidying at the end of each day which included the destruction of work by patients. Drawing paper was not supplied so Ramírez improvised using anything to hand, such as laundry lists and flattened paper cups which he glued together, using a paste made from mashed potato or chewed bread, to make sheets. Finished drawings and works in progress were hidden and it was only in 1954 that Ramírez encountered someone – Dr Tarmo Pasto, a psychology lecturer – who valued his work enough to preserve it and encourage him to make more. Ramírez developed a recognizable iconography in which trains, armed horsemen and elements from 83 Mexican folk art predominate. In the last ten years of his life the artist constructed a complex other world apparently replete with meaning that is made visible in his drawings, but which, in the absence of any verbal explanation, remains tantalisingly mute.

The Polish outsider Edmund Monsiel was an untreated schizophrenic who, in the last two decades of his life, having never before made art of any kind, produced a body of exquisitely detailed drawings, often with messianic and religious inscriptions. Though he held down a job as a weighbridge operator, after he became ill he avoided social contact and was obsessively religious. Because he dated much of his work it is possible to follow the development of his illness through his pictures, beginning with transcriptions of visual hallucinations of Christ and the Devil in 1943. These gave way to chaotic agglomerations of figures 84 and faces that seem to suggest the artist's struggle with forces that threatened to consume him entirely. Subsequently, Monsiel

developed a more rigidly defined and controlled image of a world dominated by the human face. According to the Polish psychiatrist Antoni Kepinski, Monsiel found salvation there as 'a messenger from God. ... The roles had been reversed: the world was no longer a threat to him; rather, he threatened the world, assuming moral power over it.' Characteristically, Monsiel's drawings reflected the deific world of his visions in which he was God's emissary, rather than the dingy reality of the small room in which he lived. As in so many cases, here art assumed a magical function, liberating Monsiel creatively and helping him to exercise control over the powerful forces of his fears. Control was achieved partly through the annihilation of pictorial depth and its replacement by his own marks. Extant unfinished drawings allow us to see that Monsiel began by drawing large figures on his sheet, and then systematically filling the spaces between their defining contours with other figures and faces that became increasingly reduced in scale until the whole sheet was filled.

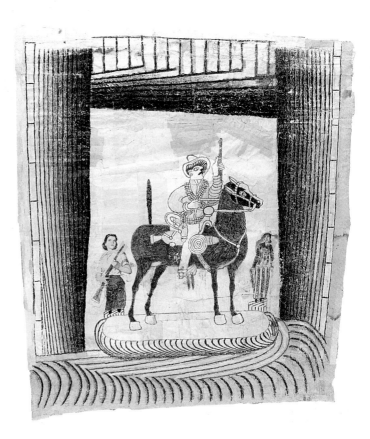

83. Martin Ramírez,
Untitled, 1953

84. **Edmund Monsiel**,
Untitled, c. 1945

Live Ground

Monsiel's drawings, like those of Wölfli, Knopf, Corbaz and others, are literally packed full with images. Yet, although the expulsion of space enables the construction of a profoundly separate world picture, paradoxically it does not also result in the removal of organicism. Despite their hieratical nature, Monsiel's pictures seem to throb with an innate life; his figures and disembodied physiognomies are elusive, threatening metamorphosis. Similarly, the work of the French schizophrenic artist Guillaume Pujolle is characterized by the metamorphosis of recognizable objects just far enough so that they retain identity, but can also be claimed emphatically for his other reality over which he exercised a control that was impossible in the mundane world of his existence.

Nowhere is this tendency clearer than in the work of Ody Saban (b. 1953), an artist of Turkish origin who lives and works in Paris. She says of herself, 'Up until nearly the age of six I took myself for a reincarnation of Lilith, who in the Old Testament is the woman cursed by the misogynist God, and I wanted to avenge Lilith (as I still do today, for that matter) and accomplish her work

85. **Guillaume Pujolle**,
The Eagles, the Goose's Feather,
1940

which, for me, is a beautiful work. Today, after seven years of psychoanalysis I still believe the same thing, but I know that it is not what one would normally call reality. Perhaps it is stronger than reality.' Like Monsiel, Saban's hermetic pictorial worlds are anchored by large central figures – often couples embracing or 87, 88 copulating – whose forms and the space around them is filled with moving, living objects that enact the fulfilment of their own desires. In common with the work of Surrealists, such as André 86 Masson (1896–1987) and Salvador Dalí (1904–89), the forms in Saban's drawings seem in a constant state of metamorphosis and

86. **André Masson**, *Labyrinth*, 1938. Influenced by Freud, Masson's work represents an attempt to gain access to unconscious thought through automatic techniques. Starting with a web of rapidly formed lines, he worked until images began to suggest themselves, concentrating on the moment of metamorphosis when forms were in the process of turning into something else. The Surrealists believed that madness, too, unlocked the doors to the unconscious and it is no coincidence that 'automatic' techniques of image production and metamorphosis are common in Outsider Art.

flux; eyes are flowers, cheeks are lakes, bodies are landscapes, and so on. However, where Surrealism utilized such visual metaphors as a means of revealing unconscious operations of thought, rather Saban presents the viewer with what she has seen to be true: 'My art is magic art. I am a shaman, a seer. I am in continual metamorphosis. … I transform myself. For example, I feel a flower. I enter into its skin and regard the world through it, just like I enter into the skin of someone else.' Saban actually sees animate objects occupying the surfaces of the larger objects around her which brings a sensual deluge to scenes whose content is already manifestly erotic.

Dangerous Creativity

It has been suggested that contemporary hospital art continues to be produced in spite of, rather than because of, the therapeutic situation. Some writers have argued that even where art continues to be produced its potency is diminished by the tendency of drug therapy to prevent the long period of gestation necessary for the construction of alternative worlds. However, if Outsider Art is defined, at least in part, by the marginalization of its creators this has to be seen as merely one more socially inflicted hurdle to creativity. In this sense, overcoming the dictates of art therapy and the numbing effect of drugs might be regarded as a perfectly legitimate challenge to the true artist outsider. Yet, it is a view based on the notion that art-making is *inevitably* restorative. This is not always true. For example, it is clear from the case notes of August Klett, one of Prinzhorn's 'schizophrenic artists', that his drawings and writings not only reproduced the pain and turmoil of his hallucinations, but also intensified his suffering. For Duf, too, the act of drawing became personally destructive. In the case of British artist Nick Blinko (b. 1961), who has in the past been hospitalized, the need to make pictures is stronger than the desire for the psychic 'stability' brought by therapeutic drugs which adversely affects his ability

89. **Nick Blinko**,
Crucified, c. 1990

to work. His images are constructed of microscopically detailed elements, sometimes consisting of literally hundreds of interconnecting figures and faces, which he draws without the aid of magnifying lenses and which contain an iconography that places him in the company of the likes of Bosch, Bruegel and late Goya. These pictures produced in periods when he was not taking medication bring no respite from the psychic torment and delusions from which he suffers. In order to make art, Blinko risks total psychological exposure.

Raymond Morris (b. 1951), another British artist, is emphatic about the dangers inherent in the act of painting. He refers to himself as an 'extrakter' (*sic.*), rather than an artist, because his pictures are a response to urging by spirits who reveal profound visions of a wholly animate universe; images are extracted from the forces around him. His *Strange Stage* (*c.* 1987) is a literal transcription of a cosmic event, with tangible primal forces swirling around and through the shaman-like figure at the centre. 'I realised that there are other sides,' he says, 'invisible, working in the so-called act of sitting in a chair.' Image formation is only one element in a visionary activity that consists of 'cabaret, poems, theatre and music, out of which a theology emerged, the structure of which is the view, my science.' Yet, it must be remembered that these performances are

90. **Raymond Morris,**
Strange Stage, c. 1987

essentially private mediations between the space of the artist's flat and its spirit inhabitants without even the idea of an audience. Morris's paintings are almost always articulated and conducted by a central presence that often contains the form of a helix which he describes as, 'the wondrous power and knowledge of within, the invisible things within Man. ... The helix is the signature of Soul.' The intensity of image-making specifically has proved dangerous to the artist's own well-being and he has managed to avoid painting since 1996 in an effort to avoid further injury, although his other activities are undiminished, including the production of large-scale texts and hand-made books. The syncopated vortexes constitute, he says, 'line, word, chapter, sentence'. Something of the destructive power of image-making can be understood when one realizes that every mark in these works comprises an element of language wrenched into being as though for the first time.

Special Worlds

In the context of contemporary practice, it is worth remembering that there are creators who cannot be easily reached in the worlds they inhabit, as well as individuals whose fundamental difference occurs not through some kind of breakdown or illness, but as a result of physiological conditions arising through heredity or brain damage caused by complications at birth. In the past many of these people were hospitalized or hidden away by relatives. The activities to which they were introduced in hospitals and day centres were invariably simple and mechanical, but the emergence of generally more enlightened attitudes towards people possessing special psychologies has led not only to their increased visibility as a functioning part of society, but also to the possibility of engaging in more truly creative practices. As in all other areas of life, only a very few of these people are artists, but in recent years it has been possible for a number of impressive creators to come to light.

Some of the most vibrant and joyous work produced since the mid-1980s has come from the hands of people with Downs Syndrome. For example, the Dutch artist Appie Prinssen's (b. 1956) renderings of the single human figure are almost iconic in their simplicity of form and use of colour, but each possesses real physiognomic character. Each drawing assumes an intensity of vision that permits no other reference outside the contemplation of the world of the picture surface. Similarly, the Dutch artist Wilco Kreisel's (b. 1964) images of landscape, such as the antediluvian *Five Trees* (1996), seem to combine a visual acuity that penetrates to the very essence of things with an unguarded exuberance. This

91

92

93

91. (preceding pages)
Raymond Morris, spread from the Scrap Book, c. 1988

124

92. **Appie Prinssen,**
Weet Niet, 1993

93. **Wilco Kreisel,**
Five Trees, 1996

LAURA'S HOTH WATER BOTTLE

94. (opposite above)
Laura Craig McNellis, *Untitled (Hot-Water Bottle)*, c. 1982

95. (opposite below)
Evert Panis, *Autos*, n.d.

96. (below) **Herbert Liesenberg**, *Untitled*, c. 1985.

The works by Panis and Liesenberg display solutions to complex representational problems which retain the absolute two-dimensional properties of their medium and have parallels in much child art such as the piece from Dubuffet's collection (plate 23). In the case of Liesenberg, figurative elements are presented in frontal or profile views and arranged in frieze-like strata. Panis uses an aerial view which nevertheless privileges important aspects of the sides of his cars through a process of pronounced flattening.

fullness of perception is merged unequivocally with representations of the sensual body in the ceramic figures of Wim van de Sluis. The clay medium affords the artist the opportunity to invest each sculptural object with a self-contained and vigorous life force which often threatens to overpower the viewer.

Other self-taught, psychologically challenged artists worthy of mention include the Americans Laura Craig McNellis (b. 1957) and Dwight Mackintosh (1906–99), and the German Herbert Liesenberg. Laura Craig McNellis is unable to read and write and painting is her primary means of self-expression outside her immediate family circle. Her subject matter tends to be commonplace objects such as kitchenware, hot-water bottles, clouds and the sun which assume a talismanic function. She paints late at night, often after the rest of the household is sleeping, using bold, rapid movements of the brush. Once the image is complete, she draws large letters across the bottom margin that problematize access to the world of the representation even as they seem to offer a verbal key. Each finished work is carefully folded and put away in a drawer. Such ritualistic practices are common in much Outsider Art, bearing witness to the operations of a hermetically closed reality inhabited and controlled by the artist.

94

Dwight Mackintosh and Herbert Liesenberg both lived with their mothers before being admitted to institutions for the mentally retarded. Liesenberg was later engaged in a workshop for the handicapped as a kitchen assistant and porter, but his talent as a draughtsman was not recognized or encouraged until the 1980s when he joined the *Schlumper* ('bunglers') artists' group. Characteristically, his drawings consist of vehicles and figures articulated by large architectural elements whose façades are formed from a mixture of traditional German exterior decoration and purely abstract geometrical pattern. In most cases the composition is layered, giving the effect of periodization, with the lower strata becoming increasingly compacted. Though pictorial depth is avoided through his reliance on frontal elevations and profile views, interestingly Liesenberg does not succumb to the same urge to fill the entire sheet of paper that we have seen in Monsiel,

96

97. Dwight Mackintosh,
Untitled, 1988

Wölfli and others. Rather, every element remains discreet and self-contained within the two-dimensional bustle. Mackintosh began to draw regularly only after his release from hospital in 1978, having spent fifty-six years in institutions. Though chronically alienated and withdrawn, he expressed his visions through the images that he made obsessively, sometimes even falling asleep over a drawing, only to pick up again, on waking, where he left off. Male figures, often with large, erect penises, were his most frequent subject, although animals and modes of transport are also common. His images are characteristically accompanied by a mass of unintelligible handwriting that performs the same function as McNellis's large, upper-case letter-forms. Mackintosh's drawings do not so much present pictures of his world as represent the process of a world unfolding in the act of mark-making. In this respect it is significant that, despite the absolute concentration that he gave to each piece, Mackintosh lost interest in his drawings entirely once they were completed.

We are given access to another sophisticated world in the drawings of the Dutch artist Jimmy Roy Wenzel whose large, richly coloured drawings are realized with a bold sureness that affords them great expressive power. As a result of brain damage suffered shortly after he was born, Wenzel is withdrawn and able to communicate verbally only with his family and those close to him, yet in his drawings – at the centre of which are dominant, eroticized female figures and Wenzel himself – he can relate his experiences of a world replete with magical imagery. As the writer and curator Ans van Berkum says, 'At a certain moment Wenzel must have found out that for him the essence of feminine attraction lies in feet and legs, shod in black boots. Since then, any girl that inspires him emerges in his drawings, standing with towering black legs and showing a tiny strap of bare flesh between boots and skirt, or sensuously reclining with naked feet, showing rows of red-nailed toes. He calls them by their name: this is Inge, Nienke, or Annemarie. But Jimmy Roy never comments any further. His mental handicap conclusively protects his privacy, leaving the images to speak for themselves.' These are women seen on real and imagined train journeys – when he is not travelling he preserves his memories by looking through a hand-made frame resembling a train window.

97

98, 99

The Culture Question

Dubuffet's original conception of the Art Brut creator was someone 'unscathed by artistic culture' whose expressive means and content derived *entirely* from his or her own 'impulses', as opposed to the conventions of 'cultural' art. Many writers have since pointed out that the ideal of which Dubuffet spoke has progressively disappeared since the Second World War. Indeed, if one includes the necessity of being resistant to all cultural imperatives – popular and minority, as well as dominant – in this definition of an 'art without precedent', this mythical creator never existed in the first place. The post-war increase in general literacy and the inescapable visual domination of advertising and the mass media are important factors in the impossibility of remaining impervious to the dictates of culture, but there is also clear evidence that popular and mass imagery influenced artist outsiders even from the outset. Similarly, in the case of artists who are schizophrenic, the means by which the thoughts are broadcast or intercepted are conceived of as actual machines that usually presuppose knowledge and awareness of particular discoveries and inventions, as in the machines of Robert Gie or Jacob Mohr's obsession with radio waves.

98. (opposite) **Jimmy Roy Wenzel**, *Untitled*, 1990s

99. (above) **Jimmy Roy Wenzel**, *Untitled*, 1990s

100

Wölfli, the prototypical outsider artist, was a semi-literate peasant who spent the last thirty-five years of his life incarcerated in a Swiss asylum. In such works as *The Holy Erillera. The Great Great Goddess* (1916) it is difficult to detect the operation of knowledge gained from anywhere much except the inner life of the artist. However, given his loss of freedom and severe restriction of movement, it should come as little surprise that Wölfli sought to ease his isolation by drawing inspiration from photographs, illustrations and descriptions in newspapers and magazines in order to enrich his delusional world. One of the things that makes the resulting works interesting is the incredible transformation wrought on image and text. In many instances we find pictures matter-of-factly collaged onto pages of Wölfli's writings, serving both as prompts for memory and, according to the writer Elka Spoerri, as 'a rediscovery of the world of his own which he had invented and built'. In this way, magazine illustrations and advertisements from the world outside the hospital can be employed metonymically in relation to his own themes and thereby unite his 'private life with life in public, with life in general'.

The use of popular images and photographic illustrations as sources of information is common in much contemporary

100. **Robert Gie**, *Circulation of Effluvia with Central Machine and Metric Scale, c.* 1916

Outsider Art. In the work of the Dutch artist Willem van Genk (b. 1927) a cacophony of discreet images, drawn mainly from printed sources, jostle and eventually coalesce into narrative. In paintings such as *Amsterdam-Moscow* (1967) quotations from a range of sources, transmuted by Van Genk's brush and pen, are laid out in meticulous detail. The crowded pictorial space does not so much deny volume or mass as demand that the viewer reads it as one might traverse a piece of rugged ground. He adds to the effect by his use of the written word – usually in several languages – which leads the viewer on a similarly labyrinthine journey through what is usually a politically charged landscape. Van Genk's work embodies a mixture of desire for travel and the memory of travel, as well as active resistance against doctrinaire activity. Indeed, the real evidence of the world evoked in his images is often to be found in the collaged letters and ephemera on the back of paintings, as in the case of a work memorializing his trip to Italy in the mid-1960s.

The inner voices that Van Genk hears alert him to external threats, from the Catholic Church and, more latterly, the ideological march of Communism (he was, for some time, himself a committed communist) to the dangers posed by the nexus of threads that he believes conspire to destroy us. His pictures

101

102

101. **Willem van Genk,**
Amsterdam-Moscow, 1967

102. **Willem van Genk**, *Rome Termini*, *c*. 1965 (reverse side)

103
104
64

103. Willem van Genk,
Trolleybus, c. 1980/90.
Van Genk's trolleybuses are actually based on cardboard kits, although the many layers of added materials, from product labels to technical-looking components, transform them into objects that are entirely his own. They take their place in his universe as the very symbols of what he perceives as the dangerous energies inherent in engineering and cables. Though impressive in themselves, the individual trolleybuses pale before the large urban installation in his living room which consists of wires, masts, product packaging and transformed toys. The whole resembles the chaotic city spaces of his later paintings, including the characteristic dense nexus of threads fashioned from wire cake stands, refrigerator grids and lengths of electric cabling.

embody his battle against this fear, especially in the obsessive attention to line and interest in modes of transport that are activated only by lines – trains and trolleybuses. The tangle of wires infects every element in drawings such as *Arnhem Bus Station* (1996), but the threads are even tangible in the slipstream of the aircraft in *Arthur Hailey Airport 2* (*c.* 1965). The world conspiracy is orchestrated, he believes, by hairdressers who assume a role in his terror which was originally initiated by the Gestapo's visit to his family home during the German occupation of the Netherlands in the Second World War. His sense of powerlessness can be briefly overcome by donning raincoats which afford him the protection he needs in the street. That this is an essentially magical sublimation of exterior power is attested to by the fact that the energy contained in each coat is usually spent after a single outing.

If Van Genk's appropriation of cultural imagery feeds an intellectual desire to describe the hidden reality that animates the world of appearance, it has a much less sinister function in other outsiders such as Hauser, whose period of creative work coincides with his time as a patient in Gugging, and Eddie Arning (1898–1993), a resident of the Austin State Hospital, Texas, for nearly four decades. Much of the content of Hauser's output is manifestly sexual, with the overt sexuality of his female subjects underscored by the sheer physicality of his mark-making. Often Hauser took relatively banal magazine pictures as his starting-point (a very common practice among artist outsiders, from Corbaz to

McKesson), though they are virtually unrecognizable in the end-products of his attempts to make real his sexual fantasy. However, in certain cases, such as *Slender Woman and Hare* (1971), Hauser used a collage technique to transplant the photographic image from the world outside the hospital into his own world and thereby his control.

The American Eddie Arning only began drawing in 1964 after his symptoms of mental illness had disappeared. His subjects were the stuff of ordinary human experience – people working, eating and engaged in leisure activities – executed in a simple, decorative style which offers quiet serenity against Hauser's expressive power. His source material was almost invariably banal or crassly commercial magazine illustrations and advertisements that are often clearly identifiable in his work. Despite this, they are invariably transformed in accordance with Arning's highly individualized personal vision which had developed during decades of isolation from the world outside the hospital. Despite the fact that comparisons have been drawn between Arning's 'appropriation' of the images of mass culture and that of American Pop artists, the two have little in common besides the simple fact of appropriation. Arning's images contain none of the ironic wit inherent in Pop Art. Rather, his sources represent symbols of a reality to be borrowed and honestly reconstructed in the artist's own naïvely realized world.

It is a truism to assert that all outsiders have connections with culture. It is also wrong to conclude therefore that there can be no Outsider Art. It is not knowledge of, or even engagement with,

a given dominant culture that destroys the outsider illusion, but functional acceptance into that culture. For Hauser, Arning and Van Genk the visual products of western mass culture served not as intellectual conduits into society, but as confirmatory statements of the reality of their own constructed worlds. This is not to be confused with the mechanism through which the work itself is appropriated by the institutions of dominant culture. Such acceptance cannot occur without a recontextualization of the work. Like all objects of material culture, Outsider Art is open to reinterpretation and new usage in its changed environment. The extent of this increases the less is known about the conditions of its creation. In the first part of the twentieth century tribal art was commonly defined in the West in terms very close to those now used for Outsider Art, based largely on a contemporary reading which foregrounded (mis)understanding of the essential anonymity of its producers and the historical amnesia inherent in its objects. However, though it must always be borne in mind and addressed critically wherever possible, the decontextualization/ recontextualization argument is unproductive if its purpose is merely to deny the legitimacy of looking at and displaying the art of other cultures, or cultural outsiders. It is doubly invidious if it is employed to justify attempts to withhold new discoveries or to destroy work to 'save' it from the risk of cultural contamination (as has been suggested in several instances). Such arguments are based (consciously, or otherwise) on the belief that cultures are essentially static and vulnerable to destruction, rather than change, resulting from contact with others. Sometimes cultural interaction is a catalyst for dramatic change and one of the residues of this is, almost unavoidably, the emergence of nostalgia for what has been and the museumification of its surviving fragments. The belief in the possibility of preservation, aspic-like, of cultures so long as they are protected from cultural contamination is fallacious since the urge to preserve is in itself evidence of cultural interaction and exchange. Where artist outsiders are institutionalized or separated through physiological difference dogmatic pronouncements concerning the relative 'purity' of one's singular vision are relatively unproblematical, but in the cases of self-taught creators operating within defined bands of social freedom the question of one's 'outsider' status becomes more focused and one's acts more intensely subject to fluctuating definitions and de-definitions.

105. (opposite) **Eddie Arning**, *'The Not Hot Hot Dog'*, 19–26 July 1968. Most of Arning's drawings derive directly from print sources in newspapers and magazines, often reproducing textual elements as well as image. In this case the source was an advertisement for Hormel wieners which featured a colour photograph of a boy biting into a hot dog. In his rendering of this image of simple enjoyment Arning seizes upon the prominent ear in the original (a constant motif in later drawings) as well as the curve of the boy's forehead and nose, but characteristically schematizes the figure, revealing elements hidden or obscured in the photograph, such as the boy's mouth, left hand and eye.

Chapter 4: Self-Taught Visionaries

Outsider Art is not only produced by individuals whose psycho-
logical state has led them to be described as outside the norms set
by the dominant culture, but also others who move freely in
society, or whose movements are restricted because they have
committed crimes. In cases such as those of Henry J. Darger or
Edmund Monsiel it is possible to conceive that it is only by chance
that they were not institutionalized, but we have also seen already
how a person might have a perfectly uneventful public career,
whilst simultaneously constructing fantastic, obsessive private
worlds, as in the biographies of Morton Bartlett and Achilles
Rizzoli. Many others, especially within blue-collar and impover-
ished social strata, begin to make art only after they retire or
become ill, as time previously filled with work is replaced by a
yawning leisured space. These creators are not the amateur
painters or naïve artists who take up art as a hobby, or strive and
fail to attain technical mastery of their means (only to discover
something more interesting along the way), but people, like the
Americans Bill Traylor (1854–1947) and Mose Tolliver, who give
themselves entirely to the creative urge, irrespective of any likely
audience for their production. Dubuffet himself was keen to
separate these different world-views: 'I must stress that this
Art Brut to which I am alluding is not to be confused with that
form of activity which has become so fashionable in recent years in
cultural circles, and which is known as "naive art" or the art of
Sunday painters. These individuals are people who are filled with
respect for cultural art, and their work is strongly influenced by its
traditions. They desire to be part of cultural art, and borrow from
it their methods, imitating it to the best of their ability. (They do
so badly, of course, because of their inexperience, a fact which
results in their efforts being of more interest than the originals
which inspire them.)' Thus, the naïve art of such figures as Henri
Rousseau, the painters of the 'Sacred Heart' group in France such
as Séraphine Louis and Louis Vivin, and American 'primitives',
for instance, Morris Hirshfield and Grandma Moses, though
interesting in itself, belongs to a different history

Art in Prisons

Given the need to kill time or to keep one's mind active, it is not surprising that prisoners have produced art and craft objects for as long as humans have held each other in captivity. Yet, the loss of personal liberty does not necessarily create the conditions for the production of Outsider Art. Much of the confusion springs from the theories of such men as Cesare Lombroso, holder of the Chair of Criminal Anthropology in Turin, Italy, and himself a pioneering collector of the visual production of prisoners, and accounts by the likes of Prinzhorn, whose *Bildnerei der Gefangenen* (*Artistry of Convicts*) was published in 1926. In both cases, prisoners are treated in pathological terms; that is, not only as individuals who have committed criminal acts, but also as if they are mentally unbalanced, thereby allowing direct parallels to be drawn between the psychology of criminals and insanity.

106. **Karen Brown**,
The Portrait of Romance, n.d.

In general, it would appear that the same conditions of poor education, impoverishment and social inequality, which constitute the background to much outsider production among those who have never been jailed, govern the lives of the most interesting producers inside. Often, though, the censorship exercised by the prison authorities and prisoners themselves adversely affects the possibility of their giving full range to their desire for expression. Although interesting artists such as the Americans Karen Brown (d. 1995), Ray Matterson and John Harvey, and the Briton Billy Morey have emerged from prison backgrounds, individuals often begin to draw for the first time since childhood while incarcerated, so very often their most powerful and arresting work is produced after they are released.

107. (above) **John Harvey**, *Jezreel*, n.d. The juxtaposition of simple, bright forms with text in Harvey's strident biblical subjects is reminiscent of much contemporary American folk art by preachers such as Sister Gertrude Morgan (1900–80), Benjamin F. Perkins (1904–93) and Howard Finster, although his emphasis on the sexuality of the figures is more unusual.

106
107

Mediumistic Art

The most intriguing cases of cultured people producing art that is nonetheless consistent with definitions of Art Brut are mediums and spiritualists, from the great French man of letters Victor Hugo (1802–85) and the dramatist Victorien Sardou (1831–1908)

108

in the nineteenth century to figures such as Marie-Jeanne Gil (b. 1942) today. The factor that unites all mediumistic artists is the practice of automatism – abandoning all claims on the sense of selfhood, they become conduits through which the spirit world makes contact with the mundane sphere. In the mediumistic practices of speaking in tongues, and automatic writing and drawing the Surrealists discovered ways of relinquishing the ego that they sought in their own work. Surrealism was defined by Breton in its first manifesto in 1924 as, 'Pure psychic automatism by which it is undertaken to express, verbally or in writing, the real functioning of thought.' Though he took his cue from spiritualism, for Breton automatism was a function of the unconscious rather than the metaphysical; in the Surrealist world-view mediumistic practice was equated with temporary access to states of delirium associated with madness. Breton attacked spiritualism for what he considered to be the 'entirely passive' and 'mechanical' ways in which it processed messages. Surrealist automatism, he argued, was rather the product of a dialogue between the conscious and unconscious self: 'Contrary to what spiritualism proposes to do – dissociate the personality of the medium – Surrealism sets out to do nothing less than unify that personality.' In either case, though, images emerge through a process of more or less controlled disengagement from conscious mechanisms, from the automatic drawings of André Masson and the later Surrealist-influenced drip paintings and painterly abstractions of Jackson Pollock (1912–56), to mediumistic drawings by Laure Pigeon and Raphaël Lonné.

109

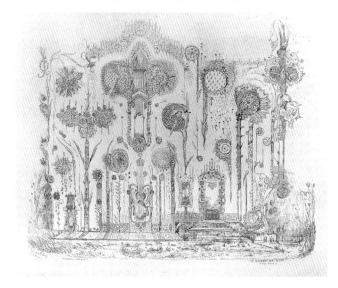

108. (right) **Victorien Sardou**,
Mozart's House (lower town),
1857–58

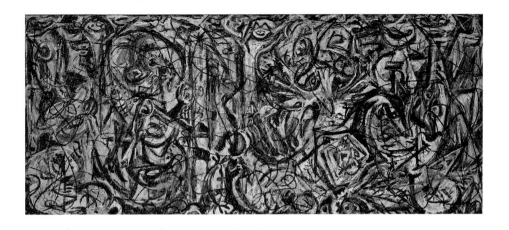

109. (above) **Jackson Pollock,**
There were Seven in Eight, 1945

For Surrealism, one of the key mediumistic figures was Hélène Smith (Elise-Catherine Müller) (1861–1932) whose normally conventional personality underwent dramatic changes during periods of trance. Through her powerful male spirit guide Smith elaborated in word and image a number of complete alternative worlds, including the life of the planet Mars. During séances she travelled to Mars and even spoke the language of its people and wrote in Martian script, thereby creating a hermetic world truly accessible only to her. Though her visual representations of Mars are transcriptions of her visions, Smith claimed that they were, in a significant way, automatic: 'The pencil glided so quickly that I did not have time to discover what contours it was making. I can assert without any exaggeration that it was not my hand alone that made the drawing, but that truly an invisible force guided the pencil in spite of me.'

110

110. (right) **Hélène Smith,**
Ultramartian Landscape, 1900

In the first part of the twentieth century spiritualism was often the vehicle through which oppressed people and those excluded in some way from the operations of the cultural machine could transcend their circumstance. For example, Augustin Lesage worked as a coal miner in the French region of Pas-de-Calais. His life, according to Michel Thévoz, was marked by 'blind obedience' to both a social system that left him poorly educated and exposed to 'exhaustion, misery, illness and downfall' and the artistic outpourings of his spiritualist activities. At the age of thirty-five Lesage was first told that he would paint pictures by a voice he heard while working at the coal face. Some months later, after having been initiated into spiritualism by some fellow miners, his spirit guides urged him to draw and paint. His first painting, made between 1912 and 1913, was a colossal piece three metres square which he painted with the precision of a miniaturist. He worked progressively over the surface of the canvas, without 111

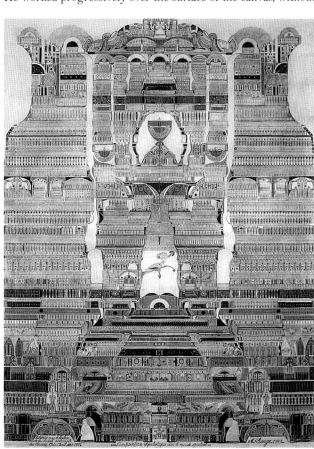

111. **Augustin Lesage,**
Symbolic Composition on the
Spiritual World, 1925

a premeditated compositional design, until the whole area was filled, describing his method in the following way: 'Never before painting a canvas, have I any idea what it would be like, never have I had any overall vision of a picture at any point in the course of its execution. A painting is built up detail by detail and nothing of it enters my head beforehand. My guides have told me: "Do not try and find out what you are doing". And I abandon myself to the directing hand.' This method of working is characteristic of almost all work produced in trance-like states, and is a particular feature of the work of others such as Lonné, Pigeon, the English spiritualist Madge Gill, and the American mediumistic artist Minnie Evans (1892–1987). Lesage himself described the state in which he painted in transcendental terms; as a liberation from his surroundings: 'When I work I feel that I am in an extraordinary atmosphere. If I am alone, as I love to be, I fall into a kind of ecstasy. It's as if everything around me were vibrating. I hear bells, a harmonious pealing, sometimes far away, sometimes nearby; it lasts all the time I am painting. But this delightful peal of bells only happens if there is silence, it stops as soon as another noise is heard.'

Raphaël Lonné, a country postman in south-west France, came to spiritualism in the late 1940s. His parents were poor farm labourers and he left school at the age of twelve. He was surprised

112. **Raphaël Lonné**,
Untitled, October 1963

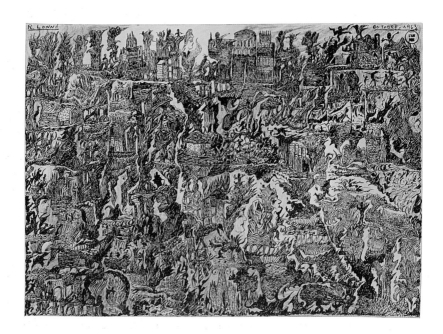

to discover that the spirit message came to him not in letter form, but in images that appeared in tiny vegetal and figurative motifs which grew to form a characteristic opulent compositional mass. The otherwise impenetrable density of his drawings is punctuated by an odd-shaped area where the sheet is left blank, giving the effect of tears or holes in the representational space – a characteristic shared to varying degrees with the work of Lesage, Pigeon and, sometimes, Gill. At first, Lonné's artistic activity was dictated entirely by spiritualism – for example, he stopped drawing in the 1950s after moving house because his spirit guide abandoned him. He began again briefly in 1960 and once more in 1963. Initially Lonné would not even sell his work because he maintained that it was the property of his spirit guide, but subsequently he relented and, unlike Lesage, in later life he rejected spiritualism and assumed an attitude to image-making that was more akin to Surrealist automatism.

112

As a woman and someone whose life was marked by trauma and personal tragedy, spiritualism afforded Madge Gill a structure that promised inclusion, as well as support for her intense emotional pain. Born illegitimate in South London, she was placed in a children's home before being sent to Canada as a farm servant. She returned to London at the age of nineteen, married and had

113. **Madge Gill**,
The Crucifix of the Soul, n.d.
(detail)

three sons. The trauma of losing one son in the influenza epidemic of 1918 was compounded a year later when she gave birth to a still-born girl, almost dying herself and losing an eye. Gill had long been in contact with spiritualist circles, and, as a direct result of trying to contact her dead children on the other side, a succession of creative activities began, culminating in the discovery of drawing in 1920. Gill worked prolifically, usually at night in a poor light, producing a vast *oeuvre* of drawings, ranging from hundreds of postcards to large pieces on calico which she worked on incrementally, the image literally growing as she unrolled the great lengths of fabric. She argued that her drawings were not produced with a 'spirit' standing beside her, but at the same time that she 'felt impelled to execute drawings' and was 'definitely guided by an unseen force' which she referred to as 'Myrninerest'. Her images almost invariably consist of chaotic arabesques that 113 seem to give a sense simultaneously of architectural interiors, robes and flowing hair. The design is usually punctuated by female faces, and sometimes full-length figures, that emerge out of 114 the dynamic space. Often, though, her process of mark-making prohibited the formation of figurative elements resulting in arabesques replete with a pulsating energy.

Marie-Jeanne Gil is a contemporary mediumistic artist whose life has been marked by other-worldly epiphanies since the age of seven when a vision of the Holy Virgin signalled her recovery from polio. She married and raised two children, but at around the age of forty left her husband to take up the calling of medium and healer. She first experienced visions proclaiming the existence of 'the Builders of the Universe' on 13 November 1993 in the form of a 'bust of a Being of Light'. She began taking photographs of natural phenomena in which she sees celestial presences and on 2 February 1994 her spirit guides dictated that they would reveal themselves and their message of transmitting the 'life force' and reviving faith through her in drawings. Like many mediums she works during 115 the night when concentration is easier, and produced her first series using her left hand, although she is naturally right-handed, suggesting a further renunciation of conscious control.

With many other artists, who might be loosely termed mediumistic, we encounter a more personal visionary preoccupation, as in the works of Jamaican-born Pearl Alcock (b. 1934), the 116 African-American artist Minnie Evans, and Europeans such as Laure Pigeon and Anna Zemánková (1908–86). All began to make art late in life and claimed inspiration from unseen forces working through them in times of quiet solitude. Zemánková, for example,

114. (opposite)
Madge Gill, *Untitled*, c. 1940

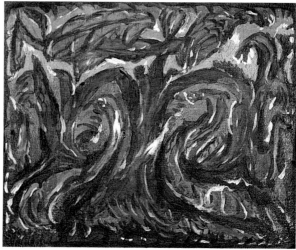

115. (top) **Marie-Jeanne Gil**,
Cosmic Roses, from the second
series, drawn with the right hand,
1995

116. (right) **Pearl Alcock**,
The Magic Tree, 1986

lived in Prague in the Czech Republic and began to draw at the age of fifty-two after suffering a period of severe depression in her forties. Her work was produced in a 'state of exaltation' at the instigation of her 'creator spirits', usually around dawn, when she felt most in touch with the magnetic forces that normally elude representation. Characteristically, she denied the existence of any premeditated plan, whilst insisting on the sureness of her vision: 'Early in the morning I am freed from all cares. There is no need for second thoughts or an eraser, the drawing works itself out delightfully. Everything goes on its own.' The compositional movements of Zemánková's pictures reflect her interest in music which she saw as revealing the community of beings and things in the dynamism of the universe.

The sense of an organic cosmos, replete with a life force that is in a constant state of formation, is also revealed in the visionary work of Minnie Evans. Born in the United States in the southern

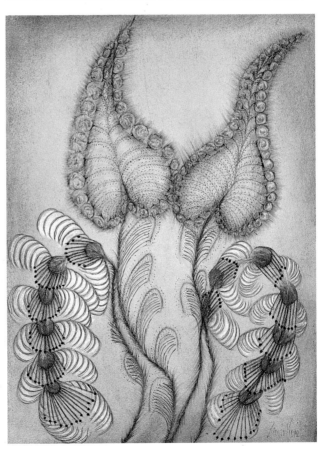

117

117. **Anna Zemánková**,
Untitled, n.d.

state of North Carolina only a generation after the abolition of slavery, she was raised largely by her grandmother, and her childhood was marked by poverty. She left school at the age of ten in order to work to help support her family and was later taken into domestic service. From 1935 she began to draw and paint, her works emerging from dreams and visions that she had experienced since childhood. Once again, we encounter claims that the images are the result of a spiritual hand guiding that of the artist and through her revealing God's message and the wonders of a paradisal domain. It is interesting to note, however, that even such 'visionary' works contain specific signs of the oppressive social context in which she laboured. For example, in a world in which for blacks, as well as whites, goodness and beauty were posited as white it should come as no surprise that despite Evans's repeated depictions of divine presences, nowhere do we find a black face.

1, 118

Laure Pigeon began to draw, without thinking of an audience for her works, after the break-up of her marriage. Though initially

118. Minnie Evans,
Untitled (Landscape – Many Faces), 1959–61

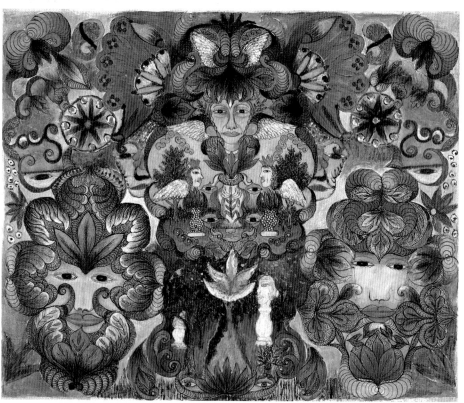

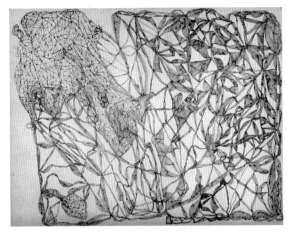

119. (above left) **Laure Pigeon**,
Drawing, November 10, 1961

120. (above right) **Laure Pigeon**,
Drawing, August 2, 1935

her automatic images were rambling and chaotic, over time they 120
came to include figurative elements and often took the form of 119
obsessive elaborations on words and the names of individuals. The
tendency to elaborate obsessively on simple forms or to repeat
mechanical actions in increasingly elaborate and often chaotic
ways is a characteristic of much outsider production. It is particu-
larly clear in the case of various kinds of automatic writing, from
the letters Emma Hauck wrote to her husband from a mental 38
asylum, to Morris's primal linguistics and Pigeon's elaborated 91
monograms. Often such works are reminiscent of embroidery and
it is significant that such women as Gill and Zemánková also
expressed themselves using these means. The French artist Marie- 121
Rose Lortet (b. 1945) uses knitting exclusively as her medium of
communication, conjuring physiognomies and metaphorical jour-
neys out of scraps of discarded yarn. In other cases, embroidery
assumes the same function as drawing and writing in elaborating a
delusional world, as in the exquisite hand-sewn jacket by Agnes 122
Richter (1873–?) in the Prinzhorn Collection, or collapsing in on
itself in a state of near autism, as in the patient known only as Miss 123
G. This is also true of the French spiritualist Jeanne Tripier
(1869–1939), who was committed to a mental hospital five years
prior to her death. Diagnosed as suffering from 'Chronic hallucina-
tory psychosis, psychic excitement, logorrhea', she translated
psychic communications into mediumistic writings and drawings.
The spontaneous, apparently abstract forms in her automatic wash 124
drawings were transformed in embroidery and crochet work made
in the hospital into chaotic, formless complexes of threads that
betray the exacting technical requirements of their construction.

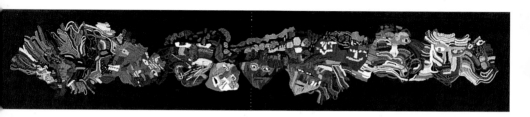

121. **Marie-Rose Lortet**, *Tunnel of Love*, 1992

122. **Agnes Richter**, hand-sewn jacket
embroidered with autobiographical and
other texts, pre-1919

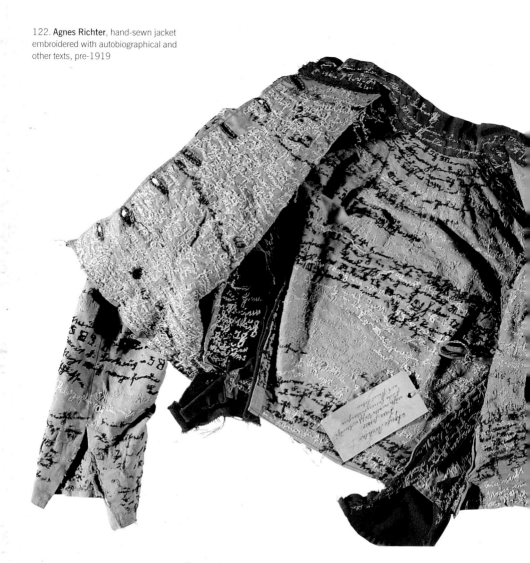

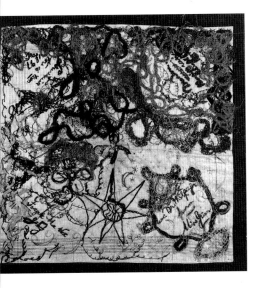

123. (above) **Miss G.**, *Untitled*, 1897

124. (right) **Jeanne Tripier**,
Large Rectangular Embroidery,
1935–39

Materials

Lortet's use of knitting and Tripier's needlework signal another characteristic factor of Outsider Art, namely a tendency to favour 'non-artistic' materials, or to mix media according to ready availability and expressive need, rather than because of any theoretical position the artists might hold. In the case of hospital art before the advent of art-therapy units, most patients were forced to improvise in the art materials they used. Thus, sculpture was often made using chewed bread and in prisons, even today, picture-making using boot polish on linen sheets or embroidery using yarn from unpicked clothing are commonplace modes of artistic production.

Early drawings by hospitalized artists such as Corbaz, Ramírez and much of Müller's graphic production were made on sheets of paper consisting of disparate scraps that were salvaged and sewn or pasted together. Yet, although for these artists this way of working was born out of absolute necessity, the practice of developing an image by bringing together separate small elements is common among practitioners working outside the hospital environment. Good examples include the Dutch artists Van Genk and Henk Veenvliet (b. 1918) whose pictures tend to consist of small, connected panels. In Veenvliet's work individual elements remain distinct, but fit together like pieces from

125

125. **Henk Veenvliet**, *Still-Life in Nature: The North Pole*, 1987

enormous jigsaw puzzles. Interestingly, where artists, for example, Lesage or Wölfli, do utilize large sheets of paper or cloth very often their working method is such that the image still grows from one place and fills the sheet incrementally. Ramírez and Gill kept their large pieces rolled up as they worked, so only a small part of the unfolding image was visible at any one time.

The issue that is perhaps most often remarked upon in relation to outsiders' attitude to their materials is their lack of preciousness. The purpose of the medium is always to convey meaning and never to signal its own value in material terms. Thus, the Polish artist Adam Nidzgorski (b. 1933) not only habitually uses newspaper as his ground, but also brings the printed words and

126. **Adam Nidzgorski**,
Untitled, 1978

images on the sheets (as well as the spaces formed around them) into play with his own drawn marks. Self-taught painters such as the Americans Mary T. Smith and Sam Doyle (1905–86) or the Jamaican Leonard Daley (b. *c.* 1930) frequently utilized whatever materials were at hand on which to make their statement to the world, including wooden palings and iron roofing sheets that were often still performing their original function. In many instances, found elements are stuck onto paintings – the French artist Alain Lacoste (b. 1935), for example, utilizes collaged elements of discarded clothing, torn and cut, and then worked into with paint, as well as papier mâché to form any element that might be readily available. This method perhaps reaches its extreme point in the constructions of such artists as Simone Le Carré-Galimard (1912–96) and the full-scale environments consisting almost entirely of materials 'salvaged' from junk yards or garbage by self-taught obsessives, for instance, Tressa 'Grandma' Prisbrey (1896–1988) or Finster. Le Carré-Galimard's work transforms the detritus of the modern, industrial world in ways that resonate with similar practices in parts of Africa, India, New Guinea and other developing countries and possesses something of the magical function that often informs that production (also a characteristic of the work of Alfonso Ossorio (1916–90), one-time custodian of Dubuffet's Collection de l'Art Brut). As Laurent Danchin has said, 'She filled her house with hundreds of puppets, masks and assemblages, creating a society of silent friends every one of which, she said, "had a soul".'

This aspect of Outsider Art has perhaps endeared it to twentieth-century mainstream western visual artists more than any other. Along with other non-western and 'low art' forms, it appeared to provide a confirmation of the expressive potential of employing inartistic media and a validation for such practices in movements from Cubism to Dada, Surrealism and beyond. The collages and constructions of the German Dadaist artist Kurt Schwitters (1887–1948) should be viewed in precisely this way. By employing junk and ephemera, such as discarded packaging and train tickets, he transformed the commonplace merely by paying it rapt attention. Similarly, the succession of so-called *Merzbauten* that he constructed in his home with increasing obsessiveness developed over long periods of time without pre-planning, evolving into new forms and containing and often concealing commonplace objects of desire. Surrealist objects and exhibition environments are also unthinkable without the precedent of art by the insane, along with the experience of fun fairs and other

127. (opposite)
Simone Le Carré-Galimard,
Orgiaques Foraines, n.d.

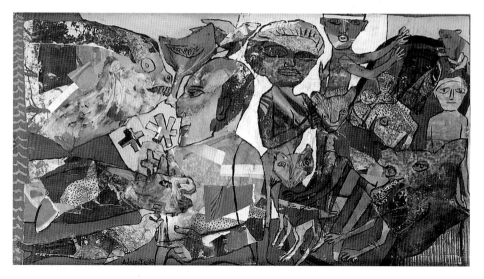

128. (above) **Alain Lacoste**,
Serout ils sauvé, 1982

129. (below) **Kurt Schwitters**,
Merz Column in the artist's apartment
in Hanover, 1923. Destroyed.

130. (right) **Alfonso Ossorio**,
Thee and Thy Shadow, 1961,
reworked 1966

popular spectacles. Similarly, with the Brutist collages of artists such as Dubuffet and Baj, or the constructions of Ossorio. All this notwithstanding, it is worth adding a cautionary note. Although it has become customary in contemporary visual art to present mass-produced objects in a relatively undigested way or in knowing juxtapositions in order to make ironic cultural comment, it would be a mistake to read ostensibly similar outsider pieces in the same way. There is no intentional irony or cultural critique in Wölfli's use of collaged advertisements and magazine illustrations, or Van Genk's appropriation of logos from soft drinks cans for the advertisements on the sides of his cardboard trolleybuses. 130

Cathartics without Catharsis

For many outsiders, such as the German artist Rosemarie Koczÿ (b. 1939) and Michel Nedjar (b. 1947), art holds at bay or controls forces that might otherwise spill into full-blown psychosis. Both artists' obsessive concern with the Holocaust spills into the

131. **Rosemarie Koczÿ**, *Untitled*, 1988. This is one of the hundreds of starkly poignant ink drawings by Koczÿ of people lost in the Holocaust. Every figure possesses an individual identity and, when seen together in groups, they present an almost overpowering image of human fortitude in the face of suffering.

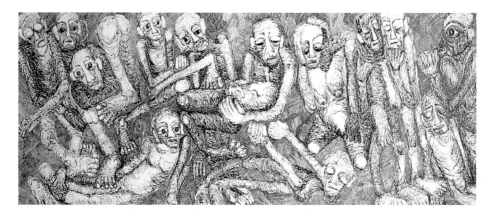

tortured forms in their work. Rosemarie Koczÿ's anguished fig- 131, 132
ures, often crushed together in large, claustrophobic friezes that
owe much to her earlier tapestries, reflect a collective memory of
inhuman suffering at the hands of the Nazis that she feels con-
stantly, as though it continues to be her lot. Often, she provides
commentary and comment on the reverse of drawings. For exam-
ple, on one she writes in English, 'I was in the camps 1942–45. I
saw every horror about humanity. I was raped at the age of 12 by
Borowski in Germany.' Yet despite the agony she feels Koczÿ still
marvels at the ability of humans to possess hope: 'Even when a
human being is reduced to the worst stage of non-existence, a tiny
ray of sunlight, a fly upon the body, a merest nothing makes it live.'

Michel Nedjar was born near Paris two years after the end of
the Second World War to a Polish mother and Algerian Jewish
father. At the age of fourteen he was apprenticed to a tailor in Les
Halles in Paris, which at that time boasted a meat market in the
morning and a flower market in the afternoon. He gave up his
prospective career to travel extensively and subsequently worked
on his grandmother's market stall in the Clignancourt flea-market
in Paris selling second-hand clothes and jewelry. In 1975 Nedjar
began making dolls from the materials that surrounded him. His 133
first dolls were playful and toylike, but their mood slowly became
darker, possessing a suggestive mystery that is clear in his 134
paintings. Roger Cardinal has suggested that parts of Nedjar's
production can be viewed as 'incoherent representations of the
Holocaust, experienced as a kind of internalised trauma, no less
harrowing for being relived within a guilty because unharmed
survivor.' His work is also informed by attempts to subsume differ-
ence and to reconcile opposites. 'One is not male, one is not female,
one is a substance', he says, and the coming into being of the art

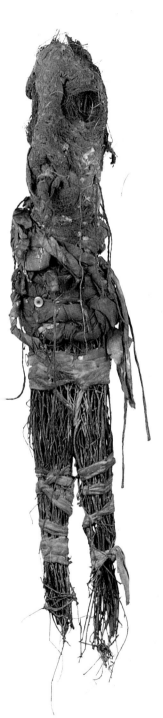

object represents a harnessing and manipulation of energies implicit in his materials: 'If I were to bury my dolls, it would be in order to dig them up again. Decaying material, the way the earth sets to work, the earth gnawing away, the mouldiness. The doll is transformed just as the body is undoubtedly transformed beneath the earth. For me there is no frontier between decay and its opposite. I need a transformation to be whole.' In one sense, art like this is extraordinary not merely because of the range of its formal invention, but also because it appears actually to *embody* the *intuitive* insight of its creator; that is, it is seen as containing and capable of communicating something of his personality. This is clear in a statement by Nedjar, in which he suggests that the creative act is essentially magical in character: 'Sometimes I bury things within my dolls. I have a woman friend whose son was stabbed to death with a knife. I made a doll with that in mind. It's only now that I realise it. Things work on me from outside. It was later on that I felt, inside the doll, the presence of my friend Hélène. I had transmitted her inside it.'

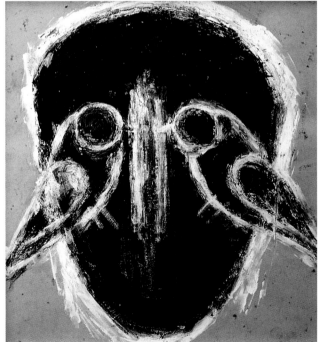

Art on the Margins

There are many apparently fully integrated individuals who, usually late in life, begin to create compulsively and without the intention of producing marketable art. These include 'classic' examples such as Scottie Wilson (Louis Freeman), as well as more recent discoveries such as Riet van Halder (b. 1930). Despite being taken up by the Surrealists in London in the 1940s Wilson remained remarkably untouched by mainstream artistic culture. This was aided, perhaps, by his near-illiteracy – he ended his schooling at the age of nine – although he insisted on the validity of his own perception of the world: 'My mind is reading all the time. I don't need papers or books. My mind is full of books.' Wilson began to draw almost by accident while living in Canada. In his works he conjures up an inner world populated by trees, birds and animals, 136, 137 and human figures that assume the guise of 'Clowns' and 'Greedies' and enact the battle between good and evil forces. Van Halder is a Dutch housewife who only began to draw and paint at the age of fifty-nine after a voice urged her to do so while she was vacuuming the house. As with Wilson, her drawings are a response to an 135 imagined world that is revealed, dreamlike, in the act of drawing and painting. The stylistic similarities of Van Halder's work compared with that of Dubuffet are all the more remarkable because of her complete ignorance of art history. On being shown some reproductions of work by Dubuffet recently, Van Halder was interested to discover how he had come to produce work similar to hers!

135. (below) **Riet van Halder**, *Untitled, c.* 1995

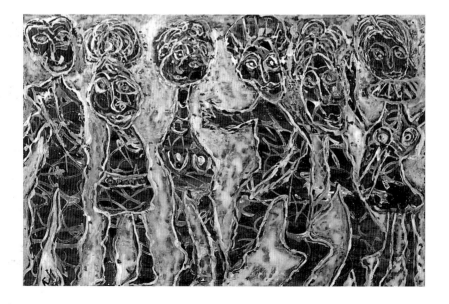

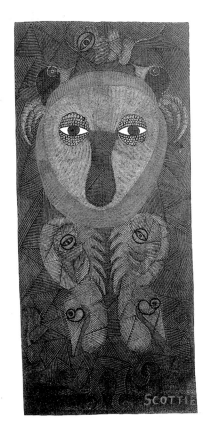

136. (right) **Scottie Wilson**,
Phantom of the Night, c. 1946

137. (below) **Scottie Wilson**,
Springtime No. 4, 1955

138. (below left)
Joseph E. Yoakum,
Mount Victoria, c. 1965

139. (below right)
Joseph E. Yoakum,
The Island of Sardinia, 1966

Joseph E. Yoakum (1888 or 1890–1972) is another self-taught artist who remained curiously untouched by the machinations of the art world, despite influencing a generation of American artists in Chicago such as Gladys Nilsson, Barbara Rossi, Jim Nutt, Ray Yoshida and Roger Brown. The details of Yoakum's life before his arrival in Chicago in the 1950s are difficult to construct accurately, but the key events are his claimed, but at present unsubstantiated, travels around the world from the age of fifteen or sixteen, and a dream he experienced in 1962 in which God told him to pick up a pen and a piece of paper and draw. His imagery consists almost exclusively of landscape 'memories' of his travels which he drew with a facility that he ascribed to a 'spiritual unfoldment'.

In the United States a new genre of largely rural, self-taught compulsive art has emerged which, though it is usually labelled as

140

138, 139

140. (below right)
Gladys Nilsson,
Stompin at the Snake Pit, 1968

141. (far below)
Mary T. Smith,
Red and Black, c. 1983

Contemporary Folk Art, is quite distinct from either the communal styles of European peasant production or American popular naïve forms exemplified in the work of John Kane or Horace Pippin. The works of African-American artists such as Mary T. Smith, Bill Traylor, Sam Doyle, Mose Tolliver, Leroy Person, Herman Bridgers (1912–90), Steve Ashby (1904–1980), Jimmy Lee Sudduth (b. 1910) and James Hampton (1909–64) possess deeply personal iconographies that nevertheless seem to communicate archetypal themes with a directness and simplicity that raises them above the communal formulæ of traditional folk art. This may have something to do with technique, for particularly in the cases of Tolliver and Sudduth there is an evident taste for purely painterly invention. Similarly, these works tend to emerge in situations where no comparable art-making activity exists.

141

142, 143

142. **Mose Tolliver**, *Family*, 1991

143. **Jimmy Lee Sudduth**,
Man with Cane, 1995

144. **Bill Traylor**, *Kitchen Scene, Yellow House*, 1939–42. In recent years Traylor has come to be regarded as one of the founding touchstones of African-American art, signalling a move for his appropriation into mainstream art histories and institutions.

Bill Traylor's productive period spanned only three years when he was in his mid-eighties, yet he produced more than 1500 drawings depicting life on Monroe Street in the black neighbourhood of Montgomery, Alabama, where he lived. He was born a slave near Benton, Alabama, and spent most of his long life working as a field hand on the same plantation. He began to draw to fill in time only after his health had forced him to give up his job. Entirely self-taught, Traylor's *oeuvre* erupted in a bold, simple style that is uncannily reminiscent of certain West African imagery, including the work of his near-contemporaries in the Republic of Congo (formerly Zaire), Albert Lubaki (b. *c.* 1895) and Djilatendo.

144

145. **Sam Doyle**, *Onk Sam*, 1978–81. Though depicting the life and folklore of his community, as well as internationally famous African-Americans, Doyle developed a highly personal painterly style. As with Tolliver and Sudduth, among others, the figure is characteristically privileged against a flat or indeterminate ground.

Though difficult to trace with exactitude, there is compelling evidence of connections with African cultures that have not been broken since the arrival in the Americas of the first slaves. Sam Doyle, for example, spent his entire life in the area around St Helena, a small island off the Carolina coast, much of whose population are Gullahs (a deformation of 'Angola') who, because of their isolated location, were able to maintain many of the old traditions of Angola, including *vodun*. Doyle only began painting in his sixties, and his work included images that relate the history and folklore of his island, as well as portraits of famous African-American heroes, such as Joe Louis and Ray Charles, to the first blacks in his community to hold jobs previously reserved for whites.

145

The sense of a living African heritage is also strong in the work of Leroy Person, a cotton gin and sawmill worker from North Carolina. Forced to retire in 1970 because of a chronic work-related respiratory illness, he began carving using a pocket knife and home-made tools in order to fill the vacuum left by work. His work consists mainly of arrangements of plants and animals, covered with incised, geometric patterning and coloured with scrap paint and wax crayon, and roughly made furniture that in 146 many ways resembles the patterning of the Bambara people of the African Niger River region. Even simpler forms appear in the work of Herman Bridgers, an illiterate African-American minister, who made stylized human figures from wooden planks. 147 Hand-sawn and coloured, they were intended to function as symbolic statuary for his 'Shady Grove House of Prayer', a small functioning church and environment next to his house. Their stylized simplicity, verging on abstraction, was, he claimed, a way of avoiding idolatry.

146. (above) **Leroy Person**,
African Throne, c. 1974

147. (right) **Herman Bridgers**,
Two Churchmen, 1984

148. **James Hampton**, *Throne of the Third Heaven of the Nations' Millenium Assembly*, c. 1950–64

The writer Robert Farris Thompson has suggested that abstraction in African-American art, as in the geometric patterning of Person's carvings, is often a result of a process of creolization. Originally, he says, 'human figures were frequently abstracted or de-anthropomorphised by Africans in the Americas who may have been trying to protect their religion in the midst of a hostile environment.' Over a period of time the original impetus may be lost while the tradition continues. Similarly, in many parts of the Southern United States it is still possible to find 'bottle trees' and 'yard shows' in which gardens are decorated with hanging bottles and discarded consumer goods, such as television sets. Thompson regards these as a 'dramatic and heavily-coded continuation of Kongo beliefs and icons' translated in their American context: 'A tree with bottles protects the household through the power of medicinal waters and a yard "dressed" to protect it from negative intrusion. The bottles of glass or plastic hang from a tree close to the home, protecting it from harmful spirits. … What might look like an assemblage of junk, or meaningless clutter is actually a complex spiritual act in plural dimension.' In the urban context James Hampton's monumental *Throne of the Third Heaven of the Nations' Millenium Assembly* (*c.* 1950–64) carries forward African elements into a Christian liturgical context. Constructed over many years from found objects and old furniture, covered in gold and silver foil, it was conceived as a display for his 'all black' church in Washington, D.C., as a sign of Christ's Second Coming, but remained unseen in a garage until after his death, when it was discovered and in due course moved to the Smithsonian Institution.

148

Environments

Compulsive creation and a more literal construction of a personal world are, probably, nowhere more overwhelming than in the full-scale environments that occur all over the world, though they are most evident in France and the United States. Occasionally they exist only as plans or models, as in the case of Achilles Rizzoli and the Zairian artist Bodys Isek Kingelez (b. 1948), who worked originally as a restorer of traditional masks. Subsequently, he began constructing paper architecture that he calls 'Models of the Extreme'. Each piece is accompanied by a long descriptive text. He calls *Red Star* (1990), for example, a 'maquette-sculpture constructed with a view to contributing to the fixed assets of the

149. **Bodys Isek Kingelez**, *Red Star*, 1990

150 and 151. (opposite)
Bodhan Litnanski, *Jardin du Coquillage*, Vitry-Noureuil, France, begun 1966

152 and 153. (below)
Tressa 'Grandma' Prisbrey, *Bottle Village*, Simi Valley, California, United States, 1955–63

People's Republic of Congo. ... Bodys Isek Kingelez, situated at the centre of his reflections bequeaths to the world a new architecture on a worldwide scale with possibilities of building all too evident but not yet exploited.' Often, as in the case of the French self-taught artist Danielle Jacqui ('She Who Paints') (b. 1934), these 'environments' constitute no more than the complete abandonment of one's living space to artistic creation (a tendency that is common among artist outsiders), at times spilling out into the surrounding environment. This is especially true of the large number of so-called shell or bottle gardens which rarely lose their essentially domestic scale. Examples include Bodhan Litnanski's *Jardin du Coquillage* in Vitry-Noureuil, France, and 150, 151 Tressa 'Grandma' Prisbrey's famous *Bottle Village* constructed 152, 153 mainly between 1955 and 1963 around her home in the United States in Simi Valley, California. Prisbrey's use of bottles as an alternative building material began in response to the need for a wall around her small plot of land, but developed into a series of buildings conceived as houses for her vast collection of pencils. She quickly added new elements to her repertoire of materials discarded by others, and began collections of other commonplace items in addition to her pencils.

The most common characteristic of these environments is the sense that they have grown through a process of organic unfolding, in much the same way as the drawings of Gill or Lesage, although almost invariably over many years, with their development usually only ceasing with the death of their creators or wilful destruction by external agents. For the obscure hermit priest Adolphe-Julien Fouré (1839–1910) and the poor South African farm labourer Nukain Mabusa (d. 1981) the creative obsession spilled literally *into* the landscape. In the course of twenty-five years, Fouré and an assistant carved a population of figures from 154–56 the unyielding granite rocks on the shore at Rothéneuf in Brittany, France, representing the infamous pirates who had terrorized the area in the sixteenth century. In composing his forms, Fouré allowed himself to be dictated to by the shapes of the rock formations themselves, resulting in a chaotic mass of creatures.

154, 155 and 156.
Adolphe-Julien Fouré,
Les Rochers sculptés,
Rothéneuf, Brittany coast,
France, 1894–1910

157 and 158. **Nukain Mabusa**,
Stone Garden, Revolver Creek,
South Africa, c. 1970–80

Mabusa's artistic activities began in the 1960s when he decided to decorate the two simple huts he had built to live in. This extended initially to the triangle of land around his home that he called his garden and subsequently spilled out onto the surrounding hillside of Revolver Creek where he systematically painted 157, 158 rocks and boulders of all shapes and sizes in characteristic geometric patterns with dots and occasional stylized animal and bird motifs. Unlike Fouré's granite carvings, almost an extension of the natural forms of the coastal promontory from the start, Mabusa's painted stone garden, though still intact, is more prone to the ravages of nature and began to deteriorate after his suicide in 1981, for like all gardens it requires someone to tend it. Happily, it was recently repainted and renovated by volunteer enthusiasts. Another South African environment, Helen Martins's (1898–1976) *Owl House* in the village of Nieu Bethesda, also maintains a precarious existence. It was constructed, under Martins's directions, by three hired men – its interiors are covered with ground glass and mirrors to play with light, reflecting against each other, and with the sun or moonlight through windows. During her lifetime the rooms were also filled after dark with paraffin lamps and candles that heightened the effect of the glass. Outside she constructed her Camel Yard with a chaos of animals, birds and human figures made from concrete and glass. There was no actual vegetation, yet she regarded the yard as her garden, saying that instead of plants she grew 'beautiful stones'.

One of the earliest surviving architectural outsider environments is the *Palais Idéal* built by Ferdinand Cheval (1836–1924), 159-61 a rural postman from Hauterives in south-eastern France, between 1879 and 1912. Although on his rounds he had dreamed about building an ideal palace he did not even contemplate the possibility of such an enterprise until one day an unusually shaped stone caught his attention. Despite possessing no knowledge either of architecture or of building methods, Cheval set about collecting stones and invented a way of applying concrete over a metal skeleton in order to bring into being the living, organic forms of his imagination. He worked in his spare time, often at night, but never wavering in his belief that he was working towards a revelatory structure that would justify his toil. He recognized that many regarded his activities as in some way pathological, but since, as he said, 'this sort of alienation was neither contagious nor dangerous, they didn't see much point in fetching the doctor, and I was thus able to give myself up to my passion in perfect liberty in spite of all.'

159, 160 and 161.
Ferdinand Cheval,
Palais Idéal, Hauterives,
France, 1879–1912. The *Palais
Idéal* was a tourist attraction
during Cheval's lifetime, as can be
seen in plate 159, a photograph
taken at the turn of the century.
The two figures in the foreground
are Cheval and his wife.

Cheval's sources consisted of half-digested memories of the pavilions of the 1878 Paris World's Fair, his military service in Algeria, and illustrations from popular magazines, all of which contributed to a singular and chaotic reconstruction of the world in microcosm. As Michel Thévoz points out, Cheval's *Palais Idéal* belongs to a 'between world' at the border of dream and reality in which the architectural process is reversed: 'Whereas an ordinary building is originally designed as a dwelling place to which the architect can if desired give an imaginary extension, Cheval started out from a dream which in the end he made into a dwelling place.'

In Los Angeles in the 1920s Simon Rodia (*c.* 1879–1965), an Italian-American construction worker turned tile-setter and telephone repairer, began work on a remarkable building project on a small lot in the poor black neighbourhood of Watts in the south-central section of the city. Using materials similar to those employed by Cheval he created a number of skeletal structures in 162, 163 steel and coloured cement, inlaid with bottles, shells, ceramic fragments and other similar materials, or bearing the impressions of mundane objects such as tools, machine parts, corncobs and the like. The interconnected mass is dominated by three breath-takingly tall towers. Rodia worked on his project, which he called *Nuestro Pueblo* ('Our Town', or 'Our People'), for thirty-three years before making over the deeds to a neighbour and abruptly disappearing. Though supporters of the 'towers' eventually tracked him down he showed no interest in them, refusing to explain his motives and, more enigmatically, declaring that he had no intention of ever returning to the city to see his work, saying: 'Don't you understand? It's the end; there's nothing there.'

162 and 163. **Simon Rodia**, *Watts Tower*, Los Angeles, United States, 1921–54

The American Clarence Schmidt's (1897–1978) *Woodstock Environment* (or *House of Mirrors*) was the product of incremental extensions to a one-room wooden cabin he built in 1940 in the Catskill Mountains. Over a period of nearly three decades it developed into a seven-storey house with thirty-five rooms which penetrated into, as well as rising out of, the surrounding hillside. The house contained a huge collection of assorted junk and was crowned by a roof garden consisting of found objects. As the house spilled over into the surrounding landscape, so nature was allowed to engage creatively with Schmidt's dwelling, not least in the form of a great tree that grew out of its centre. Though he maintained that he made his work 'to help humanity – to bring some comfort and pleasure to people', Schmidt had many enemies in the area who detested his life's work, and in 1968 his creation was burnt to the ground in mysterious circumstances. Though he began another house soon afterwards, this too was destroyed by fire in 1971.

164. **Clarence Schmidt**, *Woodstock Environment* (or *House of Mirrors*), Catskill Mountains, Woodstock, New York, United States, 1948–68

Paradise Garden (1970s), the environment created by Finster 165, 166 in Pennville, Georgia, in the United States, though similar in many ways to Schmidt's project, has fared much better. Covering more than three acres of swampy land, it was conceived not as a dwelling place, but as an earthly paradise in which visionary art and architecture are intermingled with texts that ring out sermons to all who would look upon them. Although Finster had a preconceived plan for *Paradise Garden* it was, characteristically in these kinds of project, both amorphous and grandiose, allowing the demands of its actual construction to dictate the final form that it only ever approaches, but will never reach. Finster had served for forty years as a preacher in different churches in Georgia and Alabama, but only began his artistic project in 1976 after a vision led him to give up work as a bicycle repairer and preach God's message through sacred art: 'I built this park of broken pieces to try and mend a broken world of people who are travelling their last road'.

165. **Howard Finster**,
Paradise Garden, Pennville,
Georgia, United States, 1976

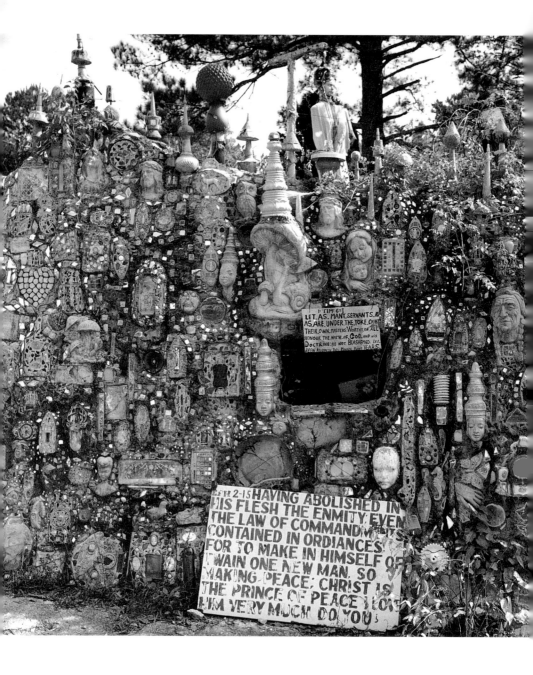

166. **Howard Finster**, inlaid wall near entrance of *Paradise Garden*,
Pennville, Georgia, United States, 1970s

Reputedly, his first symbolic act was to inlay his tools into a cement walkway as evidence of the renunciation of his past and the embrace of his calling. Everything is built out of himself, using only found materials and he makes no preparatory drawings or models. The worthlessness of the raw objects is an essential component of the spiritual transmogrification at which Finster aims: 'Most of the stuff here in the garden is junk and is not worth anything, and if it is worth anything, I damage it to where it ain't worth anything.' In recent years, as Finster's popularity has spread, an industry has grown around *Paradise Garden.* Finster's use of family members to help create paintings and sculpture bothers purists who insist that the authenticity of the work resides unequivocally in its autograph nature. Finster himself argues the reverse: 'People have been saying that I'm not doing my own paintings anymore, but that's not true. The boys get everything ready for me. They make the cut-outs, sand them down and put on the first coat of paint, according to my patterns. I've taught them exactly what to do and they do it.' His attitude is not so different to the old studio system adhered to by painters in Europe until the nineteenth century, or that of American Pop artist Andy Warhol reflecting Finster's own cultural sense of himself as artisan.

The religious theme that saturates *Paradise Garden* is also central to another American environment known as *Salvation Mountain* (begun 1985), constructed with adobe and paint in Niland County, California, by Leonard Knight (b. 1931). Entirely self-taught, Knight believes that he is little more than the agent through which God has bestowed this vision of paradise, bringing a message of divine love: 'I would say, for the most part, God did all the thinking and the planning, and God put me in this place. And I believe that He guided my paintbrush an awful lot. Because, honest, when I started, I could dig with a wheelbarrow and move sod, but that was about the it of my ability to paint.' Knight uses a lot of paint, invariably found or donated, often pouring and letting gravity do the work, as in blue streaks that form an edenic river on one side of 'mountain'. In the decade that it took for it to assume a relatively definitive form the 'mountain' has aroused fierce passions for and against it, and remains under threat from the authorities.

167

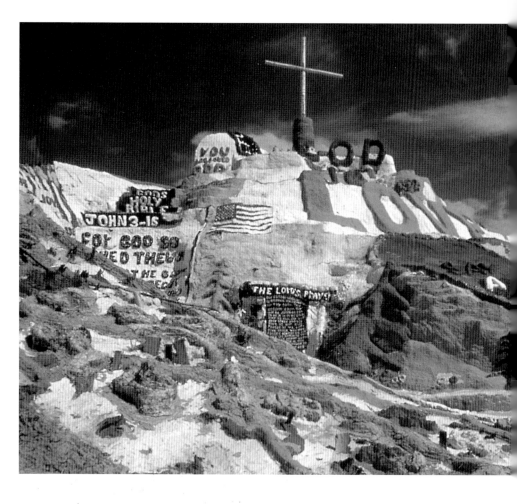

167. (above) **Leonard Knight**, *Salvation Mountain*, near Slab City, Niland County, California, United States, begun 1985

168. (right) **Eddie Owens Martin (St EOM)**, *Pasaquan*, Buena Vista, Georgia, United States, 1957–86

The varied messages consciously contained in many environments do not always correspond to accepted religions or doctrines. These range from the so-called *Jardin encyclopédique* (1952–72) of Armand Schulthess (1901–72) in the Isorno Valley in Switzerland, which purported to present systematically all world knowledge, to *Pasaquan* (1957–86), the spiritual centre in Buena Vista, Georgia, United States, of the one-person mystical cult created by Eddie Owens Martin (1908–86), the self-styled St EOM. At other times obsessional creation arises out of a simple desire to amuse oneself and, eventually, others. Examples of this include the metal whirligigs of Vollis Simpson (b. 1919) that developed in his retirement out of an interest in wind power and whose awesome scale was made possible by a knowledge of heavy machinery derived from his background as a machine repairman and (literally) house-mover. Also, the magical *Manège* (merry-go-round) constructed in the main part over a period of thirty years

169

168

170

171

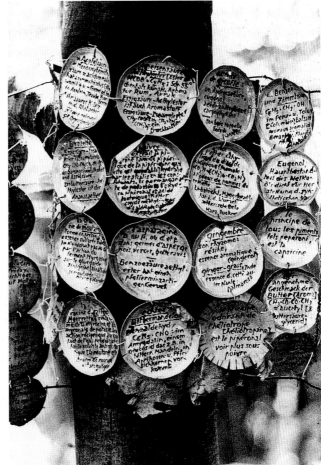

169. (right) **Armand Schulthess**, *Le Jardin encyclopédique*, Isorno Valley, Switzerland, 1952–72

170. (following pages) **Vollis Simpson**, *Whirligig Environment*, Lucama, North Carolina, United States, 1980–90

from 1955 to 1985 by Pierre Avezard (1909–92), known as Petit-Pierre, who was almost totally deaf-mute and crippled, and spent most of his life as a cowherd. The creation of environments has also provided opportunities for individuals otherwise located in cultural professions to 'undo' their conditioning to some degree. This is particularly true of creators such as CHOMO (Roger [172] Chomeaux) (b. 1907) and Alain Bourbonnais (1925–88), an artist [173, 174] and collector of what he called 'Art Extraordinary' (*Art hors-les-normes*). Although he was a professional architect, Bourbonnais attempted to adopt a stance of resistance to the cultural main-stream that is similar to, though in many ways more extreme than, that of Dubuffet. He was responsible in the early 1980s for the creation of the *Fabuloserie*, a complex of converted farm-buildings, which he described as 'a special "House" in the tranquillity of the French countryside, far from the agitation of the metropolis. It will be a kind of return-to-source for these works which so often

171. (below) **Pierre Avezard (Petit-Pierre)**, *Le Manège*, La Fabuloserie-Bourbonnais, Dicy, France, 1955–85

172. (opposite) **CHOMO (Roger Chomeaux)**, *Village de l'art préludien*, Achères-la-Forêt, Fontainebleau, France, begun 1960

come into the world at a distance from the urban scene. Having thus far been shown separately in occasional exhibitions, they will henceforth live permanently together in their "House", like some huge family. By way of this "occultation" in a special place, we hope to give concrete form to the secret wish of those who love Art Extraordinary and who sense the creative unity which underlies it, but who have thus far been denied the chance to enjoy it as a totality.' In this way, Outsider Art, having been recognized, would be segregated and 'protected' from the mainstream. The isolation of the *Fabuloserie* from other cultural centres and concentration of its objects ensures its overwhelming visual power.

Undoubtedly the largest environment in existence is Nek Chand's (b. 1924) *Rock Garden* (begun 1965) adjacent to the new 175, 176 city of Chandigarh in north-west India designed by the French architect Le Corbusier. Since its inauguration as a public space in 1976 more than twelve million people have visited the site, yet between 1958 and 1974 its existence remained a secret. This was because Chand's activities on government land were illegal. Thus, by day he worked as a Roads Inspector for the Public Works Department, and in the evening, and often through the night, he began to realize his vision of a divine kingdom that bore testament to his belief in ultimate goodness. The *Rock Garden* teems with animals and figures fashioned out of cement and inlaid with shards of pottery and glass collected from refuse sites around the city, as

173. Alain Bourbonnais among his *Turbulents*, c. 1988

well as from the villages that were demolished to make way for the construction of Chandigarh. Chand's creation was only discovered by chance when a government party happened upon it while clearing part of the forest around the city. However, the authorities, far from destroying the *Rock Garden* as the law required, realized the cultural importance of Chand's obsessive creation and so instead gave him a salary and workforce of fifty labourers so that he could concentrate full-time on his project. The collision between tradition and innovation, private vision and public space lies at the heart of the *Rock Garden*'s expressive power. As the Indian critic S. S. Bhatti points out, 'Through his Rock Garden, Nek Chand not only continues the skills and values of a long folk tradition but also extends them through new encounters, experiences, attitudes and aspirations. Thus, while his materials are by and large urban and industrial waste, Nek Chand's ideas and methods are predominantly rural in origin and character.'

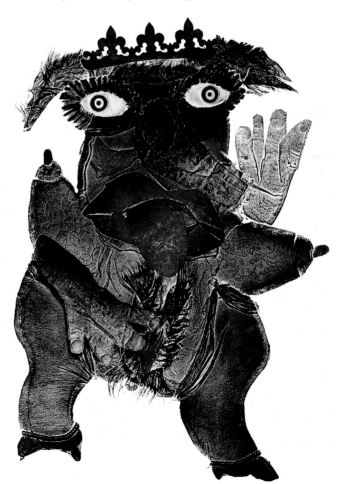

174. **Alain Bourbonnais**,
Gratte-Cul, n.d.

175 and 176. **Nek Chand**,
Massed Villagers, from the
second phase of the *Rock
Garden*, Chandigarh, India.
(Above) Detail of *Queens after
Bathing*, begun 1965

Chapter 5: Other Positions

Populations inevitably look first to themselves for cultural sustenance, but a shared sense of self-identity can be challenged by the recognition of difference in others even within small cultural units. Recognition of difference – at even the most primitive level between the 'self' and the 'object' – is controlled by our projection of 'goodness' or 'badness' onto the Other. The American writer Sander L. Gilman has argued that our common tendency to create stereotypes arises out of a basic human need to cope with 'anxieties engendered by our inability to control the world'. Encounters with Otherness result in the construction of stereotypes that operate as a means of perpetuating a sense of self-identity. However, the illusory line we draw between self and the Other is a shifting one, adjusted according to changes in our perceptions. As Gilman says, 'paradigm shifts in our mental representations of the world can and do occur. We can move from fearing to glorifying the Other. We can move from loving to hating. The most negative stereotypes always have an overtly positive counter-weight.' At the heart of this, though, lies the recognition of difference and the projection of value judgments into its identification. Historical encounters of imperialist cultures with Otherness and their aftermath offer clear examples not only of the dynamic nature of stereotypes, but also of their essentially mythic nature.

The Colonial Other
The outsiders already discussed here have emerged mainly from groups geographically inside the West, their Otherness represented by pathology, criminality, lack of education and low social class. One might also argue that at times this difference was also a function of racial or gender discrimination, although in the cases of European peasant artists or contemporary black painters and sculptors from the southern United States considerations of ethnicity are tied strongly to these other factors. When we consider the attitude of the West to its geographically distanced Others the metaphorical outside merges violently with the real.

Throughout the period of colonial expansion in the West, which began in earnest in the seventeenth century, colonial subjects were typed as Other and, through the construction of

177. (opposite) **Saou bi Boti** of Tibeita village, *Flali* mask, carved for dances in Bangofa village, Ivory Coast, Africa, 1983

a number of discourses of power and control, excluded from participation not only in determining their own destiny, but also in establishing dialogue with the subjugating power. If these unequal relationships of domination were to be maintained it was essential to render the colonial subject mute. This was achieved broadly in two ways: firstly, by developing a discourse of absolute separation between agents of the colonial power operating in the colonies themselves and the indigenous population – a structure that is brilliantly laid bare and problematized, for example, in Joseph Conrad's *Heart of Darkness* (1902); and secondly, by inscribing knowledge about the colonies in a specific scientific discourse – anthropology/ethnology – that separated it emphatically from western discourses about itself.

In cultural terms this resulted in the material culture of the colonized world being placed in the ethnographic museums that sprang up throughout Europe in the nineteenth century, rather than in art galleries or even museums of decorative arts. Here, weapons, domestic artefacts and devotional objects were treated on equal levels as cultural specimens for the purpose of study and, increasingly, as evidence of something since lost. Until the end of the nineteenth century these objects lay so far outside western aesthetic discourses as to be invisible in relation to conceptions of art. However, during this period an interest in artefacts made by extra-European peoples began to emerge out of a new Arts and Crafts aesthetic, led by the likes of Christopher Dresser and William Morris in Britain, which took its inspiration in part from pre-industrial European rural traditions – namely contemporary folk culture and that of the Middle Ages – which were perceived as more communally oriented than contemporary traditions. Precedents can be found in the Chinoiserie and Japonisme of the eighteenth and nineteenth centuries, but the interest in tribal artefacts, which developed primarily among artists around 1900, signalled the beginning of a rupture in monolithic western notions of art history and aesthetics and the opening of the possibility of cultural dialogue and interaction. During the first half of the twentieth century it remained no more than that, primarily because artists, however subversive in their intent, still laboured under essentially racist and imperialist assumptions about the identity of the colonial Other. Thus, a discourse of Primitivism developed in which the forms of non-western art and received ideas about tribal cultures – especially in Africa and Oceania – could be discerned, but which only slowly heralded a reappraisal of the ways in which they were represented by the West.

The makers of tribal objects reaching the West during the colonial period were outsiders in the very real sense that they remained anonymous and essentially invisible in western representations of their work, though they were, of course, central to the cultures to which they belonged. The artistic redesignation of tribal objects as art in a modern western sense initiated by the likes of Gauguin, Picasso and Matisse at the beginning of the twentieth century and the more rigorous questioning of western culture by the Surrealists in the 1920s and 1930s helped to bring about an interest in these artefacts for themselves. Detailed discussion of this belongs to another history, but it is important in the present context to note that the acceptance of traditional tribal artefacts into the art museums in the late twentieth century also indicates a foreclosure. Like Italian Renaissance paintings, for example, these objects are not only recontextualized in the museum space, but also implicitly recast as relics of a period now fully historical, its makers long dead. Thus, the fact of the continued existence of living, dynamic cultures in the colonial and post-colonial circumstance – including makers of 'traditional' artefacts – is tacitly ignored in favour of some lost and supposedly purer and therefore more 'authentic' past belonging to a time before the colonial invasion.

The American writer James Clifford refers to this tendency as 'The Salvage Paradigm'. In this view of the world, he says, 'most non-Western peoples are marginal to the advancing world-system. Authenticity in culture or art exists just prior to the present (but not so distant or eroded as to make collection or salvage impossible).' The price of entry into 'the modern world', he tells us, 'is always that local, distinctive paths through modernity vanish.' In the post-colonial period, emerging and developing nations still find themselves subject in many ways not only to a need to deal with the after-effects of their collective experience of the colonial past, but also the continued political, financial and cultural dominance of the West. It is an accident of the increase in travel, of colonialist and imperialist expansion, and the western mania for collecting the world, that nowadays a massive array of cultural material is available to a large proportion of the global population. This has resulted in recent years in the development of a notion of 'World Art', which turns out not to be a description of the dominant internationalist artistic current, but a construction that embraces a disparate group of makers living and working in so-called developing countries and whose 'internationalism' is paradoxically defined essentially by their adherence to localized issues and styles, as in the cases, for example, of the Ghanaian

coffin-maker Kane Kwei (b. 1924), Taiwanese folk painter Hung Tung, South African weaver Allina Ndebele, or Haitian *vodun* flag-maker Yves Telemarc. Separated from the individual contexts of its production, this work functions in the West as Outsider Art.

World Art

Artistic production in the post-colonial world is beset by a series of paradoxes that reflect precisely the reluctance of the West to believe in the possibility of the so-called developing world actually *producing* and not merely reacting to the new. This is partly exacerbated by differences in the understanding of what constitutes

178. Djilatendo,
The Hunter, 1932

art in these Other cultures. Once again, the contents of western anthropological (and latterly, modern art) collections, based as they are on artefacts, do not reflect lived reality. For example, as the cultural historian Nicholas Thomas has pointed out, although in cultures of the South Seas the category 'art' does not exist in a western sense, there are clear parallels insofar as the work of 'specialists' has always been regarded as 'special and valuable':

The category of 'art' may therefore be problematic, not so much because it marks off a domain of intensified aesthetic power and value, but because of the way in which the domain is defined. For the western

viewer 'Oceanic Art' is associated above all with objects in museums.
… It excludes ephemeral art such as sand drawings, body paintings and
other forms of self-decoration. It presumes that artists produce objects
such as masks, when in fact indigenous aesthetics may focus upon the
order of gardens, the spatial arrangement of villages or dance grounds,
or the moment of transmission of a gift. Throughout the Pacific, the
human body is a locus of artistic elaboration.

Thus, art can also be found in 'performances and practices' which may even include 'casual daily actions in which the motifs upon an implement or the tattoos on a person's body move.' A similar claim could be made for traditional art from much of sub-Saharan Africa. The carved, polychrome masks appropriated by Picasso and Derain and prized as sculpture by many western collectors were conceived as part of dance costumes; their 'aesthetic' functionality determined by performance. This kind of traditional art survives in Africa, especially outside urban areas, though its very 'authenticity' derives not from stasis, but because it bears witness to the continued development of its forms, reflecting dialogue with modernity. Take, for example, the *Flali* mask carved by Saou bi Boti for a traditional Ivory Coast dance. In many ways the mask resembles 'classic' nineteenth-century pieces, but its bright colours – achieved by using modern industrial paint – and the clothes worn by the carved musician on the crest of the mask, as well as the presence of the name of the owner written on the coiffure, mark it out unequivocally as belonging to the late twentieth century.

Art consumers in the West have consistently made value judgments on objects coming out of Africa that are based on notions of 'purity' and 'authenticity'. Thus, until recently, 'traditional' art that displays the impact of the West has been regarded as somehow devalued, evoking the shadows of early twentieth-century pseudo-scientific theories concerning the supposedly disastrous consequences of miscegenation. Yet, it is worth noting that tribal carvers have been incorporating images of the *western* Other into their pieces since the first encounters with European travellers. Even more ironically, 'traditional' objects produced specifically *for* the western market have always, and continue to be, regarded as being of intrinsically inferior quality. Often sold directly to western tourists, this kind of work has derogatively come to be called 'airport art'. African artists working from a self-consciously internationalist position have hardly fared better. Emerging at a time when newly independent African states were wrestling with issues of self-definition, work

of this type is characteristically concerned with replacing regional references with national ones and tends to embrace media and techniques that mix western and African sources. At times it embodies attempts to discover and express an inner Africanness that is related to the political notion of *négritude*, a term coined by the Senegalese poet Léopold Senghor, and which was enunciated in different ways in the mid-twentieth century by the likes of the West Indian poet Aimé Césaire and psychiatrist and writer Frantz Fanon, in his *Black Skin, White Masks* (1952). Alternatively, it operates from a more cosmopolitan base in the breadth of its stylistic sources. Artists from both camps are usually well educated and politically aware, but the market for their work tends to be restricted to national government agencies and a limited foreign audience. This is dictated by a number of factors, not least a tendency for consumption by wealthy Africans to be based primarily around the acquisition of mass-produced consumer goods rather than the purchase of indigenous art.

Many contemporary African artists make paintings; a practice that was unknown before the colonial period. This includes not only highly educated 'international' artists, but also groups of rural and urban painters from the lower, often disenfranchised strata of African society. A new rural art has emerged in many areas as a consequence of the activities of 'alternative' art schools run by Europeans with the aim of fostering individual creativity, rather than imposing a particular style or technique. The work usually has a strong narrative underpinning, as in the case of the simply stated forms of Zairian painters Tshyela Ntendu, Djilatendo and Albert Lubaki. Often old tales are reworked, as in the case of Ibibio artist Ekong Emmanuel Ekefrey (b. 1952). Despite now living in Lagos, Nigeria, much of his work concerns the life and myths of the ethnic group to which he belongs. Perhaps the best known of these rural artists is another Nigerian, Twins Seven Seven (b. 1944). The youngest and only survivor of seven pairs of twins and with little formal education, he matured as an artist in the experimental school set up by the German art critic Ulli Beier in 1964. He uses his paintings, which consist of cut and superimposed flat wooden panels, both to illustrate the myths of the Yoruba people and to tell his own stories. There is something of the magician about this painter, musician and dancer who seems to embody his own cosmology in the same way as western outsiders such as St EOM or Poladian, carrying 'heaps of necklaces that rattle as he walks and two enormous rings, one with a huge stone, that's the earth, the other in bronze with a horseman on it,

178

that's the man who lords it over the earth.' Paintings such as *The* *Architect* (1989) characteristically contain an abundant symbolism that is squeezed into every part of the panel. Pictorial depth is always very shallow and almost every object is presented as an organic, breathing thing. Like Monsiel and Saban, Twins Seven Seven often inscribes complete, separate figures onto his central protagonists. The double readings in which we are invited to partake – fishes to ears, scales to beard – are a characteristic of much traditional tribal art, from North America to the South Seas, as well as European Outsider Art, such as drawings by Johann Knopf or the bizarre shell physiognomies of Pascal Maisonneuve (1863–1934). The double reading is also a central device in the art

179. **Twins Seven Seven**,
The Architect, 1989

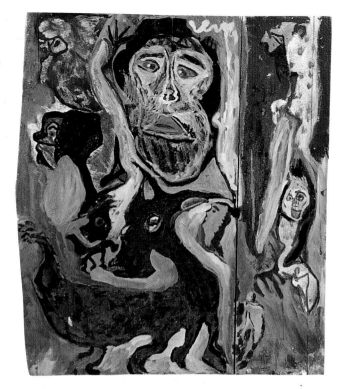

180. **Leonard Daley**, *Grey Face with Turning Goat*, 1992. This Jamaican artist from a poor background is entirely self-taught, working on any suitable material that comes to hand, from old tarpaulins to the exterior of his house. His pictures reflect the life around him in its visionary aspect, often containing strong moralizing sentiments.

of the Surrealists and Picasso. Perhaps in the work of Twins Seven Seven we are witnessing the closing of a circle of influence that started with Europe's appropriation of African forms.

The burgeoning urban centres in Africa have witnessed the emergence of popular art forms that are specifically wedded to the city. Usually practised by poorly educated, self-taught individuals and groups, its manifestations range from sign-paintings and billboards across the continent to devotional glass paintings from Senegal (a medium imported from North Africa in the twentieth century) and popular narrative paintings from the Republic of Congo (formerly Zaire). Urban art arose out of the growing population of town and city dwellers' need for a distinctive art of their own, serving small business – as advertising boards – and individuals. The commercial need to be eye-catching and legible has led to the production of paintings in bold, naïve naturalistic styles typified by the work of Congolese artists Tshibumba Kanda-Matalu and Cheri Samba (b. 1956). Though it initially served a local market, with painters specializing in a limited number of genres and reproducing their repertoire of subjects in countless variations, this art of the people has become enormously popular in the

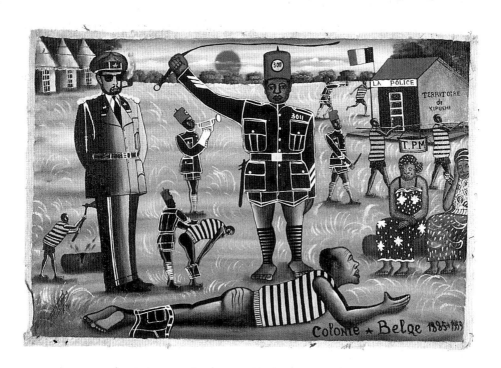

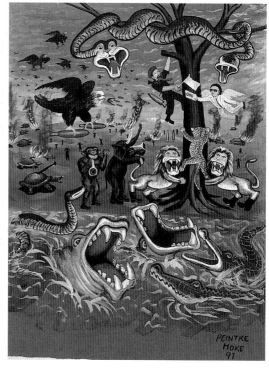

181. (above) **Tshibumba Kanda-Matalu**,
Colonie Belge 1885–1959, 1970s

182. (right) **Moke**, *The Gulf War*, 1991

West and its creators increasingly sophisticated. Cheri Samba is a case in point. One of a group of prominent urban artists in Kinshasa that includes his brother Cheïk Ledy (b. 1962) and the first 'popular' Kinshasa painter Moke (b. 1950), Cheri Samba grew up in rural 182 surroundings in Lower Zaire before migrating to Kinshasa in 1972 where he was apprenticed to established sign painters. He drew a cartoon strip for the periodical *Bilenge Info* and from 1975 began to paint on canvas. His work combines social, political, economic and cultural comment with a sharp humour reminiscent of the great eighteenth-century British moraliser William Hogarth and, often, with a distinctly erotic undercurrent. This is clear in his 'moralizing' painting, *Seduction* (1984), which depicts a young man 183 – identified as the artist himself – reading from the Bible. He has pointedly turned away from the figure in the foreground who is half modern Zairian woman and half fish. The text incorporated into the image confirms its message as a warning against the desire for material possessions. The female figure is a rendition of the ubiquitous *Mami Wata* ('Mother Water') image that is found throughout Central and West Africa. The *Mami Wata* story serves as a warning of the moral dangers inherent in the acquisition of

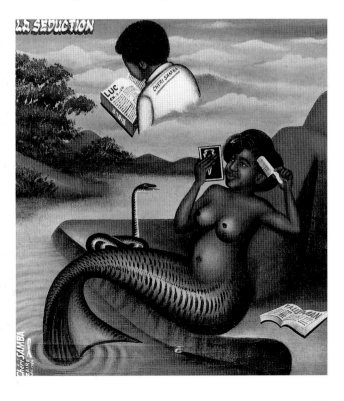

183. **Cheri Samba**, *Seduction*, 1984

wealth and power, but in cultures that forbid erotic imagery *Mami Wata* pictures – which are invariably bought by men – have increasingly come to acquire a function that makes the meaning of Cheri Samba's painting somewhat equivocal. His encounter with the West has resulted in him casting his satirical eye in that direction. *Paris is Clean* (1989), for example, is a nocturnal scene depicting African immigrants clearing Paris streets of the mess made by dogs owned by white Parisians, set against the golden glow of that icon of tourist Paris, the Eiffel Tower. Cheri Samba's success in the late 1980s was such that he was taken up by a Paris dealer, though he sums up the dangers of the outsider's brush with the western art market in *Why Did I Sign a Contract?* (1990) in which the artist depicts himself padlocked to an ultra-modern chair and held fast in the choking grip of a noose pulled by critics, curators and collectors.

In its African context urban art performs a function in the private space of the well-to-do living room that traditional art performs in the public space of the village. It defines its owners to their visitors and provides a point for social interaction while

184. **Kane Kwei**, *Mercedes Benz-Shaped Coffin*, 1989

signalling the disappearance of group control. In the Zairian city of Lubumbashi another popular tradition has grown up around history painting – the so-called 'Belgian Colony' subjects by the likes of Nkulu wa Nkulu, Kanda-Matalu and a host of unidentified 181 artists which became popular in the 1970s at a time when President Mobutu introduced a number of practices that recalled colonial abuses of human rights. Though presented as historical pieces, the white man presiding over the scene can be read as Mobutu, and sometimes the soldiers' uniforms and colonial flag are even replaced with their contemporary Zairian equivalents.

There is also a new form of essentially functional popular art that has found its way into western museums. Though it is identified with particular groups, it is not ethnically rooted and is therefore perceived as modern by its African consumers. The best-known representative of this kind of production is the workshop of Ghanaian coffin-maker Kane Kwei. Kwei produced his first representational coffin – in the shape of a boat – in the early 1970s for a dying uncle who had been a fisherman. He soon developed a series of popular types that reflected something of the life of their intended occupants. For example, a hen with chicks may be used for a woman with a large family, a cocoa pod or onion reflects important local crops, while a white 1970s model Mercedes Benz 184 is popular with successful business people. As the American art historian Susan Vogel has pointed out, westerners should be wary of misreading these objects. They are intended neither as critiques of modern life nor as Surrealistic transformations, but representations of objects from daily life. They are expressions of 'familiarity, connection, ownership'. Moreover, although Kwei's workshop supplies coffins to foreigners, the bulk of its production is destined literally to disappear.

First Nations

Indigenous cultures in countries such as the United States, Canada, Australia and New Zealand exist in a post-colonial situation in which the colonizer has become 'naturalized' and speaks with the dominant cultural voice. Whereas for the emerging African and Pacific states the desire to create inclusive national identities brought into focus questions about the acceptance or rejection of the values and structures of its western Others, the debate is far less clearly defined for First Nations peoples. Situated not at the geographical periphery of dominant global discourse, but at its centre, First Nations artists are likely to have been educated in art schools, learning additionally from traditional

185. Pansy Napangati,
Bush Mango, Two Travelling Women and Snake Tjukurrpas *(Dreamings)*, 1989. Though 'traditional' in the sense that they reproduce narratives central to lived culture and utilize elements from sand drawing and body painting, this kind of painting developed only in the 1970s. The transfer onto canvas or board involved a transformation of sources that signals not cultural stasis, but represents dynamism and significant innovation.

sources. More often than not their work can be placed in main-stream artistic discourses, though its content – both overt and underlying – tends to address issues of marginalization and the struggle for cultural identity that is meaningful in the contemporary context. Even those who choose to create through traditional forms, such as the Tahltan-Tlingit artist from British Columbia, Canada, Dempsey Bob (b. 1948), do so not to resurrect some extinct, timeless past, but to engage with the peculiar dynamics of cultural becoming. Bob's carvings include totem poles in private, government and corporate collections which communicate the living culture of his people. He says of his work, 'I'm not trying to recreate the past, but you have to have a base of understanding from which to innovate. ... I studied the old pieces to go ahead.'

The transformation of traditional forms of image production to serve contemporary concerns is equally apparent in Aboriginal

art from Australia where distinctive urban forms have developed in parallel with rural practices. In rural areas regional styles and iconographies have been retained, whilst artists often employ non-traditional media, such as acrylic on canvas. This is the case in 'dreamings' by artists from Western Central Australia such as Mick Namarari Tjapaljarri (b. *c.* 1930) and Pansy Napangati (b. *c.* 1945). Though these works – practised now by women as well as men – might be mistaken as purely decorative pieces they are, in fact, replete with representational elements that can be read by the adept. Napangati's *Bush Mango, Two Travelling Women and Snake* Tjukurrpas *(Dreamings)* (1989), for example, presents two 'dreamings' set in Luritja tribal homelands. The centre of the picture represents the site from which two sisters started a journey and to which they returned. In the top right of the picture a male and female snake fight, watched by a group of women represented by horseshoe shapes. The concentric circles at the centre of the battle signify the large plain that was formed as a result.

185

Urban Aboriginal art by the likes of Sally Morgan (b. 1951), Byron Pickett (b. 1955) and Karen Casey (b. 1956) is characterized, in the words of Australian curator and writer Wally Caruana, by the 'quest for equality and justice within Australian society as a whole'. Urban artists are as likely to employ oppressive white representations of Aboriginal culture in their critique as transformations of traditional forms. This tendency spread in the 1980s to include a number of rural artists such as Robert Campbell Jnr (b. 1944). His distinctive style shares affinities with the decoration found on traditional weapons from south-eastern Australia, and his tendency to depict his figures naked, with their oesophagus visible, is reminiscent of depictions of animals and humans from Arnhem Land in the north. He employs these means to construct sequential narratives that reveal Australian history as seen from the Aboriginal perspective, from pre-European life to politically charged images of institutionalized racism.

188

The postmodernist questioning of master narratives that has become a feature of much mainstream contemporary art in the West has seen the repositioning of women artists – those other historical outsiders in male, phallocentric culture – through the active construction of feminist critiques of the dominant order. In the same way, First Nations artists such as James Luna (b. 1950), Jimmie Durham (b. 1940) and Rebecca Belmore (b. 1960) have emerged who directly address questions of ethnic identity and the relationship of marginalized cultural groups to the self-appointed centre through conceptualist work that is at the cutting edge of

186. (right) **James Luna**,
Four Directions, Four Cars,
detail from the *Sacred Colors*
series, 1992

187. (opposite above)
Rebecca Belmore,
Ayum-ee-aawach Oomama-mowan: Speaking to their Mother,
27 July 1991

188. (opposite below)
Robert Campbell Jnr,
Death in Custody, 1987

current art-world practice. James Luna, who lives in the United States on the La Jolla Indian Reservation, California, was educated at the University of California and San Diego State University. His works, such as the *Sacred Colors* series from 1992, are concerned with mediating between cultures from the perspective of someone who is, as he says, 'in possession of Indian knowledge, as well as being a trained artist'. While Luna embraces the often conflicting nature of the 'two worlds' of his experience as a way of surviving within it, Durham asserts the need for a more complete emancipation: 'Indians of the Americas have a subtle colonial overlay to our self-definition which is almost impossible to separate out. Then, because we all still live under colonial conditions, we have a political responsibility to our own people.' Canadian conceptual and performance artist Rebecca Belmore is specifically concerned with finding ways in which to represent native women and, in doing so, give them back their own authentic voice. In the performance work *Ayum-ee-aawach Oomama-mowan: Speaking to their Mother* (1991), the artist acts as a conduit for the voices of others. The work consisted of thirteen native speakers addressing the earth directly through a huge megaphone after having listened to a call by Bernard Ominayak, chief of the Lubicon Cree in Alberta, to join the political struggle against expropriation and destruction of First Nations land.

186

187

Arts of the Post-Colonial Diaspora

The post-colonial period has witnessed movements, often in relatively large numbers, of previously subject people to the old imperialist centres in western Europe (and more recently to such countries as Canada and Australia). Since the end of the Second World War Britain's population, especially, has become richly diverse with cultural injections from Africa, the Indian sub-continent, Hong Kong and the Caribbean. However, for much of the second half of the twentieth century a mixture of racist attitudes and the fact that much of the immigrant population was absorbed into lower social classes has meant that many groups remain in marginal positions. Despite this, in the 1950s and early 1960s Afro-Asian artists such as Francis Newton Souza and Avinash Chandra worked within the dominant modernist paradigm and achieved notable success in Britain. However, as artist and writer Rasheed Araeen points out, 'despite all their success they remained the Other, in the sense that their otherness was constantly evoked as part of the discussion of their work'. Moreover, names such as these do not appear in any of the surveys of British art published since the 1960s. However, as in North America, Afro-Asian artists have begun to operate more success-fully in the (post)modern mainstream without shedding their sense of self-identity, as in the cases of Dhruva Mistry, Anish Kapoor, Sonia Boyce and Chris Ofili.

The success of artists from diasporic backgrounds must be viewed against an institutional arts policy generated in Britain in the last quarter of the twentieth century which threatened the role of these communities by establishing a separate category and public-funding structure that seemed to define the role of the black artist from outside. Such terms as 'ethnic arts', 'ethnic minority arts', 'non-British arts' and 'multi-ethnic arts' were used, thereby representing, as the writer and activist Kwesi Owusu contends, 'Black and other immigrant arts not in their own terms, but in terms of their subordination to dominant British culture. Similarly, it was a vocabulary that severed black arts in Britain from its cultural origins in the home countries of the immigrants themselves. Seen in a real perspective, the black arts are part of a global structure of modern cultural reproduction in which Britain's role, as part of its construction as a modern world economy, is one of domination. The conceptual vocabulary of 'ethnic' arts accepts this domination. Araeen is surely correct when he says that, 'The uniqueness of Afro-Asian achievement is that it does not represent separate categories of "ethnic arts" or

"black art" but is firmly located within or in relation to the mainstream; it reflects the complex articulation of modern developments in art that have taken place in post-war Britain. We must in fact oppose separate categories, whether they are racial, ethnic or cultural.' The plea for centrality in the context of cultural diversity is clearly articulated by Gavin Jantjes (b. 1948), originally from South Africa: 'Artists like myself, who stem from regions of the World Europe classified as "Third", have over many years sustained a hope that our engagement with these discourses would move Europe, and especially Britain, to lose its reluctance to take on issues which are vital to us. Make them part and parcel of its mainstream debates.'

Outsider Art has sometimes been referred to as an art without tradition, where the reference is tilted towards those self-taught individuals whose background and work appears to share no similarities with the culture in which they grew up. 'World Art', as defined above, clearly falls outside this description by virtue of the cultural centrality of its practitioners (its difference arises through the fact of exportation). However, such a definition also effectively disbars those outsiders who belong to marginalized cultural groups within a host population which nevertheless have a strong sense of identity and creative tradition. This includes peasant populations that often maintain strong folk traditions, First Nations peoples and groups formed of the post-colonial diasporas largely (though not exclusively) to the West that occurred mainly after the end of the Second World War. All of these have distinctive traditions which nevertheless share characteristics in common with the dominant culture. However, culturally, even in a society that supposedly embraces multi-culturalism, they are still marginalized. Increasingly, though, First Nations and diasporic peoples are strongly asserting their distinctive presence outside the old politics of assimilationism. As James Clifford reminds us, 'Culture is migration as well as rooting' and these new subjects bring with them 'new definitions of authenticity' that are 'no longer centred on a salvaged past. Rather authenticity is reconceived as hybrid, creative activity in a local present-becoming-future.' Thus, at the moment many groups might be legitimately (and productively, in a political sense) described as outsiders, but their trajectory, even as they assert their difference to the machine of dominant culture, is towards the inside, where that inside holds the possibility of true multiculturalism.

Bibliography and Sources

General

Jean Dubuffet's concept of *Art Brut* lies at the heart of late 20th-century theorizations on art 'outside' culture. The two major sources of his writings in English translation are: J. Dubuffet, *Asphyxiating Culture and Other Writings* (New York, 1988); and M. Glimcher, ed., *Jean Dubuffet: Towards an Alternative Reality* (New York, 1987). The key essays in which Dubuffet states his position as regards Outsider Art are: 'Art Brut in Preference to the Cultural Arts' (1949) and 'Anticultural Positions' (1951), both in Glimcher, ed., *op. cit.*; and 'Make Way for Incivism' (1967), in A. S. Weiss, ed., *Art Brut: Madness and Marginalia* (*Art and Text* special issue, 27, 1988). Since the writer Roger Cardinal coined the term 'Outsider Art' as an equivalent for the French term 'Art Brut' in his now seminal book, *Outsider Art* (London, 1972), more than quarter of a century ago, it has become the most used anglophone descriptor for the art of the insane, mediums and obsessive, untutored individuals (although it is worth noting that in the book Cardinal did not use the term Outsider Art anywhere in the body of his text, preferring to use the anglicized 'Art Brut'). Taking his lead from Dubuffet, Cardinal constructed a canon of Outsiders measured by the extent of their perceived anti-cultural position. Since that time Cardinal has been a key figure in defining and reviewing the territory, notably in the following texts: 'Singular Visions', in V. Musgrave and R. Cardinal, *Outsiders: an Art Without Tradition* (exh. cat., London, 1979); 'Toward an Outsider Aesthetic' in M. D. Hall and E. W. Metcalf, eds, *The Artist Outsider: Creativity and the Boundaries of Culture* (Washington, D.C., and London, 1994); and most recently, 'Private Worlds', in *Private Worlds: Classic Outsider Art from Europe* (exh. cat., Katonah, NY, 1998).

Useful works that cover a range of Outsider Art themes include: J. Beardsley, 'Creating the Outsider', in *Private Worlds: Classic Outsider Art from Europe, op. cit.*, pp. 4–9; J-L. Ferrier, *Outsider Art* (Paris, 1998); Hall and Metcalf, eds, *op. cit.*; Hayward Gallery, *In Another World: Outsider Art from Europe and America* (exh. cat., London, 1987); J. Maizels, *Raw Creation: Outsider Art and Beyond* (London, 1996); G. Presler, *L'Art Brut. Kunst zwischen Genialität und Wahnsinn* (Cologne, 1981); M. Thévoz, *Art Brut* (Geneva, 1995); M. Tuchman and C. S. Eliel, eds, *Parallel Visions: Modern Artists and Outsider Art* (Princeton, 1992); A. S. Weiss, *Shattered Forms: Art Brut, Phantasms, Modernism* (New York, 1992).

On madness and art, see in particular: H. Prinzhorn, *Artistry of the Mentally Ill* (New York, 1972); Hayward Gallery, *Beyond Reason: Art and Psychosis (Works from the*

Prinzhorn Collection) (exh. cat., London, 1996); W. Morgenthaler, *Madness and Art: the Life and Works of Adolf Wölfli* (London, 1992); and J. M. MacGregor's impressive historical analysis of western attitudes to madness and creativity, *The Discovery of the Art of the Insane* (Princeton, 1989).

Works concerning particular collections include: D. Ades and J. Thompson, *Art Unsolved: The Musgrave Kinley Outsider Art Collection* (London, 1998); A. Bourbonnais, *La Fabuloserie. Art hors les normes. Art Brut.* (Biarritz, SAI, 1993); J. Dubuffet and M. Thévoz, *Collection de l'Art Brut, Lausanne* (Lausanne, 1976); R. Manley, 'Lynch Collection Artists Notes.' and 'Midwife to Art: Robert Lynch and the Artists.' unpublished MS (n.d.); L. Navratil, *Gugging 1946–1986* (2 vols): *I: Art Brut und Psychiatrie; II: Die Künstler und ihre Werke* (Vienna, 1997); M. Thévoz, *Neuve Invention: Collection d'Oeuvres Apparentées à l'Art Brut* (Lausanne, Collection de l'Art Brut, 1988).

Several works deal exclusively with environments, including: J. Beardsley, *Gardens of Revelation: Environments by Visionary Artists* (New York, 1995); R. M. Manley, et al., *Self-Made Worlds: Visionary Folk Art Environments* (Aperture Books, 1997); R. Peacock and W. A. Jenkins, *Paradise Garden: a Trip through Howard Finster's Visionary World* (San Francisco, 1996); S. Rosen, *In Celebration of Ourselves* (San Francisco, 1979); D. von Schaewen, J. Maizels and A. Taschen, *Fantasy Worlds* (Cologne, 2000).

The increased interest in Outsider Art in the United States in recent years has resulted in a proliferation of books on the subject of American 'Self-Taught' artists, including: B. Brackman and C. Dwigans, *Backyard Visionaries: Grassroots Art in the Midwest* (Kansas, 1998); L. Danchin and M. Lusardy, *Art Outsider et Folk Art des Collections de Chicago* (exh. cat., Paris, 1998); K. Goekjian and R. Peacock, *Light of the Spirit: Portraits of Southern Outsider Artists* (Jackson, Mississippi, 1998); J. M. Joel, 'Vollis Simpson: the Don Quixote of East-Central North Carolina' (*Folk Art Messenger*, 1996); D. Kuspit, '"Suffer the Little Children to Come unto Me": Twentieth-Century Folk Art', in *The New Subjectivism: Art in the 1980s* (Ann Arbor, 1988), pp. 453–65; K. Moses, *Outsider Art of the South* (Schiffer, 1999); B.-C. Sellen and C. J. Johanson, *20th Century American Folk, Self-Taught, and Outsider Art* (Neal-Schuman, 1993); G. C. Wertkin and E. Longhauser, eds, *Self-Taught Artists of the 20th Century: an American Anthology* (San Francisco, 1998); J. Wilkinson et al., *Bill Traylor Drawings from the Collection of Joe and Pat Wilkinson* (New York, 1997).

A number of other general works are also worthy of mention: Angel Row Gallery, *Ingenious Creator* (exh. cat., Nottingham, 1997); art.tm, *Soloists: an Exhibition of Outsider Art in Scotland* (CD-ROM, Inverness, 1998); O. Billig and B. G. Burton-Bradley, *The Painted Message* (Cambridge, Mass., 1978); R. Ferguson, M. Gever,

T. Minh-Ha, eds, *Out There: Marginalization and Contemporary Cultures* (New York, 1990); J. Fineberg, ed., *Discovering Child Art: Essays on Childhood, Primitivism and Modernism* (Princeton, 1998); D. Kuspit, 'Choosing Psychosis: Max Ernst's Artificial Hallucinations', in *Signs of the Psyche in Modern and Post-Modern Art* (Cambridge, 1993), pp. 76–85; S. Malvern, 'Recapping on Recapitulation (Or How to Primitivise the Child)' (*Third Text*, 27, 1994, pp. 21–30); J. S. Pierce, 'Paul Klee and Baron Welz' (*Arts Magazine*, vol. 52, no. 1, 1977, pp. 128–31); R. Porter, *A Social History of Madness: The World Through the Eyes of the Insane* (New York, 1987); K. Samaltanos, *Apollinaire, Catalyst for Primitivism, Picabia, and Duchamp* (Ann Arbor, 1984); A. T. Scull, *Museums of Madness* (London, 1982); V. L. Zolberg and J. M. Cherbo, eds, *Outsider Art: Contesting the Boundaries of Culture* (Cambridge, 1997).

A number of specialist magazines dealing with issues of marginality and Outsider Art also exist, including: *Raw Vision, The Folk Art Messenger, L'Arte Naïve, L'Oeuf Sauvage, Création Franche* and *Third Text*. In addition, there are many interesting and informative sites on the World Wide Web, including many devoted to individual artists. They are too many to list here and change relatively frequently. However, they can be accessed by using the key words 'Outsider Art' with any search engine.

Introduction

M. Thévoz, 'An Anti-Museum: The Collection de l'Art Brut in Lausanne', in Hall and Metcalf, eds, *op. cit.*, p. 70; on A. Louden see, for example, J. Windsor, 'The Outed Outsiders' (*The Independent on Sunday*, 1 October 1995, pp. 78–81) and 'Catch 22: The Case of Albert Louden' (*Raw Vision*, 18, 1997, pp. 50–53); A. Breton, *Mad Love* (trans. M. Caws, Nebraska, 1988), p. 25.

Chapter 1

R. Cardinal, 'Toward an Outsider Aesthetic', *op. cit.*, p. 22; J. Dubuffet, from *Prospectus et tous écrits suivants* (Paris, 1967) – English version in Glimcher, ed., *op. cit.*, p. 33; J. Dubuffet, *'L'Art brut préféré aux arts culturels'* (1949) – English version in A. S. Weiss, ed., *Art Brut* (*Art and Text* special issue, 27, 1988), p. 33; J. Dubuffet, 'Anticultural Positions', in Glimcher, ed., *op. cit.*, p. 127; P. Klee, *The Diaries of Paul Klee 1898–1918* (Berkeley, 1968), p. 266; W. Kandinsky, 'On the Question of Form', in W. Kandinsky and F. Marc, ed., *The Blaue Reiter Almanac* (London, 1974), pp. 174, 176; J. Fineberg, *The Innocent Eye* (Princeton, 1997), p. 50; Constant, 'Manifesto' (1948), as quoted in W. Stokvis, *Cobra* (New York, 1988), p. 30; P. Klee, *The Thinking Eye: The Notebooks of Paul Klee* (London, 1961), p. 451; P. Alechinsky, as quoted in J.-C. Lambert, *Cobra* (London, 1983), p. 183; on M. Bartlett see M. Harris, *Family Found* (Connecticut, 1994); J. Dubuffet, 'Notes for the Well-Read' (1945), in Glimcher, ed., *op. cit.*, pp. 80, 77; J. Dubuffet, 'Perceiving' (1960), in Glimcher, ed., *op. cit.*, p. 182; J. Dubuffet, as quoted in MacGregor (1989), *op. cit.*, p. 293; A. Breton, as quoted in Cardinal

218

(1972), *op. cit.*, p. 15; J. Dubuffet, quoted in
J. MacGregor, 'Art Brut Chez Dubuffet'
(*Raw Vision*, 7, 1993), p. 47; J. Dubuffet,
in Weiss, ed. (1988), *op. cit.*, pp. 32, 33;
J. Dubuffet, as quoted in Cardinal (1972),
op. cit., pp. 27, 29; J. Dubuffet, 'Make Way for
Incivism', in Weiss, ed. (1988), *op. cit.*, p. 35;
J. Dubuffet, as quoted in MacGregor (1989),
op. cit., p. 302; Cardinal, 'Singular Visions',
op. cit., p. 22; M. Thévoz, 'An Anti-Museum:
The Collection de l'Art Brut in Lausanne',
in Hall and Metcalf, eds. *op. cit.*, p. 70.

Chapter 2

A. Beveridge, 'The Work of Andrew
Kennedy' (*Raw Vision*, 23, 1998), p. 50.
Beveridge is responsible for the rediscovery
of Kennedy's work; M. Réja, as quoted in
MacGregor (1989), *op. cit.*, p. 174; *The Daily
Mirror* front page, 9 August 1913; anon.,
The Times, 14 August 1913, as quoted
in MacGregor (1989), *op. cit.*, p. 166;
W. Herzefelde, as quoted in S. Gilman,
Difference and Pathology (Ithaca, 1985),
p. 229; K. Wilmanns, as quoted in Hayward
Gallery (1996), *op. cit.*, pp. 7, 8; Prinzhorn,
op. cit., pp. 1, 3, 39, 42, 40; MacGregor
(1989), *op. cit.*, p. 199; Prinzhorn, *op. cit.*,
pp. 160, 171, 106, 130, 114, 115, 200;
A. Wölfli (1913), as quoted in E. Spoerri and
J. Glaesemer, eds, *Adolf Wölfli* (Berne, 1976),
n.p.; Morgenthaler, *op. cit.*, pp. 45, 80, 49, 80,
64, 62; the most thoroughgoing account
of Wölfli's life and work can be found in
E. Spoerri, ed., *Adolf Wölfli: Draftsman,
Writer, Poet, Composer* (Ithaca and London,
1997); J. Dubuffet, as quoted in Thévoz
(1995), *op. cit.*, p. 165; Thévoz (1995), *op. cit.*,
p. 166; A. Corbaz, as quoted in Cardinal
(1972), *op. cit.*, p. 169; Thévoz (1995), *op. cit.*,
p. 170; Prinzhorn, *op. cit.*, p. 271; A. Breton,
Manifesto (1930), as quoted in MacGregor
(1989), *op. cit.*, p. 275; P. Eluard, as quoted in
ibid., p. 275; A. Breton, *Nadja* (New York,
1960), pp. 129, 142, 143, 136, 142; Gilman,
op. cit., p. 222; M. Nordau, *Degeneration*
(London, 1920), pp. vii–viii; T. B. Hyslop,
as quoted in MacGregor (1989), *op. cit.*,
p. 162; Nordau, *op. cit.*, p. 326; J. Dubuffet, as
quoted in MacGregor (1989), *op. cit.*, p. 359;
activities at the Centro Psiquiatrico Pedro II
in Rio de Janeiro were initiated by a Jungian
psychiatrist, Dr Nise da Silveira. In 1952 she
established a 'Museum of Images from the
Unconscious' (see *Raw Vision*, 20, 1997,
pp. 52–57); on La Tinaia in Florence, see
Raw Vision, 22, 1998, pp. 38–45; on the
Haus-Kannen in Munster, see Alexianer-
Krankenhaus, *Das Haus-Kannen-Buch*
(Munster, 1994); C. Delacampagne, 'Beyond
Art Brut' (*Raw Vision*, 8, 1993), p. 18;
L. Navratil, 'The History and Prehistory of
the Artists' House in Gugging', in Hall and
Metcalf, eds, *op. cit.*, pp. 209, 210; Navratil,
'Art Brut and Psychiatry' (*Raw Vision*, 15,
1996), p. 46; on A. Rainer as a collector, see
Museum de Stadshof, *Collectie Arnulf Rainer*
(exh. cat., Zwolle, the Netherlands, 1996);
A. Rainer, 'My Underdrawings of Franz
Xaver Messerschmidt', in *Franz Xaver
Messerschmidt Character Heads 1770–83*

(exh. cat., London, 1987), p. 35; Navratil,
'The History and Prehistory of the Artists'
House in Gugging', in Hall and Metcalf, eds,
op. cit., p. 202.

Chapter 3

J. MacGregor, 'Thoughts on the Question:
Why Darger?' (*Intuit*, 1998), J. Dubuffet, as
quoted in MacGregor (1989), *op. cit.*, p. 303;
R. Cardinal, 'Private Worlds', *op. cit.*, p. 11;
R. Cardinal, in Henry Boxer Gallery, *Malcolm
McKesson: an Exquisite Obsession* (Richmond,
Surrey, 1996), n.p.; M. McKesson, as quoted
in *ibid.*; M. T. Wilmer, in *ibid.*; on A. Rizzoli,
see J. F. Hernandez, J. Beardsley, R. Cardinal,
A. G. Rizzoli: Architect of Magnificent Visions
(New York, 1997); J. MacGregor, 'Thoughts
on the Question: Why Darger?', *op. cit.*;
Darger, as quoted in Tuchman and Eliel, eds,
op. cit., p. 36; J. MacGregor, 'Henry Darger:
Art by Adoption' (*Raw Vision*, 13, 1995–96),
p. 29; on R. C. Wilkie, see C. Shriqui,
'Innocence Lost' (*Raw Vision*, 25, 1998–99),
pp. 56–59; on M. Bartlett, see M. Harris,
*Family Found: the Lifetime Obsession of Self-
Taught Artist, Morton Bartlett* (Connecticut,
1994); A. Kepinski, 'The Case of Edmund
Monsiel' (*Raw Vision*, 10, 1994), p. 41;
O. Saban, radio interview, France Inter,
11 December 1997; Weiss (1992), *op. cit.*,
p. 70; on supposed long-term harm of drug
therapy, see, e.g., J. MacGregor, 'Altered
States – Alternate Worlds', in Danchin and
Lusardy, *op. cit.*, pp. 30–51; T. Thorne, 'Nick
Blinko: the Devil is in the Detail' (*Raw Vision*,
17, 1996), p. 42; all quotations from Raymond
Morris are from conversations with the
author, May–September 1998; observations
on J. R. Wenzel from Ans van Berkum,
Director of the Museum de Stadshof, Zwolle;
conversation with the author, May 1998;
E. Spoerri, 'Inventory of Basic Forms and
Picture Types', in 'The Pictorial Work of
Adolf Wölfli', in Spoerri and Glaesemer, eds,
op. cit., p. 31; on W. Van Genk, see A. van
Berkum, *Willem van Genk* (Museum de
Stadshof, Zwolle, 1998); on Western artists'
interest in 'primitive' sources, see C. Rhodes,
Primitivism and Modern Art (London and
New York, 1994).

Chapter 4

J. Dubuffet, as quoted in MacGregor (1989),
op. cit., p. 302; the standard work on Naïve
Art remains O. Bihalji-Merin, *Modern
Primitives: Masters of Naïve Painting* (London,
1961). See also, R. Cardinal, 'Regards sur la
peintre naïve' (*L'Oeuf Sauvage*, 9, 1994); on
art in prisons, see P. Kornfeld, *Cellblock Visions*
(Princeton, 1997); A. Breton, 'The Automatic
Message' (*Minotaure*, 3–4, 1933), p. 61;
A. Smith, as quoted in Tuchman and
Eliel, eds, *op. cit.*, p. 252; A. Lesage, as
quoted in M. Thévoz, 'Augustin Lesage and
Spiritualism' (*Raw Vision*, 1, 1989), pp. 14, 16;
M. Gill, as quoted in Cardinal (1972), *op. cit.*,
p. 135; the information on M.-J. Gil follows
closely L. Danchin's 'The Celestial Visions
of Marie-Jeanne Gil, Versailles' Mediumistic
Artist' (*Raw Vision*, 15, 1996, pp. 36–39);
A. Zemánková, as quoted in Hayward

Gallery (1987), *op. cit.*, p. 52; on M. Evans
see, e.g., G. Coker, 'Elephants Around the
Moon: the Art of Minnie Evans' (*Raw Vision*,
11, 1995, pp. 28–35); on H. Veenvliet, see
Museum de Stadshof, Zwolle, *Henk Veenvliet*
(Zwolle, the Netherlands, 1998); L. Danchin,
'Simone Le Carré-Galimard' (*Raw Vision*, 17,
1996), p. 51; on K. Schwitters' *Merzbauten*, see
D. Elger, 'L'œuvre d'une vie: les *Merzbau*', in
Centres Georges Pompidou, *Kurt Schwitters*
(exh. cat., Paris, 1994), pp. 140–51; R. Koczÿ,
statement 7.9.96 on reverse of a drawing
dated 20.8.1989 #12, in the collection of the
Museum de Stadshof, Zwolle; J. Rivais, '"I am
Weaving You a Shroud": an Interview with
Rosemarie Koczÿ' (*Raw Vision*, 25, 1998–99),
pp. 32–39; R. Cardinal, 'Within Us these
Traces' (*Art and Text*, 27, 1988), p. 49;
M. Nedjar, 'I Am Tied to the Threads of the
World' (*Art and Text*, 27, 1988), pp. 53, 55, 58;
on M. Nedjar, see also S. Zander, ed., *Michel
Nedjar: Les ongles en denil* (exh. cat., Cologne,
1995); L. Freeman, as quoted in Cardinal,
'Singular Visions', *op. cit.*, p. 30; Museum
de Stadshof, Zwolle, *Riet van Halder* (exh.
cat., Zwolle, the Netherlands, 1997); B. I.
Kingelez, as quoted in Groninger Museum,
Africa Now (exh. cat., Groningen, the
Netherlands, 1991), p. 60; on H. Martins,
see S. Ross, 'The Owl House' (*Raw Vision*,
5, 1991), pp. 26–31; F. Cheval, as quoted in
Cardinal (1972), *op. cit.*, p. 147; M. Thévoz
(1995), *op. cit.*, p. 34; on F. Cheval see J.-P.
Jouve, *Le Palais Idéal du Facteur Cheval*
(Hédouville, France, 1994); S. Rodia, as
quoted in Cardinal (1972), *op. cit.*, p. 172;
C. Schmidt, as quoted in *ibid.*, p. 68; H.
Finster, as quoted in J. F. Turner, 'Howard
Finster's Paradise Garden' (*Raw Vision*, 2,
1989), pp. 15, 8; L. Knight, as quoted in L.
Yust, 'Salvation Mountain' (*Raw Vision*, 16,
1996), p. 41; A. Bourbonnais, as quoted in
Cardinal (1979), *op. cit.*, p. 26; S. S. Bhatti,
'The Rock Garden of Chandigarh' (*Raw
Vision*, 1, 1989), p. 25.

Chapter 5

Gilman, *op. cit.*, pp. 12, 18; for a more detailed
discussion of western primitivism, see
Rhodes, *op. cit.*; J. Clifford, 'The Others:
Beyond the "Salvage" Paradigm' (*Third Text*,
6, 1989), pp. 73, 74; N. Thomas, *Oceanic Art*
(London and New York, 1995), pp. 26–29;
description of Twins Seven Seven from
J.-H. Martin, 'Tell-tale Art', in Groninger
Museum, *op. cit.*, p. 33; S. Vogel, *Africa
Explores* (New York, 1994), p. 99; D. Bob, as
quoted in D. Nemiroff, *Land, Spirit, Power*
(Ottawa, 1992), p. 122; the description of
P. Napangati's picture is derived from that
in B. Lüthi, ed., *ARATJARA: Art of the First
Australians* (exh. cat., Cologne, 1993), p. 347;
W. Caruana, *Aboriginal Art* (London and
New York, 1993), p. 195; J. Luna, as quoted in
Nemiroff, *op. cit.*, p. 190; J. Durham, as quoted
in *ibid.*, p. 143; R. Araeen, ed., *The Other Story:
Afro-Asian Artists in Post-War Britain* (exh.
cat., London, 1989), p. 13; K. Owusu, *The
Struggle for Black Arts in Britain* (London,
1986), p. 50; Araeen, *op. cit.*, pp. 105–06; G.
Jantjes, in *ibid.*, p. 126; J. Clifford, *op. cit.*, p. 75.

List of Illustrations

Measurements are in centimetres, followed by inches, height before width before depth

1 Minnie Evans, *Untitled (Landscape – Many Faces)*, 1959–61. Mixed media on canvas board 50.8 × 61 (20 × 24). Courtesy Luise Ross Gallery, New York; **2** Adolf Wölfli, *General View of the Island Neveranger*, 1911. Crayon and colour pencil on newspaper 99.8 × 71.2 (39¾ × 28). © Adolf-Wölfli-Stiftung, Kunstmuseum, Bern; **3** Heinrich Anton Müller, *Personnage avec chèvre*, 1917/22. Black and white chalk over pencil on cardboard 80 × 55.5 (31½ × 21¾). Kunstmuseum, Bern; **4** Aloïse Corbaz, *Dans le Manteau de Luther*, c. 1950. Coloured crayons on paper 120 × 74 (47¼ × 29⅛). Collection de l'Art Brut, Lausanne; **5** Madge Gill, *Composition*, 1951. China ink. Collection de l'Art Brut, Lausanne; **6** Gaston Chaissac, *Untitled*, c. 1957–59. Oil on hardboard 145 × 122 (57 × 48). Musée de l'Abbaye Saint-Croix, Les Sables-d'Olonne. © ADAGP, Paris and DACS, London 2000; **7** Gaston Chaissac, *Totem*, n.d. Painted assemblage, height 176 (69¾). Collection de l'Art Brut, Lausanne. © ADAGP, Paris and DACS, London 2000; **8** Jean Dubuffet, *The Reveller*, 1964. Oil on base of black acrylic 195 × 130 (76¾ × 51¼). Dallas Museum of Art. Gift of Mr and Mrs James H. Clark. © ADAGP, Paris and DACS, London 2000; **9** Howard Finster, *What is the Soul of Man*, 1976. Paint on wood 44.5 × 72.4 (17½ × 28½). Collection Willem & Diane Volkersz. Photo courtesy *Raw Vision*; **10** Albert Louden, *Family*, c. 1980. Watercolour and pastel 40 × 29.5 (15¾ × 11⅝). Collection de l'Art Brut, Lausanne; **11** Albert Louden, *Landscape*, c. 1980. Oil on canvas and pastel 40.6 × 30.5 (16 × 12). Photo courtesy Marion Harris, Simsbury, CT; **12** Eugene von Bruenchenhein, *Untitled*, c. 1945. Hand-coloured photograph 20.3 × 25.4 (8 × 10). Photo Carl Hammer Gallery, Chicago, courtesy *Raw Vision*; **13** Martin Ramírez, *Untitled*, 1954. Coloured pencil on paper 139.7 × 129.5 (55 × 51). Private collection, photo courtesy *Raw Vision*; **14** Georg Kerschensteiner, Child's Drawing, *Snowball Fight*, plate from *Die Entwicklung der Zeichnerischen Begabung (The Development of the Gift of Drawing)*, 1905; **15** Paul Klee, *Human Helplessness*, 1913. Pen on paper 17.8 × 9.9 (7 × 4). Kunstmuseum, Bern. Paul Klee Stiftung. © DACS 2000; **16** Jean Dubuffet, *White Mirobolus*, 1945. Haute pate on canvas 46 × 38 (18 × 15). Private collection. © ADAGP, Paris and DACS, London 2000; **17** Karel Appel, *Hip, Hip, Hoorah!*, 1949. Oil on canvas 82 × 129 (32¼ × 50¾). © Tate Gallery, London 1999. © DACS 2000; **18** Asger Jorn, *Letter to my Son*, 1956–57. Oil on canvas 130 × 195.5 (51¼ × 77). © Tate Gallery, London 1999; **19** Constant, *Festival of Sadness*, 1949. Oil on canvas 85 × 110 (33½ × 43¾). Boymans Van Beuningen Museum, Rotterdam. © DACS 2000; **20** Tom R,

drawing of a dog, 1996. Pen on paper 9.5 × 16.5 (3¾ × 6½). Photo courtesy the author; **21** Jean-Michel Basquiat and Cora Bischofberger, *Untitled (Pakiderm)*, 1984. Acrylic on canvas 120 × 120 (47¼ × 47¼). Galerie Bischofberger, Zurich. © ADAGP, Paris and DACS, London 2000; **22** Annemarie Münter, *Untitled (House)*, 29 August 1913. Watercolour and pencil on paper 21.1 × 16.6 (8⅜ × 6½). Gabriele Münter und Johannes Eichner Stiftung, Munich; **23** Child's drawing from Jean Dubuffet's collection, May 1939. Gouache on paper 31.5 × 22.8 (12⅜ × 9). Collection de l'Art Brut, Lausanne; **24** August Natterer, *Witch's Head (Transparency)*, pre-1919. Pencil, watercolours, pen on varnished card 25.9 × 34.2 (10¼ × 13½). The Prinzhorn Collection, Psychiatric Clinic, Heidelberg University (Inv 184); **25** Vonn Ströpp, *Untitled*, c. 1984. Acrylic on board 190.5 × 114.3 (75 × 45). Courtesy Henry Boxer Gallery, Richmond, England; **26** Jean Dubuffet, *La Belle aux seins lourds*, 1950. Oil on canvas 114.9 × 88.2 (45¼ × 34¾). Private collection. © ADAGP, Paris and DACS, London 2000; **27** Jean Dubuffet, *Man with a Rose*, 1949. Oil on canvas 116 × 89 (45⅝ × 35). Kunstmuseum, Hanover. © ADAGP, Paris and DACS, London 2000; **28** Heinrich Anton Müller, *Two Faces*, c. 1917–22. Black crayon and chalk on two sheets of coloured wrapping paper sewn together 78 × 82 (30¾ × 32¼). Collection de l'Art Brut, Lausanne; **29** Josef Heinrich Grebing, *Calendar of my 20th Century – Chronology for Catholic Youths and Maidens (Hundred-year Calendar)*, n.d. Collage with pencil, pen, indian ink, inks, watercolours in an exercise book 32.7 × 21.1 (12¾ × 8⅜). The Prinzhorn Collection, Psychiatric Clinic, Heidelberg University (Inv 613); **30** Jacob Mohr, *Proofs*, c. 1910. Pencil, pen on office paper 33 × 21 (13 × 8¼). The Prinzhorn Collection, Psychiatric Clinic, Heidelberg University (Inv 627/1); **31** Andrew Kennedy, *Factory Maid*, c. 1890s. Pencil on paper 27.8 × 38.5 (11 × 15¼). Royal Edinburgh Asylum; **32** Louis Soutter, *Seuls*, n.d. Finger paint on paper 65 × 50 (25½ × 19¾). Musée Cantonal des Beaux-Arts, Lausanne; **33** Louis Soutter, *Ascension*, 1937–42. Ink on paper 64 × 49 (25¼ × 19¼). Courtesy Galerie Karsten Greve, Cologne; **34** A Mad Museum: the insane as artists from *The Sketch*, 22 November 1905; **35** George Grosz, *Street Scene with Draftsman*, c. 1917. Pen and ink 33.4 × 21.5 (13¼ × 8½). Graphische Sammlung der Staatsgalerie, Stuttgart. © DACS 2000; **36** Oskar Kokoschka, *Self-Portrait with Doll*, 1920–21. Oil on canvas 84 × 119 (33 × 46⅞). Nationalgalerie, Berlin. © DACS 2000; **37** Photograph of Katharina Detzel with a male stuffed dummy of her own making, c. 1918. The Prinzhorn Collection, Psychiatric Clinic, Heidelberg University (Inv 2713a); **38** Emma Hauck, *Letter to Husband*, 1909. Pencil on paper 61 × 10.3 (24 × 4). The Prinzhorn Collection, Psychiatric Clinic, Heidelberg University (Inv 3621 recto); **39** J. B. Murry, *Untitled*, 1980s. Mixed media on paper 36 × 28 (14¼ ×

11). Private collection; **40** Cy Twombly, *Untitled*, 1970. Oil based house paint, wax crayon on canvas 200 × 240 (78¾ × 94½). Private collection; **41** Joseph König, *Untitled*, 1991. Wax crayon on paper, six panels, each 43 × 61 (17 × 24). Haus-Kannen, Munster. On loan to the Stadshof Museum, Zwolle, The Netherlands; **42** Johann Knopf, *Petition No. 2345, the mysterious affairs of the murderous attacks*, n.d. Pencil, pen on paper 34 × 29.6 (13¾ × 11¾). The Prinzhorn Collection, Psychiatric Clinic, Heidelberg University (Inv 1494/4 recto); **43** Johann Knopf, *Big Bumperton on the Sabbath*, n.d. Pen, coloured pencil on writing paper 20.8 × 16.5 (8¼ × 6½). The Prinzhorn Collection, Psychiatric Clinic, Heidelberg University (Inv 1487 recto); **44** Karl Genzel, *Three Head-Footer Figures*, from Hans Prinzhorn, *Bildnerei der Geisteskranken (Artistry of the Mentally Ill)*, 1922. The Prinzhorn Collection, Psychiatric Clinic, Heidelberg University; **45** Hyacinth, Freiherr von Wieser, *Circle of Ideas of a Man Projected onto the Outer World*, n.d. Pencil, pen on drawing paper 33.3 × 25.2 (13⅛ × 10). The Prinzhorn Collection, Psychiatric Clinic, Heidelberg University (Inv 2457); **46** Hyacinth, Freiherr von Wieser, *Lively Contemplation of Rev. W. Obermaier*, n.d. Pencil on drawing paper 18.3 × 26.3 (7¼ × 10⅜). The Prinzhorn Collection, Psychiatric Clinic, Heidelberg University (Inv 2459); **47** Paul Klee, *Ventriloquist*, 1923. Watercolour on coloured sheet 39 × 28.9 (15¾ × 11¾). The Metropolitan Museum of Art, New York. The Berggruen Klee Collection, 1984. © DACS 2000; **48** Heinrich Anton Müller, with machines he invented, in the courtyard of the Münsingen Asylum, near Bern, Switzerland; **49** Adolf Wölfli, *Chocolat Suchard*, 1918, from *Book with Songs and Dances*, Book 15, page 1907. Pencil, colour pencil and collage on newsprint 99.7 × 71 (39¼ × 28). © Adolf-Wölfli-Stiftung, Kunstmuseum, Bern; **50** Adolf Wölfli, *H.M. Queen Hortensia on the Telephone*, 1920. Crayon and coloured pencil 41 × 29 (16¼ × 11½). © Adolf-Wölfli-Stiftung, Kunstmuseum, Bern; **51** Adolf Wölfli, *The Chimpanzees of the Union of Canada*, 1911, *From the Cradle to the Grave*, Book 4, page 143. Pencil and colour pencil on newsprint 50 × 37 (19¾ × 14½). © Adolf-Wölfli-Stiftung, Kunstmuseum, Bern; **52** Gaston Duf, *Rinauserose Vilritites*, c. 1948. Colour pencil 50 × 68 (19¾ × 26¾). Collection de l'Art Brut, Lausanne; **53** Aloïse Corbaz, *Enlève dans le Manteau royal de Sirene*, c. 1940. Crayon and coloured pencil on paper 32.4 × 24.5 (12¾ × 9¾). Collection de l'Art Brut, Lausanne; **54** Aloïse Corbaz, *Mickens*, c. 1955. Mixed media on paper 100 × 146 (39¾ × 57½). Collection de l'Art Brut, Lausanne; **55** Carlo Zinelli, *Long-Legged Bird*, 1964. Gouache on drawing paper 70 × 50 (27½ × 19¾). Collection de l'Art Brut, Lausanne; **56** Carl Lange, *On the Holy Miracle in Bread*, c. 1900. Pencil on drawing paper 49.2 × 35.5 (19⅜ × 14). The Prinzhorn Collection, Psychiatric Clinic, Heidelberg University (Inv 98); **57** Carl Lange, *The photographically verifiable, interleaved miraculous images,*

revealing a fifteen-year-old crime, in the insole of the victim's shoe, c. 1900. Pencil on drawing paper 51.2 × 65.2 (20¼ × 25⅝). The Prinzhorn Collection, Psychiatric Clinic, Heidelberg University (Inv 99); **58** August Natterer, *Miraculous Shepherd*, pre-1919. Pencil, watercolours on watercolour board varnished, mounted on grey cardboard 24.5 × 19.5 (9½ × 7¾). The Prinzhorn Collection, Psychiatric Clinic, Heidelberg University (Inv 176); **59** Max Ernst, *Oedipus*, 1931, cover of special issue of *Cahiers d'Art*, Paris, 1937. © ADAGP, Paris and DACS, London 2000; **60** *The Lover's Flower*, from André Breton's *Nadja*, Paris, 1928; **61** Cesare Lombroso, epileptics, from *L'Homme criminel*, Paris, 1887; **62** Germaine Berton and members of the Surrealist group, from *La Révolution surréaliste*, No. 1, December 1924; **63** Page from the *Degenerate Art Exhibition Guide*, Munich, 1937, comparing works by a mental patient, Karl Genzel, *Head of a Girl*, 1912/13, and an Expressionist, Eugen Hoffmann, *Girl with Blue Hair*; **64** Johann Hauser, *Reclining Woman*, 1994. Pencil and coloured pencil on paper 62.4 × 88 (24½ × 34¾). Haus der Künstler, Gugging; **65** Johann Hauser, *Slender Woman and Hare*, 1971. Pencil and collage 29.6 × 21 (11⅝ × 8¼). Collection Arnulf Rainer; **66** Johann Fischer, *Unser Trautes Sovarenes*, 1990. Pencil and coloured pencil 43.9 × 62 (17⅛ × 24½). Haus der Künstler, Gugging; **67** August Walla, *Marchen*, 1989. Acrylic on board 200 × 160 (78¾ × 63). Haus der Künstler, Gugging; **68** Oswald Tschirtner, *Many Flying Angels*, 1972. Pen and ink 21 × 14.8 (8¼ × 5⅞). Haus der Künstler, Gugging; **69** Arnulf Rainer and Johann Hauser, *Venus unter blauer Tuchtent*, 1994. Mixed media on paper 40 × 30 (15¾ × 11⅞). Collection Arnulf Rainer. © Arnulf Rainer; **70** Arnulf Rainer, *Profil im Whiskyrausch*, 1966. Oil on cardboard 65 × 40 (25½ × 15¾). Photo courtesy Galerie Ulysses, Vienna. © Arnulf Rainer; **71** Max, *Untitled*, 1972. Pencil on paper 30 × 20.4 (11¾ × 8). Collection Arnulf Rainer; **72** Arnulf Rainer, *Verziehen*, 1969–70. Oil crayon on photograph 60 × 50 (23⅝ × 19¾). Photo courtesy Galerie Ulysses, Vienna. © Arnulf Rainer; **73** Ank van Pagée, *Untitled*, n.d. Oil and pastel 63 × 50 (24⅞ × 19¾). Museum de Stadshof, Zwolle, The Netherlands; **74** Klaus Mücke, *Yellow Nuns*, n.d. Gouache on paper, laid down on canvas 106 × 304 (41⅞ × 119¾). Museum de Stadshof, Zwolle, The Netherlands; **75** Achilles Rizzoli, *Shirley Jean Bersie Symbolically Sketched/Shirley's Temple*, 1939. Coloured ink on rag paper 96 × 60.5 (37¾ × 23¾). Photo The Ames Gallery, Berkeley, CA, courtesy *Raw Vision*; **76** Malcolm McKesson, *Mistress Reducing Man to Page*, c. 1975. Pen, ink and watercolour on paper 25.4 × 20.3 (10 × 8). Courtesy Henry Boxer Gallery, Richmond, England; **77** Malcolm McKesson, *Dancing Page Boy*, c. 1970. Pen and ink on paper 22.9 × 17.8 (9 × 7). Courtesy Henry Boxer Gallery, Richmond, England; **78** Henry J. Darger, *Storm Brewing*, 1920–70. Collage and watercolour 77 × 317 (30¾ × 124⅞). Collection de l'Art Brut, Lausanne;

79 Henry J. Darger, *Untitled*, n.d. Pencil and watercolour on paper 60.8 × 95.4 (24 × 37½). Private collection; *My Sexual Reality (Angela and Ruby)*, 1995. Watercolour and ink on paper 35.6 × 25.4 (14 × 10). Courtesy Henry Boxer Gallery, Richmond, England; **81** Morton Bartlett, *Seated Boy and Boy with Fishing Rod*, c. 1950s. Seated boy, height 68.6 (27), standing boy, height 66 (26). Courtesy Marion Harris, Simsbury, CT; **82** Morton Bartlett, *Untitled*, c. 1950s. Silver gelatin print 8.9 × 10.8 (3½ × 4¼). Courtesy Marion Harris, Simsbury, CT; **83** Martin Ramírez, *Untitled*, 1953. Pencil, crayon and collage 124.5 × 91.4 (49 × 36). Courtesy Sotheby's, New York; **84** Edmund Monsiel, *Untitled*, c. 1945. Pencil on paper 20.3 × 15.2 (8 × 6). Courtesy Henry Boxer Gallery, Richmond, England; **85** Guillaume Pujolle, *The Eagles, the Goose's Feather*, 1940. Coloured crayons and ink 48.6 × 63.5 (19⅛ × 25). Collection de l'Art Brut, Lausanne; **86** André Masson, *Labyrinth*, 1938. Oil on canvas 120 × 61 (47⅛ × 24). Musée National d'Art Moderne, Paris. © ADAGP, Paris and DACS, London 2000; **87** Ody Saban, *Kiss Me*, 1998. Coloured inks on paper 48.3 × 73.7 (19 × 29). Courtesy Henry Boxer Gallery, Richmond, England; **88** Ody Saban, *To Caress the Roses of Your Cheeks*, 1998. Coloured inks on paper 63.5 × 96.5 (25 × 38). Courtesy Henry Boxer Gallery, Richmond, England; **89** Nick Blinko, *Crucified*, c. 1990. Pen and ink on paper 30.5 × 28 (12 × 11). Courtesy Henry Boxer Gallery, Richmond, England; **90** Raymond Morris, *Strange Stage*, c. 1987. Gouache, pen and ink on paper 42 × 59 (16½ × 23¼). Photo Keith Thompson; **91** Raymond Morris, spread from the *Scrap Book*, c. 1988. Ballpoint pen, fibre tip pen and gouache on paper 36.5 × 49 (14⅜ × 19¼). Photo Keith Thompson; **92** Apper Prinssen, *Weet Niet*, 1993. Oil on pastel on paper 61 × 47 (24 × 18½). Museum de Stadshof, Zwolle, The Netherlands; **93** Wilco Kreisel, *Five Trees*, 1996. Pastel on paper 50 × 70 (19¾ × 27½). Museum de Stadshof, Zwolle, The Netherlands; **94** Laura Craig McNellis, *Untitled (Hot-Water Bottle)*, c. 1982. Mixed media on newsprint 50.8 × 71.1 (20 × 28). Ricco-Maresca Gallery, New York. Photo Art Resource, New York; **95** Evert Panis, *Autos*, n.d. Pen on paper 50 × 70 (19⅝ × 27½). Museum de Stadshof, Zwolle, The Netherlands; **96** Herbert Liesenberg, *Untitled*, c. 1985. Wax crayon, crayon and pencil on paper 40.6 × 55.9 (16 × 22). Courtesy Henry Boxer Gallery, Richmond, England; **97** Dwight Mackintosh, *Untitled*, 1988. Pen and crayon 66 × 50.8 (26 × 20). From the Collection of Carolyn Walsh, courtesy of Sailor's Valentine Gallery, Nantucket; **98** Jimmy Roy Wenzel, *Untitled*, 1990s. Crayon on paper 100 × 65 (39¾ × 25½). Museum de Stadshof, Zwolle, The Netherlands; **99** Jimmy Roy Wenzel, *Untitled*, 1990s. Mixed media on paper 65 × 100 (25½ × 39¾). Museum de Stadshof, Zwolle, The Netherlands; **100** Robert Gie, *Circulation of Effluvia with Central Machine and Metric Scale*, c. 1916. Pencil and indian ink on tracing paper 48.3 × 69.2 (19 × 27¼). Private collection;

101 Willem van Genk, *Amsterdam-Moscow*, 1967. Mixed media on board 128 × 147 (50¾ × 57⅞). Collection Musée d'Art Moderne, Villeneuve d'Ascq. Photo Museum de Stadshof, Zwolle, The Netherlands; **102** Willem van Genk, *Rome Termini*, c. 1965 (reverse side). Mixed media on board 69 × 284 (27⅛ × 111⅞). Museum de Stadshof, Zwolle, The Netherlands; **103** Willem van Genk, *Trolleybus*, c. 1980/90. Mixed media 91 × 120 (35⅞ × 47¼). Museum de Stadshof, Zwolle, The Netherlands. Photo courtesy the author; **104** Willem van Genk, *Arthur Hailey Airport 2*, c. 1965. Mixed media on paper 91 × 120 (35⅞ × 47¼). Collection Galerie Hamer, Amsterdam; **105** Eddie Arning, *'The Not Hot Hot Dog'*, 19–26 July 1968. Wax crayon and pencil on woven mulberry-coloured paper 55.9 × 40.6 (22 × 16). Abby Aldrich Rockefeller Folk Art Center, Williamsburg, Virginia; **106** Karen Brown, *The Portrait of Romance*, n.d. Mixed media and glitter on paper 61 × 45.7 (24 × 18). Photo Courtesy Phyllis Kornfeld, author of *Cellblock Visions: Prison Art in America*, Princeton University Press, 1997; **107** John Harvey, *Jezreel*, n.d. Paintstick on cardboard panel 42 × 78.7 (16½ × 31). Collection Justin Massingale. Photo Courtesy Phyllis Kornfeld, author of *Cellblock Visions: Prison Art in America*, Princeton University Press, 1997; **108** Victorien Sardou, *Mozart's House (lower town)*, 1857–58. Etching 56 × 64 (22 × 25¼). Collection l'Art Brut, Lausanne; **109** Jackson Pollock, *There were Seven in Eight*, 1945. Oil on canvas 109.2 × 259.1 (43 × 8'6). The Museum of Modern Art, New York. Mr and Mrs Walter Bareiss Fund and Purchase. Photograph © 1998 The Museum of Modern Art, New York. © ARS, NY and DACS, London 2000; **110** Hélène Smith, *Ultramartian Landscape*, 1900. Watercolour, indian ink, pencil and egg albumin varnish on paper 22.9 × 30.1 (9 × 11⅞). Private collection; **111** Augustin Lesage, *Symbolic Composition on the Spiritual World*, 1925. Oil on canvas 205 × 145 (80¾ × 57). Collection de l'Art Brut, Lausanne; **112** Raphaël Lonné, *Untitled*, October 1963. Chinese ink and coloured crayons 25 × 33.5 (9⅞ × 13¼). Collection de l'Art Brut, Lausanne; **113** Madge Gill, *The Crucifix of the Soul*, n.d. (detail). Ink on calico 147 × 1062 (57⅞ × 418). From the collection of Newham Museum Service; **114** Madge Gill, *Untitled*, c. 1940. Ink on card 20.3 × 7.6 (8 × 3). Courtesy Henry Boxer Gallery, Richmond, England; **115** Marie-Jeanne Gil, *Cosmic Roses*, from the second series, drawn with the right hand, 1995. Felt pen on paper. Private collection; **116** Pearl Alcock, *The Magic Tree*, 1986. Acrylic on board 28 × 34 (11 × 13¼). Museum de Stadshof, The Netherlands; **117** Anna Zemánková, *Untitled*, n.d. Pen and pastel on paper 41.9 × 31 (16½ × 12¼). Private collection; **118** Minnie Evans, *Untitled (Landscape – Many Faces)*, 1950–61. Mixed media on canvas board 50.8 × 61 (20 × 24). Courtesy Luise Ross Gallery, New York; **119** Laure

Pigeon, *Drawing, November 10, 1961*. Violet and blue ink on drawing paper 65 × 60 (25½ × 23¾). Collection de l'Art Brut, Lausanne; **120** Laure Pigeon, *Drawing, August 2, 1935*. Blue ink on paper 24 × 31 (9½ × 12¼). Collection de l'Art Brut, Lausanne; **121** Marie-Rose Lortet, *Tunnel of Love*, 1992. Knitted yarn. Museum de Stadshof, Zwolle, The Netherlands. © ADAGP, Paris and DACS, London 2000; **122** Agnes Richter, hand-sewn jacket embroidered with autobiographical and other texts, pre-1919. Yarn on institutional grey linen. Neck to hem 36.5 (14¾). The Prinzhorn Collection, Psychiatric Clinic, Heidelberg University (Inv 743); **123** Miss G., *Untitled*, 1897. Embroidery thread on linen handkerchief 37 × 36 (14½ × 14¼). The Prinzhorn Collection, Psychiatric Clinic, Heidelberg University (Inv 6053); **124** Jeanne Tripier, *Large Rectangular Embroidery*, 1935–39. Cotton, wool and string 25 × 90 (9¾ × 35¼). Collection de l'Art Brut, Lausanne; **125** Henk Veenvliet, *Still-Life in Nature: The North Pole*, 1987. Watercolour on paper, 12 works, 24.1 × 19.2 each (9½ × 7½). Private collection, on loan to the Museum de Stadshof, Zwolle, The Netherlands; **126** Adam Nidzgorski, *Untitled*, 1978. Wax crayon on newspaper 50 × 34 (19¾ × 13¾). Museum de Stadshof, Zwolle, The Netherlands; **127** Simone Le Carré-Galimard, *Orgiaques Foraines*, n.d. Photo courtesy La Fabuloserie, Dicy, France; **128** Alain Lacoste, *Serout ils sauvé*, 1982. Mixed media collage 32 × 59.5 (12½ × 23½). Museum de Stadshof, Zwolle, The Netherlands; **129** Kurt Schwitters, *Merz Column*, 1923, in the artist's apartment in Hanover; destroyed. © DACS 2000; **130** Alfonso Ossorio, *Thee and Thy Shadow*, 1961, reworked 1966. Mixed media assemblage 244 × 122 (96 × 48). Private collection; **131** Rosemarie Koczÿ, *Untitled*, 1988. Pen and ink on paper 35.5 × 27 (14 × 10¾). Museum de Stadshof, Zwolle, The Netherlands; **132** Rosemarie Koczÿ, *Untitled*, 1985 (detail). Ink on canvas 153 × 575 (60 × 226¼). Museum de Stadshof, Zwolle, The Netherlands; **133** Michel Nedjar, *Poupée*, n.d. Mixed media on paper 97 × 19 × 20 (38¼ × 7½ × 7¾). Museum de Stadshof, Zwolle, The Netherlands; **134** Michel Nedjar, *Untitled*, n.d. Mixed media on paper 43 × 41 (17 × 16¼). Museum de Stadshof, Zwolle, The Netherlands; **135** Riet van Halder, *Untitled*, c. 1995. Mixed media on paper 16 × 24 (6¼ × 9½). Museum de Stadshof, Zwolle, The Netherlands; **136** Scottie Wilson, *Phantom of the Night*, c. 1946. Pen and ink on paper 40.6 × 20.3 (16 × 8). Courtesy of Henry Boxer Gallery, Richmond, England; **137** Scottie Wilson, *Springtime No. 4*, 1955. Pen and ink on paper 94 × 158.7 (37 × 62). Courtesy Gimpel Fils Gallery, London; **138** Joseph E. Yoakum, *Mount Victoria*, c. 1965. Coloured pencil on paper. Courtesy Phyllis Kind Gallery, New York; **139** Joseph E. Yoakum, *The Island of Sardinia*, 1966. Coloured pencil on paper 30.2 × 47.9 (11⅞ × 18¾). Courtesy Phyllis Kind Gallery, New York; **140** Gladys Nilson, *Stompin at the Snake Pit*, 1968. Watercolour 55.9 × 76.2 (22 × 30). Private collection;

141 Mary T. Smith, *Red and Black*, c. 1983. Oil on wood 40.6 × 162.6 (16 ×.64). Courtesy the Anton Haardt Collection; **142** Mose Tolliver, *Family*, 1991. Paint on board 30.5 × 55.9 (12 × 22). Courtesy the Anton Haardt Collection; **143** Jimmy Lee Sudduth, *Man with Cane*, 1995. Paint and mud on wood 110.5 × 72.4 (43½ × 28½). Photo © Scott Metcalfe 1999; **144** Bill Traylor, *Kitchen Scene, Yellow House*, 1939–42. Pencil on cardboard 55.9 × 35.5 (22 × 14). The Metropolitan Museum of Art, New York. Anonymous gift 1992; **145** Sam Doyle, *Onh Sam*, 1978–81. Enamel on board 80 × 53.3 (31½ × 21). Ricco-Maresca Gallery, New York. Photo Art Resource, New York; **146** Leroy Person, *African Throne*, c. 1974. Treewood, lumber and nails, height 58.4 (23). The Lynch Collection of Outsider Art, Wesleyan College, NC; **147** Herman Bridgers, *Two Churchmen*, 1984. Painted wood assemblage from church pew 51 × 63.5 × 73.6 (20 × 25 × 29). The Lynch Collection of Outsider Art, Wesleyan College, NC; **148** James Hampton, *Throne of the Third Heaven of the Nations' Millenium Assembly*, c. 1950–64. Gold and silver aluminium foil, coloured Kraft paper and plastic sheets over wood, paperboard and glass. 180 pieces in overall configuration 3.2 m × 8.23 m × 4.42 m (10'6" × 27' × 14'6"). National Museum of American Art, Washington, D.C. Gift of anonymous donors. Photo Art Resource, New York; **149** Bodys Isek Kingelez, *Red Star*, 1990. Paper, cardboard, veneer, tulle, wire 84.5 × 92 × 50 (33¼ × 36¼ × 19¾). © C.A.A.C. The Pigozzi Collection, Geneva. Photo Claude Postel; **150** and **151** Bodhan Litnanski, *Jardin du Coquillage*, Vitry-Noureuil, France, begun 1966. Photos © Maggie Jones Maizels, courtesy *Raw Vision*; **152** and **153** Tressa 'Grandma' Prisbrey, *Bottle Village*, Simi Valley, California, USA, 1955–63. Photos © Daniel Paul; **154**, **155** and **156** Adolphe-Julien Fouré, *Les Rochers sculptés*, Rothéneuf, near Saint-Malo, Brittany coast, France, 1894–1910. Photos © Daro Montag, courtesy *Raw Vision*; **157** and **158** Nukain Mabusa, *Stone Garden*, Revolver Creek, South Africa, c. 1970–80. Plate 157: photo © Peter Cooper, 1982; plate 158: photo © John Clarke, 1982. Both photos, courtesy *Raw Vision*; **159**, **160** and **161** Ferdinand Cheval, *Palais Idéal*, Hauterives, near Lyon, France, 1879–1912. Plate 159: photo © Claude Prevost; plates 160 and 161: photos © Maggie Jones Maizels. All photos, courtesy *Raw Vision*; **162** and **163** Simon Rodia, *Watts Tower*, Los Angeles, USA, 1921–54. Photos © Marcus Schubert, courtesy *Raw Vision*; **164** Clarence Schmidt, *Woodstock Environment* (or *House of Mirrors*), Catskill Mountains, Woodstock, New York, USA, 1948–68. Photo © Beryl Sokoloff, courtesy *Raw Vision*; **165** Howard Finster, *Paradise Garden*, Pennville, Georgia, USA, 1976. Photo © Ted Degener; **166** Howard Finster, inlaid wall near entrance of *Paradise Garden*, Pennville, Georgia, USA, 1970s. Photo © Ted Degener; **167** Leonard Knight, *Salvation Mountain*, near Slab City, Niland County, California, USA, begun 1985. Photo © Larry Yust, courtesy

Raw Vision; **168** Eddie Owens Martin (St EOM), *Pasaquan*, Buena Vista, near Columbus, Georgia, USA, 1957–86. Photo © Roger Manley, courtesy *Raw Vision*; **169** Armand Schulthess, *Le Jardin encyclopédique*, Isorno Valley, Switzerland, 1952–72. Collection de l'Art Brut, Lausanne; **170** Vollis Simpson, *Whirligig Environment*, Lucama, North Carolina, USA, 1980–90. Photo © Ted Degener; **171** Pierre Avezard (Petit-Pierre), *Le Manège*, La Fabuloserie-Bourbonnais, Dicy, France, 1955–85. Photo courtesy La Fabuloserie-Bourbonnais, Dicy, France; **172** CHOMO (Roger Chomeaux), *Village de l'art préludien*, Achères-la-Forêt, Fontainebleau, France, begun 1960. Photo © Maggie Jones Maizels, courtesy *Raw Vision*; **173** Alain Bourbonnais among his *Turbulents*, c. 1988. Photo courtesy La Fabuloserie-Bourbonnais, Dicy, France; **174** Alain Bourbonnais, *Gratte-Cul*, n.d. Collage, ink and colours 80 × 70 (31½ × 27½). Photo courtesy La Fabuloserie-Bourbonnais, Dicy, France. © ADAGP, Paris and DACS, London 2000; **175** and **176** Nek Chand, *Massed Villagers*, from the second phase of the *Rock Garden*, Chandigarh, India. Whole garden 1965–95. Detail of *Queens after Bathing*, begun 1965. Photos © Maggie Jones Maizels, courtesy *Raw Vision*; **177** Saou bi Boti of Tibeita village, *Flali* mask, carved for dances in Bangofa village, Ivory Coast, Africa, 1983. Photo © Lorenz Homberger; **178** Djilatendo, *The Hunter*, 1932. Watercolour on paper 40 × 75 (15¾ × 30). Collection Eric Kawan; **179** Twins Seven Seven, *The Architect*, 1989. Ink on cut and superposed wood 61 × 41 (24 × 16¼). © C.A.A.C. The Pigozzi Collection, Geneva. Photo Claude Postel; **180** Leonard Daley, *Grey Face with Turning Goat*, 1992. Mixed media on wood 45.7 × 40.6 (18 × 16). The Wayne and Myrene Cox Collection, Minneapolis, Minnesota, USA. Photo © Wayne Cox; **181** Tshibumba Kanda-Matalu, *Colonie Belge 1885–1959*, 1970s. Paint on flour sack 36 × 45 (14¼ × 17¾). Collection Bogumil Jewsiewick; **182** Moke, *The Gulf War*, 1991. Oil on canvas 176 × 130 (69¼ × 51¼). © C.A.A.C. The Pigozzi Collection, Geneva. Photo Claude Postel; **183** Cheri Samba, *Seduction*, 1984. Paint on flour sack 80 × 60 (31½ × 23¾). Collection Ciciba, Libreville; **184** Kane Kwei, *Mercedes Benz-Shaped Coffin*, 1989. Wood and enamel paint, length 265 (104¾). Museum voor Volkerkunde, Rotterdam; **185** Pansy Napangati, *Bush Mango, Two Travelling Women and Snake* Tjukurrpas (*Dreamings*), 1989. Acrylic on canvas 212 × 340 (83½ × 134). Gabrielle Pizzi Collection, Melbourne. © Aboriginal Artists Agency; **186** James Luna, *Four Directions, Four Cars*, detail from the *Sacred Colors* series, 1992. Found objects, paint on canvas 182.8 × 182.8 (72 × 72). Collection the artist; **187** Rebecca Belmore, *Ayum-ee-aawach Oomama-mowan: Speaking to their Mother*, 27 July 1991. Performance work with 13 native speakers, 2m megaphone, Banff, Alberta. Photo collection of the artist; **188** Robert Campbell Jnr, *Death in Custody*, 1987. Synthetic polymer paints on canvas 82.2 × 120 (32¾ × 47¼). The Holmes à Court Collection, Heytesbury. Courtesy of Roslyn Oxley9 Gallery, Sydney

Index